CONTEMPORARY wedding PHOTOGRAPHY

A DAVID & CHARLES BOOK
Copyright © David & Charles Limited 2006

David & Charles is an F+W Publications Inc. company
4700 East Galbraith Road
Cincinnati, OH 45236

First published in the UK in 2006

Text and illustrations copyright © Julie Oswin and Steve Walton 2006

Julie Oswin and Steve Walton have asserted their right to be identified as authors
of this work in accordance with the Copyright, Designs and Patents Act, 1988.

A catalogue record for this book is available from the British Library.

ISBN-13: 978-0-7153-2460-8 hardback
ISBN-10: 0-7153-2460-8 hardback

ISBN-13: 978-0-7153-2461-5 paperback (USA only)
ISBN-10: 0-7153-2461-6 paperback (USA only)

Printed in China by SNP Leefung
for David & Charles
Brunel House Newton Abbot Devon

Commissioning Editor Neil Baber
Editor Ame Verso
Copy Editor Cathy Joseph
Art Editor Sarah Underhill
Designer Jodie Lystor
Production Controller Bev Richardson

Visit our website at www.davidandcharles.co.uk

David & Charles books are available from all good bookshops; alternatively
you can contact our Orderline on 0870 9908222 or write to us at FREEPOST
EX2 110, D&C Direct, Newton Abbot, TQ12 4ZZ (no stamp required UK only);
US customers call 800-289-0963 and Canadian customers call 800-840-5220.

CONTEMPORARY wedding PHOTOGRAPHY

D&C
David and Charles

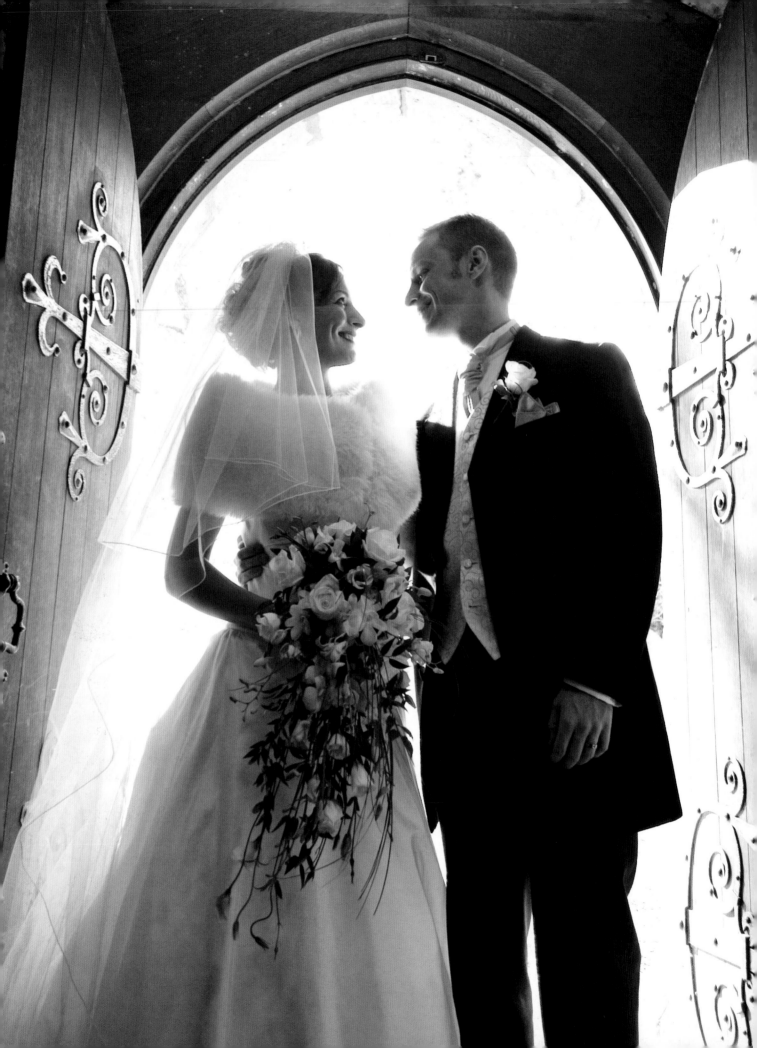

Contents

Introduction 6

CHAPTER 1

Preparation 16

Meeting Your Clients 18
The Pre-Wedding Shoot 20
Selecting Locations 22
The Wedding Photographer's Kit 24
Sequence of Events 26

CHAPTER 2

Directing Poses 28

Natural Poses 30
Romantic Poses 32
Outdoor Poses 34
Dramatic Poses 36
Directing Groups 38
Directing Large Groups 40

CHAPTER 3

Photographing Details 42

Before the Ceremony 44
After the Ceremony 46
The Rings 48
At the Reception 50

CHAPTER 4

The Wedding Story 52

PART 1: At the Bride's Home 54
PART 2: At Home with the Groom 60
PART 3: En Route with the Groom 64
PART 4: Arriving with the Bride 66
PART 5: The Ceremony 68
PART 6: The Signing 70
PART 7: Reportage Shots 72
PART 8: Group Shots 80
PART 9: The Bride and Groom Leaving 88
PART 10: The Reception 94
PART 11: Cake and Party Time 102

CHAPTER 5

Editing and Digital Darkroom 106

Editing Your Photographs 110
Digital Darkroom 112
Printing Advice 120

CHAPTER 6

Designing the Album 122

Album Styles and Choices 124
Designing the Album 126
Magazine Style Albums 128
Traditional Style Albums 130

CHAPTER 7

The Business of Marketing 132

Marketing 134
Websites 138

• The A–Z of Professional Wedding
 Photography Tips 140
• Index 142

Introduction

From its earliest days until comparatively recently, wedding photography followed an accepted combination of formal, posed images of the happy couple and interminable family group images. The composition of family groups conformed to rigid standards that remained largely unchanged for decades. The set expressions and regimented poses created by 19th-century wedding photographers were dictated partly by social convention and partly by a technology that required subjects to remain motionless throughout lengthy exposures to avoid image blurring.

This stereotypical social imagery remained the standard until around the 1930s when the rapid development of affordable, basic photographic equipment, changing social habits and expectations, and the evolution of a less regimented approach to social photography gained wider appeal. The major breakthrough in wedding photography must surely have come when some early pioneer realized the 'lifestyle imagery' potential in allowing his sitters to look happy for the camera.

A more sophisticated and affluent society brought higher expectations, aspirations and the confidence of customers to dictate their own personal requirements. The days of the wedding photographer who arrived on the day with just a medium-format camera, a couple of lenses, a flashgun, a tripod and four or five rolls of film are well and truly over. Society no longer requires that kind of approach. This is contemporary wedding photography and the shackles have been cast off.

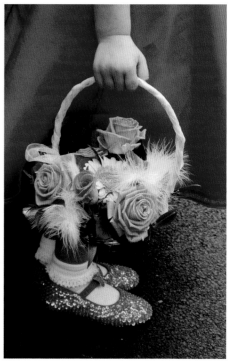

You can't fail with a shot of this nature. It has softness, lovely colour and, of course, the cuteness of the little girl peeping through.
Nikon DSLR, 17–55mm lens, 1/60sec at f/2.8

Capturing a moment in time, like this shot of a little bridesmaid holding the flowers, says more than words. A 80–200mm lens allows you to get in close without drawing too much attention to yourself. Ensure you have enough space to use this lens. Working quickly and under pressure at a wedding doesn't give you a lot of time to change lenses.
Nikon DSLR, 80–200mm lens, 1/250sec at f/2.8

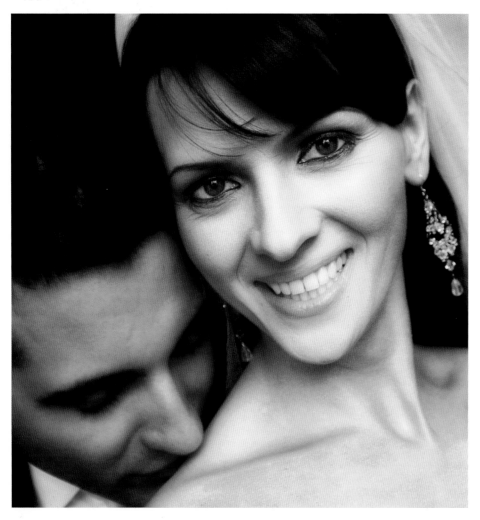

Get in close. The eye contact between the bride and the camera makes this shot, and the expression in her eyes says it all. Expression, expression! That is the key to good wedding photography.
Nikon DSLR, 28–80mm lens, 1/125sec at f/4

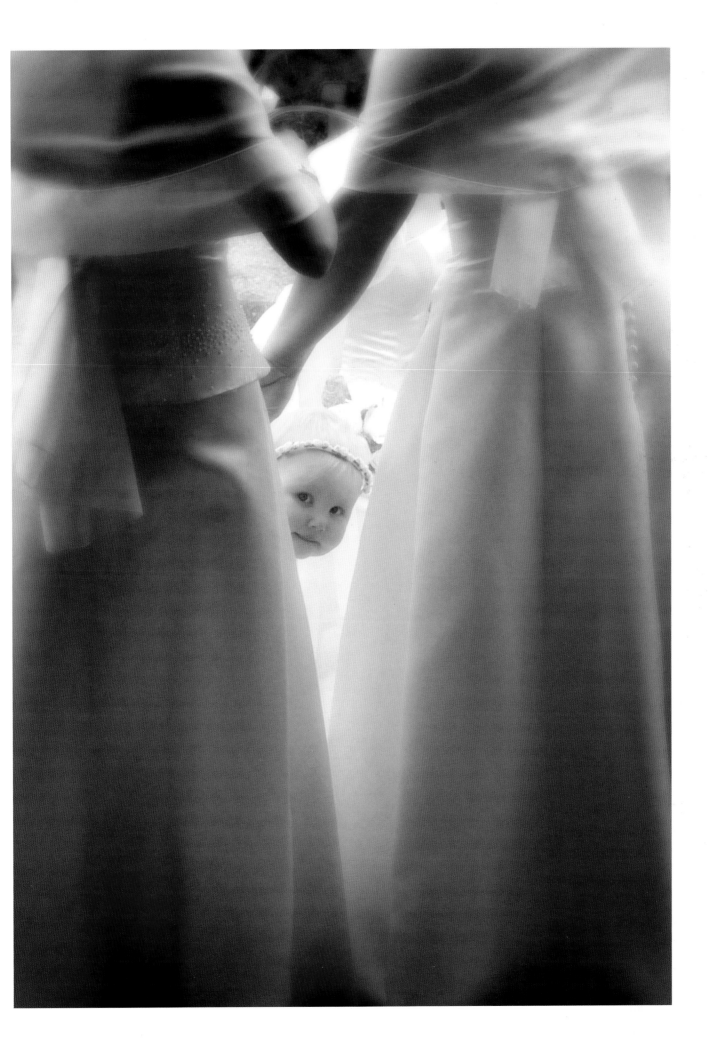

This award-winning photograph was captured between the ceremony and reception. The bride was told to turn slowly towards the sunlight until she was asked to hold the pose. The breeze has just taken her shawl and lifted it slightly, giving movement and shape to the image. The photograph was converted to black and white and blue-toned.
Nikon DSLR, 28–80mm lens, 1/250sec at f/8

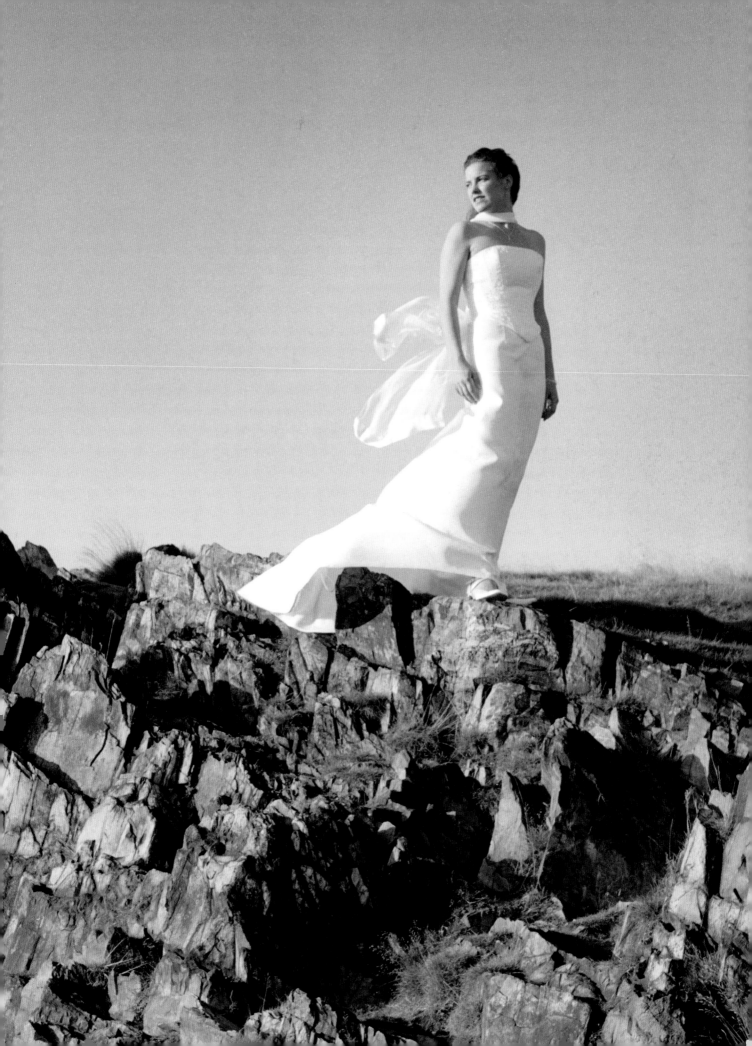

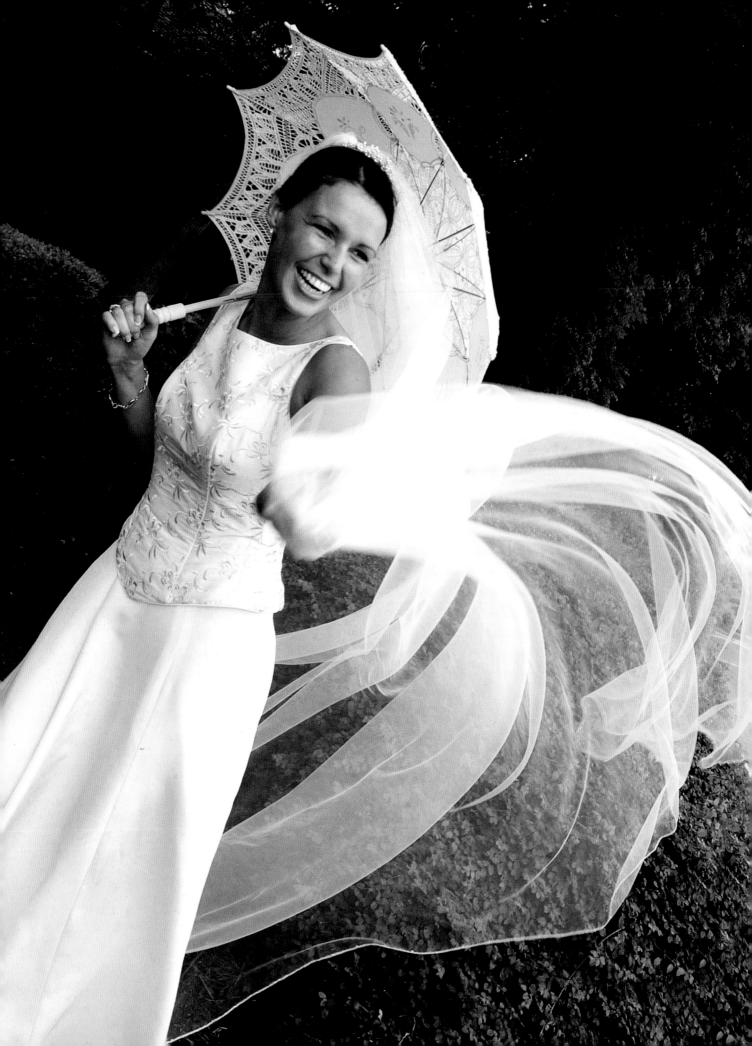

Digital Innovation

Wedding photography as a developing genre has been accelerated by digital capture, improved image manipulation and album design software packages. As early adopters of digital technology, we have been at the forefront of contemporary wedding photography capture and presentation. In the early days, our conversion to a digital workflow was met with scepticism and doubt by many of our industry colleagues. What has happened in the intervening years is quite predictable. Those sceptics have either now taken the digital route themselves, or they have simply gone out of business. It is a very stark fact of business that if you are unable to provide a product that is in demand, you will cease to trade.

There is no doubt that digital technology has allowed us, and photographers in many other fields, to expand our creative repertoire, both in photography and presentation. Our own early conversion to digital capture and workflow has paid off, but there is no future and nothing to be gained by sitting at the top of the learning curve and gazing down with smug satisfaction as the competition frantically tries to catch up. Those who have both creative ability as photographers and the willingness to gain expertise with evolving technology will take the industry forward. Wedding photography is an exciting place to be at the moment, constrained only by the vision and enthusiasm of its best practitioners. It is a fluid environment and, for professionals, our businesses can grow with it. Interested amateurs can benefit from our techniques to extend their abilities and range.

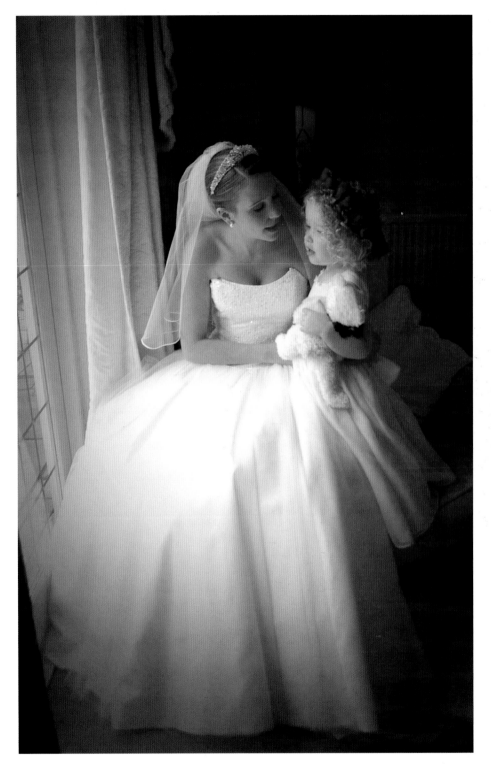

This is a beautiful image of the bride and her daughter, Libby. The little girl was looking through the window for squirrels. Notice how the bride's face has been illuminated by the light reflecting off her dress. Flash would have killed the atmosphere here.
Nikon DSLR, 28–80mm lens, 1/60sec at f/4

Directing the bride to throw her veil around created movement in this image. Again, the picture works because of the bride's expression and the composition.
Nikon DSLR, 28–80mm lens, 1/60sec at f/5.6

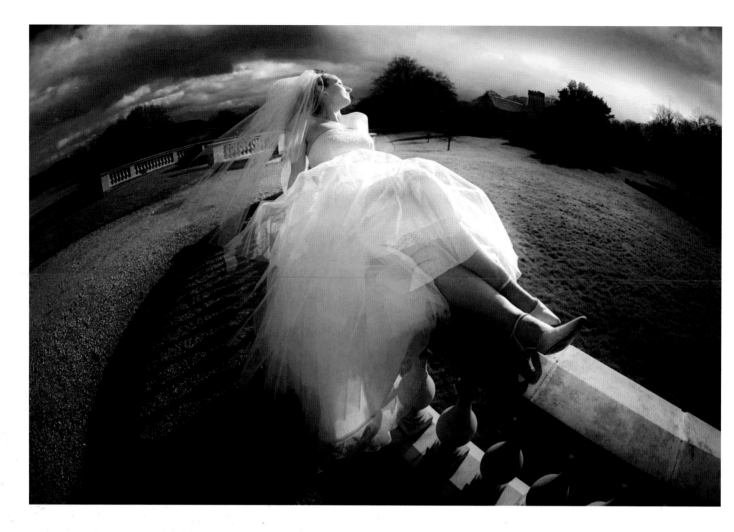

Creative Approaches

Contemporary wedding photography, as we refer to it in this book, consists of four areas, which call for different techniques and approaches. The documentary or photojournalistic style is used for the bride and groom in preparation, the ceremony and the signing of the register. For this, we use a combination of unposed and camera-aware techniques with our subjects. A little direction or encouragement helps with the story and refinement of the images.

Immediately after the marriage ceremony, there is an outpouring of emotion and expression, which calls for a fly-on-the-wall, reportage approach to the photography. There is no intervention by us and, although the subjects may well be aware of the presence of the camera, they are generally oblivious to it. The object is to capture all of the excitement and expression as close friends and relatives congratulate the newly married couple.

The family group photographs and a group shot of all the guests require a greater degree of posed direction but, as you will see, these images can be produced with a minimum of fuss and formality. While

still an important part of the album, the set-up groups are, these days, the least popular part of wedding photography for the couple and guests. It is important to make every effort to take them quickly and professionally, while ensuring the experience is as enjoyable as it possibly can be for everyone involved.

Finally, there is our signature editorial style of photographing the couple alone. Our inspiration is drawn from many sources, from fashion and lifestyle publications and men's magazines to advertising and glamour images. For the short period of time – around 20–30 minutes – that we are alone with the couple, direction and control is intense, but above all fun for both the couple and ourselves.

The Photographer's Journey

These four distinct styles of photography combine to create a contemporary, stylish and complete story of the wedding day. The photography provides the building blocks; the post-production treatment and final album presentation complete the storybook. Contemporary wedding photography can provide an unlimited outlet

This creative and dramatic image was created using a fisheye lens, a wall for the bride to sit on and finally, by turning the bride towards the light, the composition was complete.
Nikon DSLR, 10.5mm fisheye lens, 1/60sec at f/8

for expression and creativity. Each wedding is different and brings its own challenges, providing the spur to push ourselves a little further and thus refine our ideas.

Within this book, we shall take the reader on a journey through our approach to wedding photography. Beginning with the initial enquiry and booking, we explain the steps to take during the preparation for the wedding and how to gain the confidence and trust of the couple. Following from that, every aspect of the day's coverage is examined, from the basics of posing groups and individuals, to taking pictures unobtrusively and controlling available light. A section on the Wedding Story shows how the photography of the day develops

to build up a story of people, events and emotions. Advice, tips and techniques for success are provided throughout.

The final three chapters examine the work to be done once the wedding is over, from editing and digitally enhancing the photographs, to designing the couple's selection in the album. There is also advice on marketing, since wedding photography, no matter how creative, is still a business and there is always the need to stay one step ahead of competitors.

Wedding photography has evolved into art where once it was a craft. The aim of this book is to show some of the many creative possibilities and provide the inspiration to look for more.

This image has won numerous awards. It shows the expression and emotion that all brides should feel on their wedding day. After conversion to black and white, the image was blue-toned and vignetted at the corners to add depth and mood.
Nikon DSLR, 28–80mm lens, 1/250sec at f/2.8

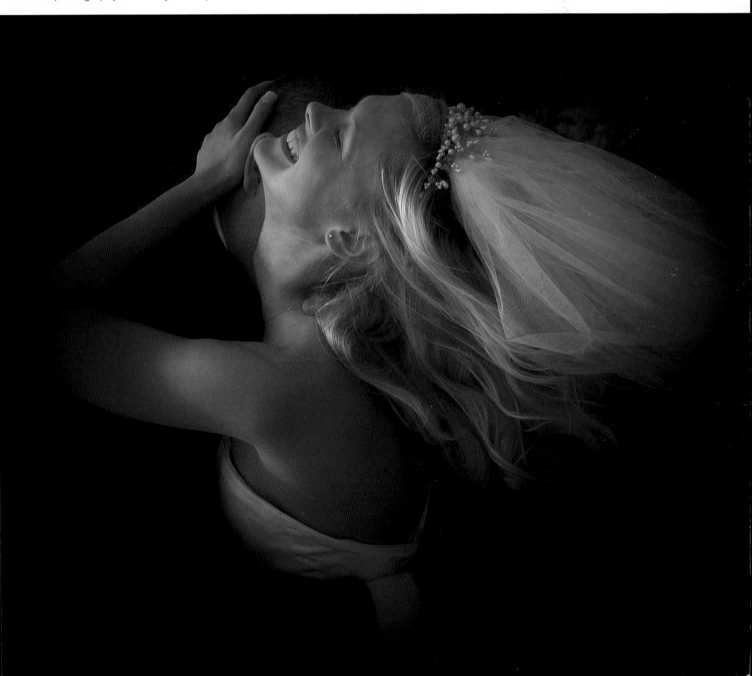

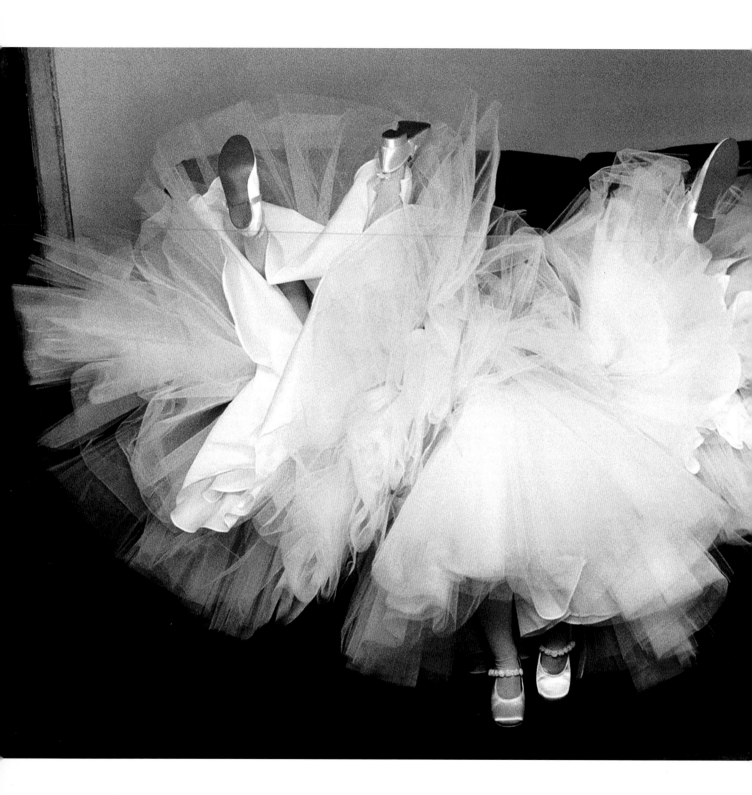

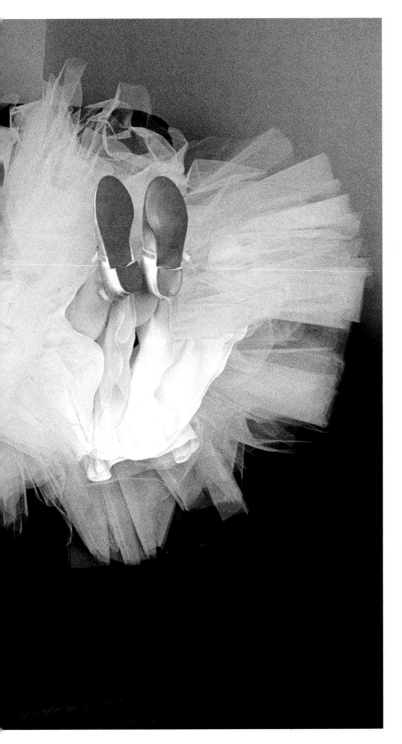

Always be prepared for the unexpected. This image was created without intervention by Julie. The four bridesmaids were waiting for the bride to finish her preparations. As children will, they became restless and began to play on the sofa, falling backwards and kicking their feet in the air. It would be impossible to choreograph this moment or repeat it. Julie became the UK Avant Garde Wedding Photographer of the Year at the British Professional Photography Awards in 2001; this image has the contemporary but timeless quality that has become her signature.

The importance of entering competitions and acheiving success in major awards cannot be overstated. It is one of the most effective ways to raise your profile and secure wedding bookings – everyone likes to be associated with a winner!
Nikon DSLR, 28–80mm lens, 1/60sec at f/5.6, bounced flash

Preparation

This chapter looks at the various stages that take place in the run-up to a wedding, from the first meeting with the clients to drawing up a schedule of events. In between, there is an informal meeting with the couple at the venue for the pre-wedding photo shoot. As well as providing them with an additional service, it is a good chance to find locations that will be used for photography on the day.

The final phase of the preparations is the last pre-wedding interview with the couple, which takes place about two months before the big day. By this stage, all their plans will be in place and any changes to the original itinerary can be discussed. The suppliers will all have been appointed and the couple will have a confirmed guest list.

Thorough preparation pays off ensuring that everyone has a clear knowledge of the planned sequence and timing of the day's events. An additional, vital benefit is that the couple and photographer have built a strong rapport and can greet each other as friends when the day finally arrives.

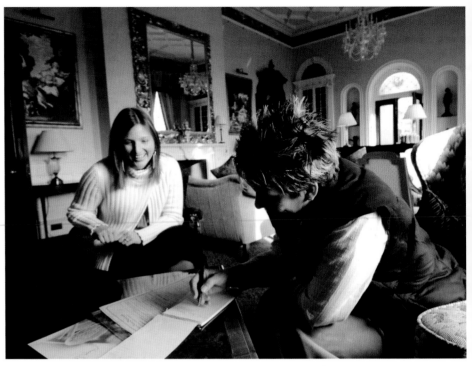

ABOVE AND RIGHT: At the first meeting with potential clients, display albums are shown and the couple's likes and dislikes noted. It is also the chance to check that you can get on with each other and build up the rapport that will be vital on the day.
Nikon DSLR, 28–80mm lens, 1/60secs at f/5.6

Meeting Your Clients

The frequency of telephone enquiries about your services measures the effectiveness of marketing and advertising strategies. The percentage of those enquiries that convert into confirmed bookings are indicators of your product, the marketplace, your pricing, marketing strategy and yourselves, as perceived by the couple at the first meeting.

'It would be a disservice to both the clients and photographer if the acceptance of a booking was based purely on financial motives.'

Most phone calls will no doubt come as a result of recommendation, either personal or from the couple's reception venue or as the result of an Internet search. The couple will have found your website, liked what they have seen and want to know what you can offer that competitors cannot. Advertising and publicity in bridal magazines also bring in enquiries, but perhaps not so many.

The most frequent opening question on the telephone is, 'How much do you charge?' Quickly followed by, 'How many photographs do we get in our album?' This sets the challenge of securing a booking from an enquirer whose maximum budget is less than your costs, or one who sees wedding photography as a low priority. It's more encouraging to hear, 'We've seen your website, are you available to photograph our wedding?' Money is not the primary concern for these people. They will have an idea of the value of wedding photography and, hopefully, an indication of your fees.

Set aside two evenings a week for initial meetings with clients and make the appointments for a convenient time.

RULE OF THUMB

The initial meeting with clients is an important chance for both parties to see if a rapport can be established between you, which will be essential on the wedding day. A friendly atmosphere, the offer of coffee and pleasant small talk will help put them at ease.

Display albums should show the full range of your style. This image has been converted to monochrome and darkened by a vignette to accentuate the bride's face.
Nikon DSLR, 17–55mm lens, 1/60secs at f/5.6

An hour is probably sufficient to explain your packages and pricing. First impressions count, so a friendly approach pays off. Offer the couple coffee, ask them how they came to hear of you and congratulate them on their choice of venue. Once they are feeling relaxed, you can begin to show them display albums. During this time, establish the sort of photography that they are looking for, what they like and dislike, how many guests they expect to be present and so on.

The first meeting is the opportunity to decide whether or not you would wish to accept the booking if the couple do want to employ you. Occasionally, you may be unwilling to go ahead, for a variety of possible reasons. Usually it is because one or both of them has been difficult to get along with at the first meeting. For wedding photography to be successful, there has to be a strong rapport between the photographer and clients. It is the only way that good images can be created, with relaxed and happy expressions on everyone's faces. Without that, it is impossible to give full attention to the couple and it is a disservice to everyone involved to accept a booking purely for financial reasons.

If you feel you should refuse, be honest but diplomatic. Explain to the couple that you feel your style of wedding photography is not really suited to them and it would be better for them to seek the services of someone else. After years of experience in the industry, we can recognize the signs and make our decision at a very early stage of the first interview. Anyone who has struggled to photograph a wedding without the all-important rapport will understand the sense of irritation one sometimes feels. It is hard not to think about the bookings you have had to turn down from couples that seemed more pleasant, co-operative and wealthy than the ill-tempered, tight-fisted pair of ogres in front of the camera right now! It is not a scenario that is conducive to good quality wedding photography.

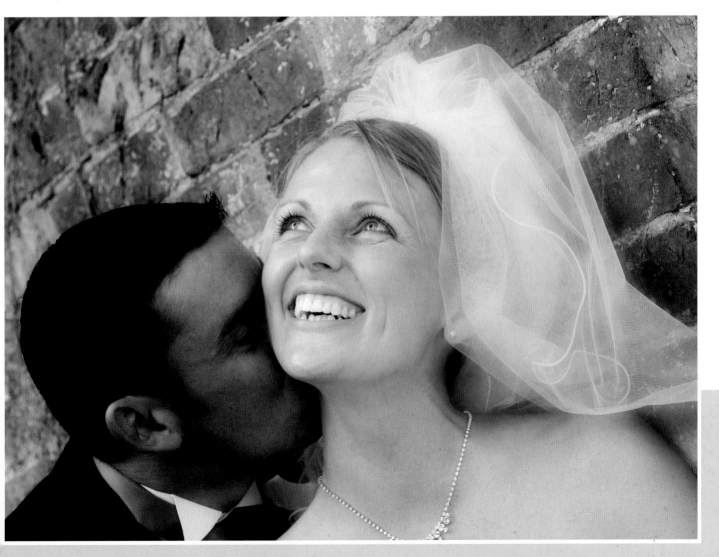

Towards the end of the meeting, when the couple are hopefully convinced that they want you as their photographer, you can explain your costs in detail. Be sure to point out any extra expenses that may be incurred for travel and accommodation so that they have a clear idea of what to expect if they wish to proceed. It's our own policy not to use incentives for them to book us and we do not employ any hard-sell tactics.

Some couples insist that they want to secure our services and make the booking after the meeting. They will pay the deposit and complete the contract. For most, we explain that, as they have taken the trouble to come and meet us, we will hold the date for them for seven days to allow them to make a decision.

This is the first time that you will photograph the couple. Make it an intimate, stress-free and relaxed experience for the couple. Take this opportunity to confirm the couple's confidence in you as their wedding photographer.
Nikon DSLR, 55mm lens, 1/60sec at f/2.8

The Pre-Wedding Shoot

To meet with the couple, discuss their wedding plans and have the opportunity to take a few portraits is an ideal ice-breaker for both the clients and the photographer. Remember, this is the first time that they will have seen you with a camera in your hand, doing the job you will be paid for at their wedding, so it is very reassuring for them. For your part, it is a chance to observe how the couple interact with each other and how comfortable or self-conscious they feel being photographed. This is all useful information to store up so you can take an appropriate approach on the day.

The couple receive a complimentary photograph taken at this photo shoot, which usually takes place around six months before the wedding at the venue where it will take place. Some may take a digital file for use on their wedding stationery, for example, and others may opt for a mounted print to be taken to the reception for signing by their guests.

Use this meeting to become your clients' ally and their friend. Reinforce their confidence in you. Pass on tips and ideas to help with the planning of their day. For example, many couples will go to great lengths to arrange a marquee reception at either of their respective family homes. This is a huge undertaking and the event may become disjointed and confusing for guests without a professional toastmaster or organizer to take charge. In order to create a storybook coverage of the wedding, it is vital that the photographer is allowed to get on with it, without having to assume the unofficial role of event organizer as well.

The pre-wedding photo shoot is key to consolidating the rapport that you are now developing with the couple. Digital photography has a huge advantage at this stage in allowing the images to be reviewed by the clients almost instantly. A few well-executed, flattering portraits of them will be very well received and establish their confidence in you as their wedding photographer.

After the photo shoot, back at the studio, compile a draft list of the photographs planned for the day, together with a contact sheet of the portraits just taken. Mail this immediately, with a covering letter asking the couple to select one image to be used as they wish. Remember to say that additional pictures can, of course, also be purchased at current studio prices.

'The pre-wedding shoot is the first time that they will have seen you with a camera in your hand, doing the job you will be paid for at their wedding.'

This portrait was taken in the couple's garden during a pre-wedding visit. The image is a close crop of the couple with a large aperture to soften the foliage behind them.
Nikon DSLR, 28–80mm lens, 1/125sec at f/5.6

The same couple on their wedding day. Again, they should look loving, so wait until they have the right expressions on their faces. Using a wide-angle lens will allow you to include the location but make sure you use a wide aperture so that not too much of the image is sharp and distracting.
Nikon DSLR, 24mm lens, 1/500sec at f/5.6

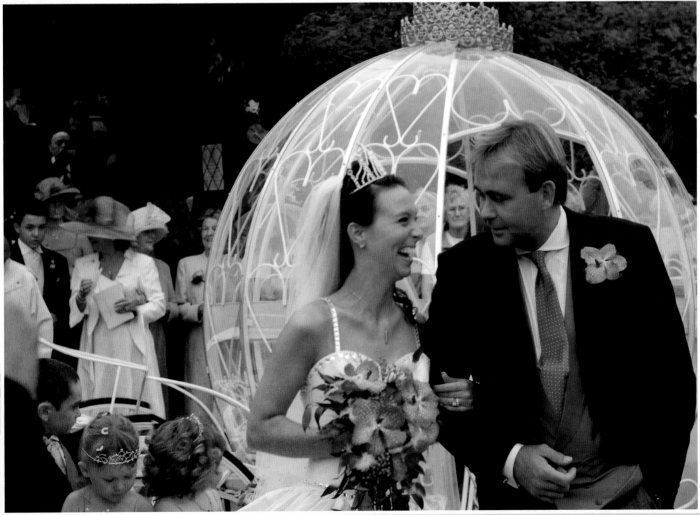

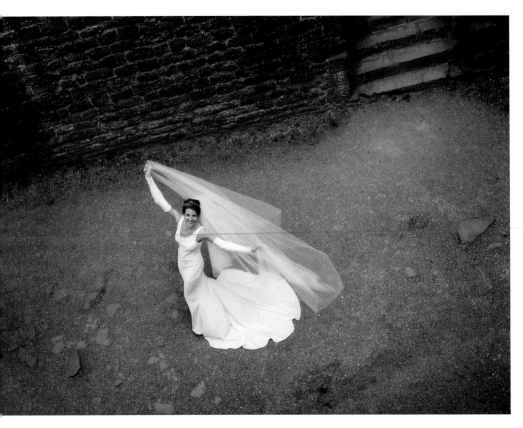

Don't always choose the obvious viewpoints, daring to be different will set your wedding photographs apart. Good communication is the key to this kind of shot. The bride was directed in her pose and position, towards the direction of the light.
Nikon DSLR, 24–120mm lens, 1/60sec at f/5.6

will lead the eye into the frame, or you may see the final image as a panorama in which you can use the rule of thirds to place the couple. Lighting provides inspiration, too – perhaps the way light streams through a high window, forming a perfect pool of light for the bride to stand in.

The choice of location will contribute to the mood of the image. For example, reflections and water can convey romance while architecture can be dramatic. Keep a look out for locations en route to the reception. If you find somewhere you want to use, see if you can arrange for a short stop-off with the couple and confirm the plan with the chauffeur on the day.

It is important to have a back-up plan for the times when circumstances are beyond your control, so have a reserve of locations to use if the weather is bad. In temperate climates, wet and dull days can be expected at any time of the year, as can harsh sunlight and high-contrast lighting.

Learning to respond to changing conditions comes with experience, but it is imperative to work to a pre-defined plan to keep up standards and to avoid panic setting in.

As soon as you have found a location, make a note of where the light is falling.

Selecting Locations

Varied, interesting locations will really add impact to a portfolio, and seeking them out is a great challenge and a sign of the photographer's expertise. It's all part of the ability to 'see' an image before taking the photograph, without which we would all simply be mediocre snappers, recorders of the mundane and out of business! Potential locations are all around, even in the most superficially ordinary places such as hotel corridors, in the street or in the grounds of the reception venue.

The pre-wedding meeting at the venue is the time to find places that will make images stand out. Take the time to tell the couple what appeals to you about a particular spot as this will help them to understand and co-operate with you patiently. It may be that it has strong, inherent compositional aids, such as the sweep of a low wall that

'Look for locations that will contribute to feelings of romance or drama within the final image.'

The bricks are ideal as lead-in lines here, drawing the eye to the face of the bride. An aperture of f/2.8 allowed shallow depth of field, concentrating attention on the subject, not the bricks.
Nikon DSLR, 28–80mm lens, 1/250sec at f/2.8

Directional lighting is ideal to illuminate the faces of the couple or the bride on her own, as this will provide the best modelling of their features.

If the couple are extrovert and comfortable with being photographed in public places, there are many more possibilities open to you, such as parkland, plazas and city architecture, which lend themselves well to a reportage style of photography. With less extrovert couples, look for locations that are sympathetic to their dispositions. A romantic environment will work better for them, as, by their nature, these couples will need to be close to each other. Use this to your advantage and create soft, natural images of them.

At the pre-wedding visit to the venue, you also need to decide on the best location for the formal group shots, ideally somewhere with a plain background of trees or greenery. Keep your eyes open for a high viewpoint, from where you will photograph the largest group of guests, preferably with back lighting.

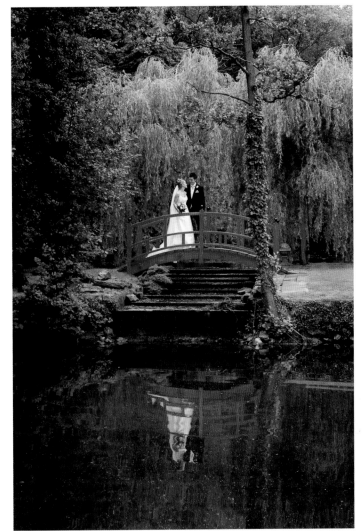

An ideal romantic setting with the shot composed to include both the couple and their reflection in the lake.
Nikon DSLR, 300mm lens, 1/60sec at f/8

RULE OF THUMB
Recce the location before taking the bride and groom to it. It is much more professional if you take them straight to the best position without dithering.

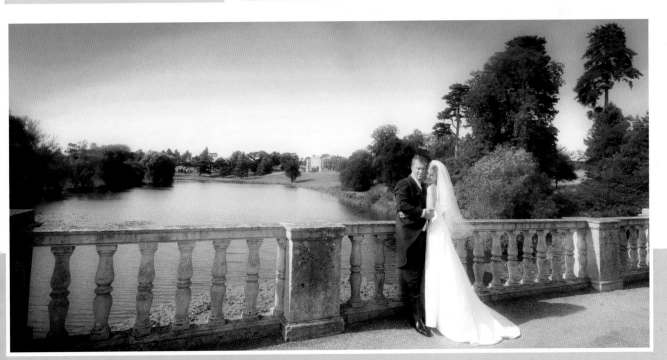

A wide-angle lens was used to include the sweep of the wall and then the image cropped to create a much more interesting panorama.
Nikon DSLR, 12–24mm lens, 1/125sec at f/11

The Wedding Photographer's Kit

A few years ago, a medium-format film camera was the wedding photographer's chief tool. Nowadays, the digital SLR (single lens reflex) camera has taken over that role and, with a range of lenses and accessories, it copes with most situations perfectly. We each carry Nikon DSLRs and find that a 28–80mm f/2.8 and a 17–55mm f/2.8 are the most useful lenses. Also recommended are a 10.5mm f/2.8 fisheye, 12–24mm wide-angle zoom, 70–200mm f/2.8 and a 300mm f/2.8 telephoto. Storage media for the cameras are Lexar and 1GB CF (CompactFlash) cards. A portable 40GB storage device can also be carried if necessary.

A camera support, either tripod or monopod, is advisable in many situations, such as shooting in low light or to help accurate composition when photographing groups of people. Our choice of tripod is a Manfrotto carbon fibre model, which is strong but not too heavy and equipped with a quick-release ball head. For convenience and speed while working, the quick release plate can remain constantly attached to the camera body.

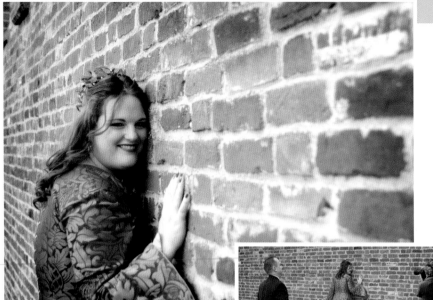

Brick walls create diagonals and lead-in lines. Shoot with a wide aperture.
Nikon DSLR, 28–80mm lens, 1/125sec at f/2.8

'It would be very foolish to attend a wedding without some form of reserve camera should the unexpected happen.'

To enhance natural daylight and fill in shadows, a variety of Lastolite Tri-Grip reflectors are useful, along with a Lastolite Tri-Balance to support them. One additional piece of equipment that is occasionally invaluable is a small battery-operated video light. This is used hand-held, off-camera for directional lighting effects, when shooting close-in head and shoulder shots of the bride, for example.

For the rare occasions that call for on-camera flash, such as the signing of the register in a room with low light, we carry SB800 Speedlight flashguns with spare batteries. Sometimes studio flash may be necessary, particularly in the winter when the days are shorter and it is not possible to work with available light. For shooting family groups in these circumstances, we use two Bowens Esprit 500 heads with a softbox and brolly set-up. The flashes are fired by an infrared remote trigger attached to the camera.

A long telephoto lens is useful to compress perspective but is best used with a tripod or monopod to avoid camera shake.
Nikon DSLR, 70–200mm lens, 1/250sec at f/5.6

RULE OF THUMB

A back-up camera and lens is absolutely essential for peace of mind should the unexpected happen. Keep it separately from your other equipment, ie, locked in the car. Carry spare batteries, plenty of storage cards and always check all equipment the day before the wedding.

For carrying the equipment, our favourite bags are made by LowePro, with a rectangular shape and top-opening lids. These are far more convenient to use than backpack-style bags as it is much easier to replace or retrieve items when the bag is carried on your shoulder. It is also more stable when placed on the ground

and harder for items to fall out if the bag is picked up in haste when the lid is not fastened. There are plenty of pockets for storage media, spare batteries, cable releases, lens cloths, the schedule of photography and other items that always seem to find their way into the bags.

For back-up, take an additional digital SLR, fitted with an all-round lens such as 24–120mm, a CF card and a fully charged battery. This essential piece of equipment can remain in the car out of sight, but it is there ready and waiting, just in case you ever need it. It would be very foolish to attend a wedding without some form of reserve camera should the unexpected happen. Camera failure is fortunately extremely rare and has never happened to us with our Nikons, but experience has taught us that back-up equipment is essential for peace of mind.

Professional equipment insurance should be reviewed periodically to be certain that you have adequate cover. Accidental breakage and even the possibility of theft is unfortunately something that must be considered. Professional indemnity insurance and public liability cover are also absolutely mandatory for anyone working as a professional wedding photographer. It is wise to apply for membership of a genuine professional association, as they are able to offer insurance deals at preferential rates for their members.

Check all equipment on the day before the wedding to make sure that it is complete and that there are no problems, and ensure that the batteries are charged and the CF cards are cleared and formatted ready for work. Clean the lenses and eyepieces of the camera bodies and the CCDs (charge-coupled devices) if necessary.

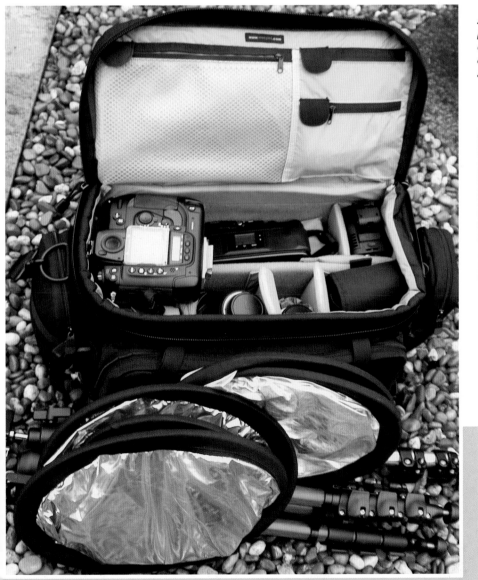

A digital SLR camera is the professional wedding photographer's chief tool. A 28–80mm lens is extremely versatile, especially if it has a wide maximum aperture of f/2.8.

EQUIPMENT CHECKLIST

- 2 x Digital SLR camera bodies
- 28–80mm f/2.8 Zoom lens
- 17–55mm f/2.8 Zoom lens
- 70–200mm f/2.8 Zoom lens
- 12–24mm Zoom lens
- 10.5mm Fisheye lens
- 300mm f/2.8 Telephoto lens
- 2 x SB800 Speedlights
- CF cards (formatted)
- Spare charged batteries
- Tripod
- Monopods
- Reflectors
- Small video light
- The schedule of photography
- Back up: digital SLR, 24–120mm lens, CF card, spare battery
- If required: 2 x Bowens flash heads, stands, softbox, brollies, power leads and infrared trigger
- Portable digital storage device

Sequence of Events

The schedule of photography for the wedding is compiled from the information that you receive from the couple at the final pre-wedding meeting, around six weeks before the day. It's a vital document, containing all the details about where and when the day's events will take place and a list of photographs planned for each stage, from the bride's house, to the start of the wedding breakfast. It is also very helpful to include the names of the best man, ushers, matron of honour, bridesmaids, pageboys and the couple's immediate families on both sides. Ask the groom, too, who he thinks would be the most capable usher on the day

to help you with the family groups and any other organization that may be required.

The schedule must be adhered to if you are to stay in control of the photography. You need to know exactly where you should be at any one time and what, or whom, you should be photographing. Some photographers find it quite easy to work by memory. You will find that a list is extremely beneficial. With so many things to think of on the day, you do not want to rely on your brain to remember all the requested photographs, as well as the right lens, exposure, aperture and so on.

You will look so much more professional if you speak to important guests using their first names and it is virtually impossible to remember all these from an appointment weeks before. The group photographs, in particular, are far easier to organize if you can ask the usher to fetch family members by their individual names, rather than shout out 'bride's family'. This latter approach is automatically fraught with problems as some members of the family may not be required in the photograph. Confusion sets in and delays occur when guests are unsure whether they are included or not.

If flash is needed, try to bounce it from the ceiling to give softer light for portraits. Direct flash is too harsh and creates heavy, unflattering shadows.
Nikon DSLR, 28–80mm lens, 1/60sec at f/8

> ## RULE OF THUMB
> *Communicate with your couple at all times. Remember, every couple has different personalities and different expectations of their day. Although weddings may follow roughly the same format, each one you photograph will be unique, and should treated as so by you.*

The schedule not only keeps you in control on the day, it also ensures that you do not forget any important images, especially those that the couple have specifically requested. Periodically during the day, check your time schedule and cross through the images that have been taken. If you find you have missed an image, say at the bride's home because either the bride or her mother wasn't ready in time, these can easily be taken at the venue during the group photographs.

It is very important, when drawing up the schedule, to ensure adequate time is allotted both for the photography and for the couple to enjoy time with their guests. There is nothing worse than the feeling of being rushed. Make sure that the venue doesn't dictate a schedule that is suitable only from their point of view. One of the first things you should do when arriving at the venue is meet with the person in charge of proceedings and liase with him/her about the timings you each have on your schedules. You must ensure you finish at the agreed time.

Careful planning of the day with the couple will always pay off because the bridal party, the guests and, especially, the bride and groom, will do exactly what you require of them, but at the same time relax and enjoy themselves. The last thing anyone wants is for the photographer to go running around shouting out orders. This way you will stay quietly and confidently in control.

The maximum aperture of the lens has given shallow depth of field which has put the faces of the bartenders out of focus, concentrating the eye on the line of glasses.
Nikon DSLR, 28–80mm lens, 1/60sec at f/2.8

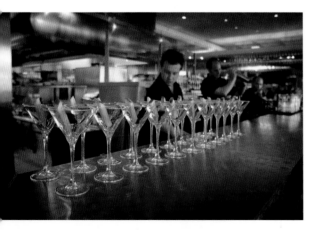

'With so many things to think of on the day, you don't want to rely on your brain to remember all the names and timings.'

OUR SCHEDULE

10 September
Guy and Pennita's Wedding
Contemporary magazine style.

11:30am Bride getting ready at mother's home. Bride is to leave the house by **12:40pm** to allow for the journey in the horse and carriage to the church. Bridesmaids (4) to leave in a white Daimler: Michelle (adult). Three little ones – Olivia, Molly & Megan. Joe – Page Boy.

12:45pm Groom will meet Steve at the church. All the guys in the bridal party will be wearing lilac Gucci ties. Best Man: James. Ushers (7): Andrew, Neil, Simon, Harvey, James, Robert & Ben.

Guests 180

All guests to be seated in the church by **1:15pm**.

1:30pm Ceremony - Parish Church
Confetti cones will be at the church for the guests. All guests will be provided with button-holes.

Informal photography outside the church.

Couple will leave for their house - we have approximately half an hour from **3:15pm** until **3:45pm** for the photographs of Guy & Penny at the house.
Style: Fun, glamorous, romantic, relaxed

Reception - marquee in the grounds of the Manor
B & G will arrive in the coach at **3:50pm**
Drinks reception

Group photographs – 4:00pm
1: B & G plus Penny's mum
2: B & G plus Guy's mum & dad
3: B & G plus Auntie Margaret, Uncle Arnold and Maggie
4: B & G plus Penny's Cousins – Richard Ely, Stewart Ely, Nick Ely and Andrew Evans
5: B & G + Auntie Renny and Uncle David

Bridal party photographs - ushers, bride, groom and bridesmaids.
Style: Fun, relaxed and informal

Photograph marquee, details + cake
Group photography of everyone to take place at **4:20pm**

4:30pm - Line-up
5:00pm - Speeches and the cutting of the cake
5:45pm - Dinner will be served

Mother is making the speech
Penny singing
Three waiters
Beef being served – Guy involved in this

7:30pm - Powder puff girls will be on duty
8:00pm - DJ will start
8:30pm - First dance (Westlife) will take place
9:00pm - Main band will start

Photography ends approx. 9:30pm

Directing Poses

The importance of high-quality posed wedding images cannot be overstated. The key to success is the photographer's ability to interact and communicate with the bride and groom and other members of the wedding party to extract the best expressions and composition. Professionalism, technical expertise and confidence each play a major role.

Contemporary wedding photography relies greatly upon direct input by the people in front of the camera, as well as from the photographer behind it. This is a fact that must be clearly communicated to and understood by all couples, even before a booking is made. They need to know that there will be some intervention and coaching to ensure that they are standing how you want them to stand, facing where you want them to face and interacting with each other with the desired expressions.

For some couples, their wedding day presents an exciting opportunity to pose for a professional photographer, possibly for the first time since their school or college days. For others, it may be a daunting prospect. The photographer must have the sensitivity to consider this and respond to any situation with a combination of gentle persuasion and confident direction. The couple need to be perfectly clear about what you are aiming to achieve for them.

This chapter illustrates our approach to photographing individuals, the couple together, small and large groups in different ways: relaxed, romantic, classical, dramatic and stylized. We look at how success can be achieved by careful selection of locations, using the available light and including other elements within an image to make it stronger and more interesting to the viewer.

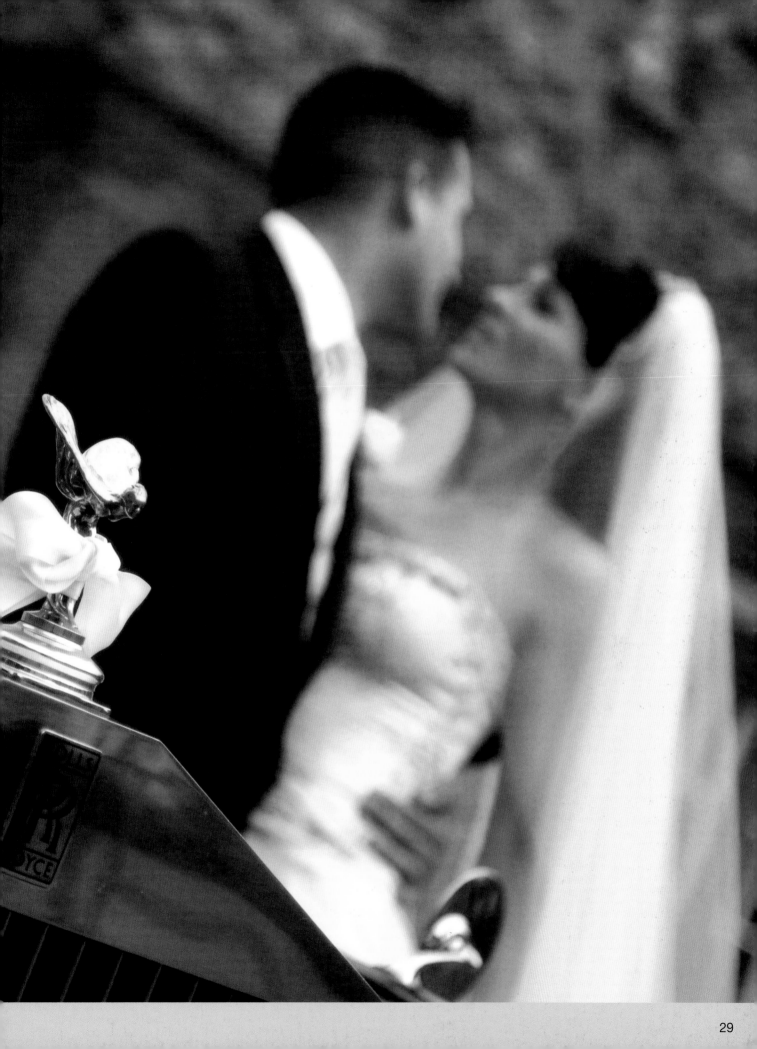

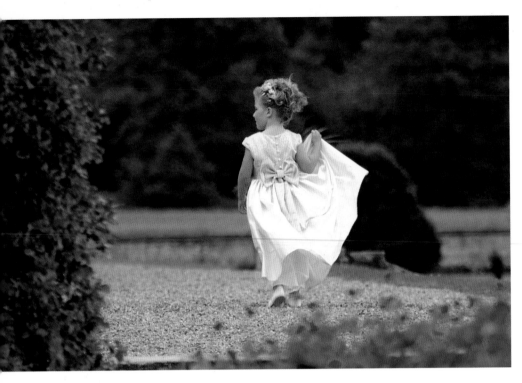

Allowing the couple time to be alone as they walk to or from a location creates opportunities for informal photography. They are relaxed as they chat to each other, briefly unaware of the camera. Use a wider-angle lens to include some of the environment.
Nikon DSLR, 24–120mm lens, 1/125sec at f/5.6

Children are often better photographed when they are just doing their own thing. It's the 'aaah factor' that succeeds.
Nikon DSLR, 70–200mm lens, 1/250sec at f/2.8

Natural Poses

Posing the bride and groom in a way that shows them as they really are, without false or forced expression, adds a very personalized statement to their wedding images. This is how their friends and family see them in their everyday lives – the expansive gesture, the tilt of the head or the captivating smile are the distinguishing traits of their character.

It's the closest friends and family members who will look beyond the surface of an image to the soul within. When reviewing wedding albums with clients we often hear the words, 'Oh look, that's just how he really is,' or 'You've caught her expression perfectly.' It's not difficult to achieve, but it does require a little thought and direction.

Observation is crucial and time spent watching how individuals appear to be at ease with themselves, especially in the company of the one they love the most, will pay dividends for the photographer who is striving for the 'natural look'. With a little experience, much relevant information can be learned as early as the initial meeting. Does the bride try to cover her teeth when she laughs? Is the groom concerned about his profile because he has a prominent nose? These sorts of issues are very common as many people are hung-up about some small aspect of their physical appearance. As photographers, we can't offer a cure, they will have lived with their particular issue for most of their lives. What we can do is quietly observe and set out to

RULE OF THUMB

When holding the camera to your face, make sure you keep both eyes open, one on the viewfinder and the other watching the wedding party.

'It takes only seconds to encourage someone to reduce their height, bringing their head to the correct level, but it will help produce an image that will last a lifetime.'

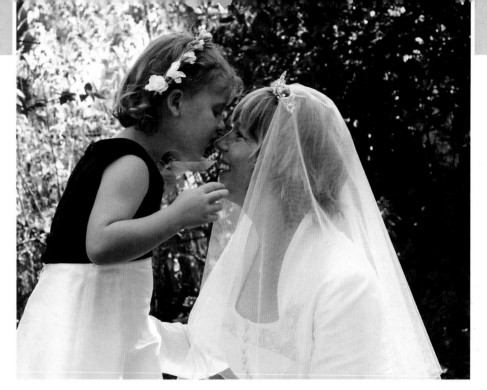

A short telephoto lens of around 70mm is good for working at close quarters. Although there were many guests just outside the crop on this image, the perspective is flattering and there are no distractions. The bride was aware of the camera and had been asked to bend her knees to bring her down to the level of the bridesmaid.
Nikon DSLR, 24–120mm lens, 1/250sec at f/5.6

create sympathetic images that do not draw undue attention to any physical aspects we sense they are uncomfortable with.

Capturing natural poses and good facial expressions is often better achieved by photographing from a distance with a telephoto lens of around 300mm. Wide apertures will isolate the subject from the background and the narrow angle of view will compress the perspective and reduce the chance of distracting elements intruding within the scene. The obvious benefit of working at a distance with a telephoto lens is that your subjects, although aware of the camera, are less inhibited and this is reflected in more natural expressions.

Sometimes opportunities for images arise simply because one of us just happens to be in the right place at the right time. The shot of the young bridesmaid shown far left is an example. We noticed that she had started

In this sequence the couple were asked to sit down by a fountain and chat. With the camera some distance away, they were able to forget it was there and enjoy a spontaneous joke.
Nikon DSLR, 300mm lens, 1/500sec at f/4.5

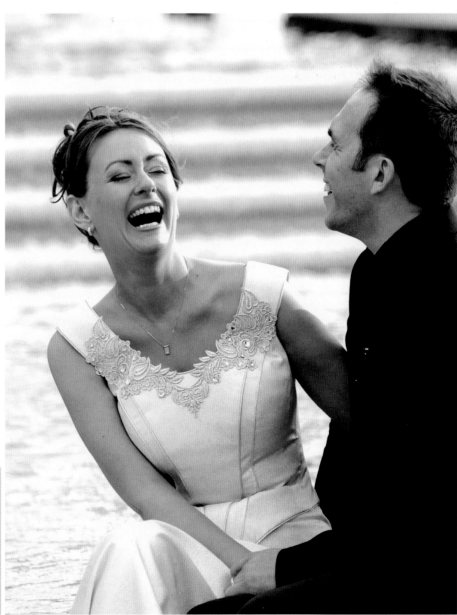

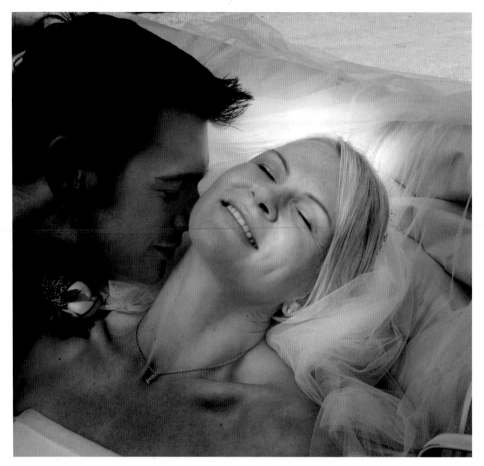

Ask the groom to kiss the bride's neck on the far side of the camera so you can capture her expression. This will happen naturally, it's just a matter of waiting for it.
Nikon DSLR, 28–70mm lens,
1/30sec at f/5.6, reflector

to walk away from where the family group photographs were being taken and asked her to hold her dress as she walked. Luck played a part in that there were no unwanted intrusions into the frame by other guests.

An interaction between the bride and a very young bridesmaid will often produce a pleasing image. The only intervention necessary is to ask the bride to bend her knees, bringing her height down to the same level as the bridesmaid. The veil or hair will

not then fall forward to obscure their faces and the composition is much more flattering to both, especially the bride, as her bodice will not gape.

The same approach works very well with an able-bodied person and someone confined to a wheelchair. In this situation, avoid any composition that would make a disabled person appear to be dominated by

having to look up. Visual contact at eye-level will produce a much better image with pleasing facial expressions.

Romantic Poses

It would be unthinkable to photograph a wedding without including a selection of romantic images in the portfolio. Since she was a young girl it will have been the bride's dream to marry a handsome man who will love and cherish her forever. Every bride deserves to have her dream fulfilled and to be able to see in the images the evidence that it really happened. The groom, too, will want pictures that convey the feelings he has for his new wife.

Of course, there is much more to creating a romantic pose than simply asking the couple to embrace and kiss each other. The starting point is to look for a quiet location away from the guests where you can work with the couple without interruption. Take the time to talk to them about their day and their honeymoon plans. Tell the bride how fabulous she looks and how proud the groom must be of her. The aim is to carefully reintroduce the romance of their wedding day, as it had been in their minds during the months of planning. With complete privacy, you can calm, reassure and support the couple, then gently direct them towards being relaxed and loving with each other.

For the romantic images, it is wise to select a number of potential locations around the reception venue during the pre-wedding meeting and photo-shoot. Look for interesting elements that can be

This romantic image was taken from a short distance away to allow the couple to relax with each other before the photographer went in closer. The doorway here makes a perfect frame for them, enhanced by stunning autumn colour.
Nikon DSLR, 28–80mm lens, 1/60sec at f/5.6

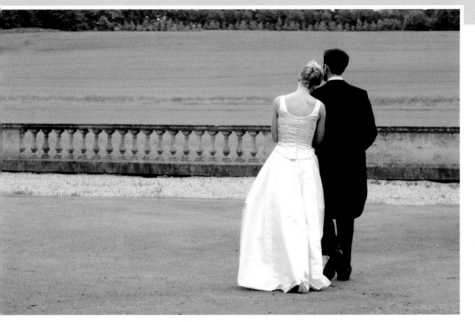

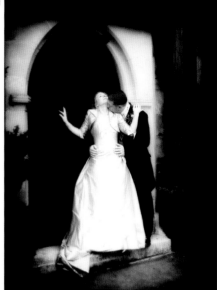

A romantic image can be created with very little intervention. This couple were already in physical contact with their arms linked and holding hands. The separation of the couple from their guests increases the feeling of intimacy and the tilt of the bride's head into the groom's shoulder completes a romantic moment.
Nikon DSLR, 24–120mm lens, 1/250sec at f/5.6

Use a long lens to stand away from the couple, allowing emotion and expression to come through. Ask the bride to throw her head upwards, close her eyes and think loving thoughts!
Nikon DSLR, 70–210mm lens, 1/125sec at f/5.6

included, such as archways, doors, trees and waterfalls. You don't need a sweeping vista to use as a background, but fragments of a scene that will combine with the couple to generate an appropriate mood.

For most couples, the romantic poses on their wedding day are the most intimate pictures they will ever have taken. A reticent couple will need to be persuaded gently into the poses that you want, while a more extrovert pair may well need a little subtle restraint. We find a great benefit of covering weddings together is that we can show the bride and groom exactly what we want them to do or how to stand by demonstration, without having to physically touch them. A little banter between us works well in putting everyone at ease.

A good basic tip for posing the couple is to stand them side by side, putting their weight on their middle legs. This way they will naturally fall into a relaxed pose and their bodies will form a V shape. When posing a larger bride, however, make sure that you place the groom slightly in front of her so that the bride is trimmed down by the groom's darker suit line. If he is on the large side, then place the bride in the dominant position.

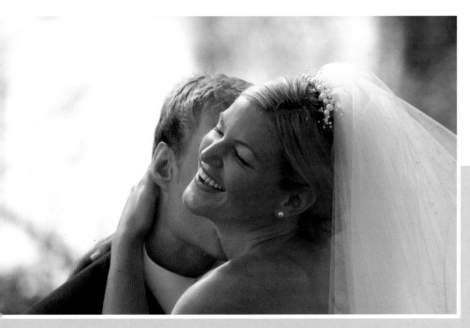

'Do couples really want their ecstasy for each other to be revealed in their wedding images? Of course they do!'

The groom has his back to the light source but turning the bride's face towrds the light source has created depth and modelling to her face. Care was taken to ensure her nose did not break through the outline of her cheek.
Nikon DSLR, 70–200mm lens, 1/250sec at f/4

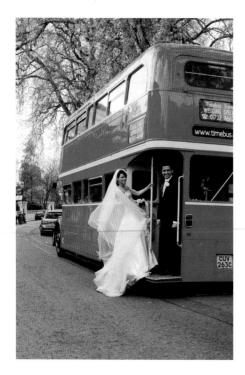

This couple and guests had travelled to London from the USA for the wedding. Determined to take in the sights during the day, they hired a red London bus to take their guests from the church to the reception venue. This shot was set up just before the bus set off.
Nikon DSLR, 28–70mm lens, 1/125sec at f/8

With a very tall groom and a petite bride, try to put the couple into poses that compensate for their height differences. Sit the groom down on a bench and allow the bride to wrap her arms around his neck. Or sit them both down on steps and again position them to balance their heights. Lying the couple down on a blanket on the ground or bed will also produce a balanced composition as well as naturally promoting an intimate mood.

Hand-held reflectors are put to good use now. Often, the light will be very directional and shadows need to be lifted. A touch of white reflector close in will add sparkle to eyes, lips and teeth. If the groom's face is looking down towards his bride or away from the light source there is an obvious danger that his eyes will sink into dark sockets. A reflector is used to restore sparkle and the all-important glint in his eyes as he embraces his bride. Be careful not to overdo the use of reflectors, though, bearing in mind that good modelling light is required on faces to give them a three-dimensional quality.

Outdoor poses

The bride and groom will have spent a great deal of time planning their wedding, usually beginning months in advance. Most will take a great deal of care in picking the venue, even to the extent of travelling overseas and taking their guests with them. It is vital for their photographer to understand that their choice of location is a way of making the day stand out for them and their guests, setting it apart from the usual wedding format. Our aim is for their friends to look at the album and say, 'Wow, what a great idea for a wedding.' Naturally, that's what the couple want to hear too.

Inevitably this will present the challenge of photographing the couple outdoors, whether it is within the grounds of the venue, in the streets en route to it or incorporating a personal touch that the couple have introduced, such as an unusual vehicle to transport themselves or their guests.

Weddings that take place in inner city or urban environments offer diverse opportunities for creative images. It is the almost incongruous inclusion of a bride and groom within an otherwise mundane scene that raises the image to a much more interesting level. Street photography can produce powerful shots in various styles of presentation. Monochrome reduces the elements of a composition to its shapes, structures and textures without the distraction of sometimes intrusive and inharmonious colour. Cross-processing turns the world of colour upon its head to produce vibrant and eye-catching images. The addition of a tone such as sepia, blue or red will add mood.

We have the music, fashion and advertising industries to thank in showing the way to use real-life outdoor settings in a lively, contemporary style. Amazing new

A romantic sunset for the couple on a warm summer's evening. A little fill-in flash, two stops below the ambient light, balanced the exposure on the couple with the afterglow in the sky.
Nikon DSLR, 28–70mm lens, 1/180sec at f/22, fill-in flash

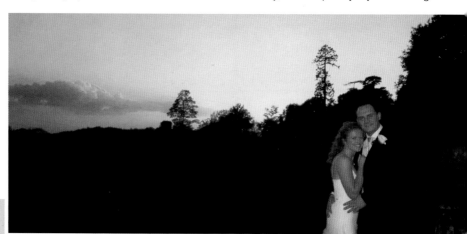

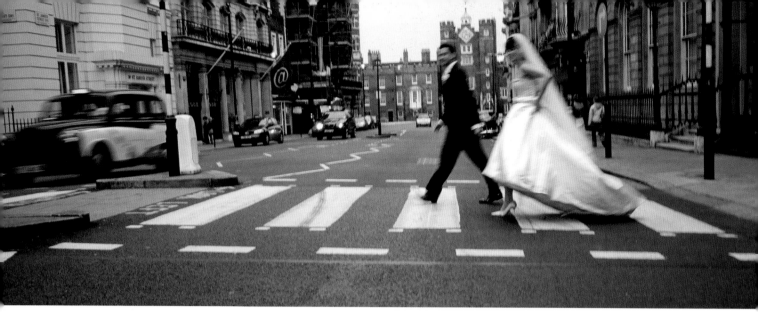

This central London location gave us unlimited photographic opportunities with the couple en route to the reception. Who could resist creating the black-and-white image on a pedestrian crossing? Slow shutter speed was deliberately chosen to add a sense of movement. The cab was an added bonus!
Hasselblad X-pan II, 1/30sec at f/5.6

technology has helped, too, allowing much more creative freedom through feature-packed cameras and powerful editing software. It is up to the photographer to take advantage of these opportunities by working confidently with changing or mixed lighting in a variety of locations.

Hand-held reflectors are essential for controlling the lighting when posing couples outdoors. Not only are they useful for throwing light back into the eyes of the subjects and lifting shadows, they are also ideal for shielding subjects from harsh light. It is easier for a photographer to give their full attention to a couple if an assistant is helping to control the light with a hand-held reflector. Failing that, a member of the wedding party can usually be cajoled into taking this role.

It may be the mood created by a dramatic and colourful sunset that you want to record. On these occasions, a burst of flash is often needed to balance the light on the couple while retaining the colours in the sky. With their backs to the light source, the couple would be way too dark if the exposure was based on the sky. Conversely, the sky would be overexposed and without detail if the exposure was set on the couple.

'The venue and personal touches that the couple have chosen, such as an exotic holiday destination or the hire of an unusual vehicle, must be included in the photography. These are their personal statements and the marks of individuality that set their wedding day apart.'

This bride was driven to her wedding in a New York cab. Roll down the window before taking a shot of the bride's arrival in the car and ask her to lean forward slightly. Beware of harsh shadows that will be caused by direct flash.
Nikon DSLR, 28–80mm lens,
1/125sec at f/5.6, reflector

Fill-in flash is used to balance the exposure between the two, producing an image that retains the mood.

Directing poses outdoors often requires a degree of spontaneity, looking around for a graphic representation of a location. The zebra crossing, for example, is instantly recognizable and gives the viewer more than a clue as to the city where the shot shown on page 35 took place. All it needed from us was, 'Hey guys, a shot of you both on the crossing would be fun.' It's about the couple enjoying their wedding day, reassured that their plans have been noted and will be incorporated artistically in their wedding images.

Dramatic Poses

Creating dramatic wedding images is not only a challenge but a passion. These are the images that display a photographer's creativity and persuade potential clients to make a booking. Once you have successfully taken shots that have atmosphere, excitement and impact, you'll find yourself drawn more and more to this style of photography.

Drama can be created from the weather, the light, the location and, of course, the pose. A gust of wind will cause the bride's veil to fly, a stormy sky will set the mood and the location can be made to look more exciting by the careful selection of lens focal length. There is much to consider and usually a minimum amount of time available. It is worth using the time to create just a few images that are consistently strong rather than a greater number that are not as good. Weaker images will erode the impact of the stronger ones.

The key is an ability to see the final image in your mind's eye. The shot below of the bride on a hillside was taken en route from the church to the reception. We had arranged at the final pre-wedding meeting for the couple to stop for 15–20 minutes at this location for some photographs. The high winds and stormy sky were a real bonus on the day and it was clear that the very long train of the bride's gown and her long veil would be central to the shot we were determined to capture. As it was, the wind was so strong that the veil was torn from the bride's head! Once replaced, she was asked to hold it up high with both hands so that the wind would catch it to make it fly. Placing her to the left of centre in the frame and using a wide-angle lens gave a sense of space around her. After a couple of shots, a gust of wind caught the train and the veil together and the exposure was made at just the right moment.

Imposing architecture is an obvious element to use for dramatic images. Architecture provides a glimpse into another world, of past glory and different values. Whether ancient or modern, architecture is often seen as tangible evidence of the path that has led to the development of a sophisticated society. Buried within that path are stories of heroism, intrigue and drama, both real and imaginary. With architecture and a little artistic direction, dramatic images of the bride and groom can be created.

If a sense of drama has already been planted in the mind of the viewer by the choice of location, all that is needed is to pose the bride and groom in a way that will complete the mood. This requires interaction between them and the classic shot of the groom embracing his bride and kissing her neck is a starting point. Take note of the direction of the light and make sure that the bride's face is not turned away from it. A wide-angle lens will take in more of the building, but be aware of the foreground. Encourage her expressions of ecstasy and the dramatic quality of the image is complete.

The shot of the bride and the car (right) is evocative of opulence, of another time and a world which most of us can only imagine. The wide-angle lens and small aperture ensures sharpness from the foreground to the distance. This contributes to the 'layering' of the bride, car and chateau. The bride is the subject and the car and building serve as props, which create the story for the viewer. Rocks, buildings, cars, cliffs, street furniture, weather; drama is all around and it serves as a great encouragement to strive for exciting imagery.

'The key to achieving a sense of drama is to see the final image in your mind's eye.'

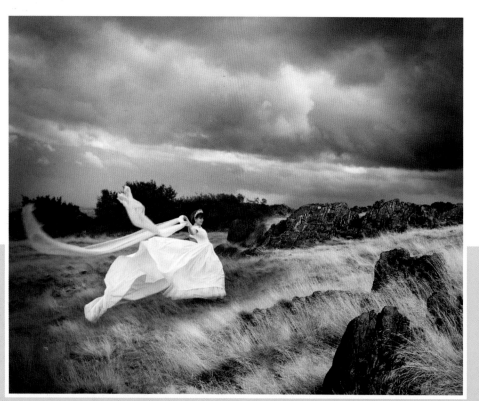

Stormy weather provided a good opportunity to take some dramatic, Wuthering Heights *inspired images of this bride, including this award-winner. She had designed her own wedding dress with a long train and veil – a perfect combination with 40mph winds and a stormy sky. Black-and-white film was used and the print blue-toned.*
Mamiya RB67, Fuji Neopan ISO 400, 90mm lens, 1/60sec at f/8

The low, tilted camera angle and a wide-angle lens to take in the darkening winter sky, join the recipe to create this dramatic image. The bride's face has been lifted towards the light source to give modelling and shape to her features.
Nikon DSLR, 12–24mm lens, 1/125sec at f/8

Directing Groups

The aim of the formal group photographs is to capture the love and pride of the immediate families and to provide a lasting memory of the wedding day for the couple, their families and future generations. As the photographer, your name will be associated with this cherished archive for a very long time and so it is essential for all parties that you get it right.

Your manner should be polite and jovial to maintain a happy and relaxed mood that will be reflected in people's expressions in the photographs. That isn't always easy as this is traditionally the least enjoyable part of the wedding celebration for everyone involved. It is during the family group session that friction between the guests and the photographer is most likely to arise and you must take every measure to prevent this.

To begin with, it is often best to simply arrange the family groups slightly to one side of the main body of guests. This ensures that the relatives who are called forward for the formal photographs are not made to feel they are being separated from the event. Many guests will attempt to photograph over your shoulder at this time and a barrage of flashes from their compact cameras will be distracting and irritating for those posing for the picture and could affect your exposure. It is up to you, as the

professional, to take control of the situation. In our experience, trying to prevent guests from taking their own shots of the group that you have so painstakingly assembled will only serve to antagonize everyone. It is far better to ask guests politely to refrain from taking their pictures until you have taken yours.

Occasionally there will be a persistent offender who will not co-operate. The use of large reflectors now proves to have

other advantages – simply hand the guest a reflector and ask him or her to assist you with lighting the group. This tactic usually works and the former nuisance suddenly becomes far more willing to help than hinder. Potential confrontation and tension has been dissipated and you are now free to proceed.

Working with a hand-held camera during formal group photography has the serious drawback that eye contact between photographer and subjects is lost. It is also

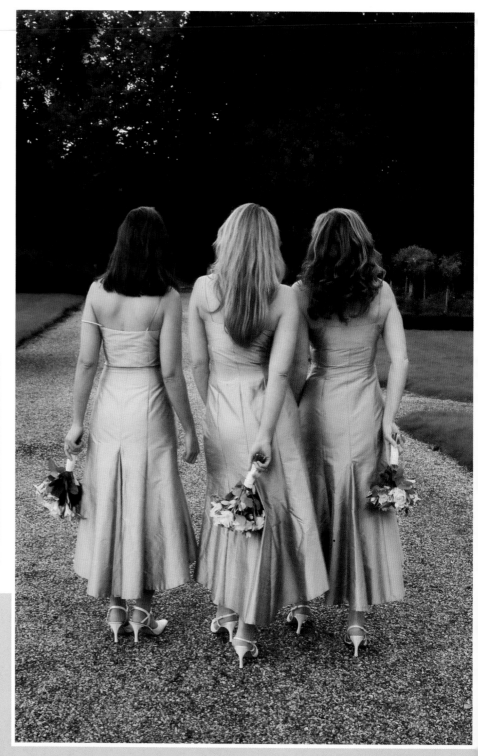

> ### Rule of thumb
> *To create an intimate composition with groups of three to five people, move in close on their heads and shoulders. For larger groups, aim for three-quarter length compositions. Use a reflector to direct light into the shadow area under the brim of ladies' hats. Select a wide aperture to throw backgrounds out of focus.*

The back view of bridesmaids' dresses is often very attractive and makes a nice alternative angle for a small group such as this. The girls were directed to stand with their weight on one leg and to slightly point their feet.
Nikon DSLR, 28–70mm lens, ISO 400, 1/125sec at f/5.6

'As a professional, you will only be as good as your last commission. Handle the formal family and group photography well and your reputation will soar.'

extremely difficult to talk to the group while holding a digital SLR to your eye. If you use a tripod, however, you can communicate freely with them and make the exposure at that decisive moment when all their expressions are correct and you have their attention. Another major advantage of the tripod-mounted camera is that you are immediately recognized by everyone as the person in control of the situation.

Try to encourage the couple to keep the family group shots to a minimum so they can be competed in the shortest time time possible. Our guideline is for around six to eight different family group photographs, depending on the circumstances. Divorced parents and new partners will have an impact on the number of groups. It is also wise to do some homework to establish what the feeling is between separated parents to avoid possible friction or embarrassment.

Unless required to do so for cultural reasons, there is no need to photograph the extended families in a formal line-up. They will be included later in overhead shots of the bride and groom with all their guests.

A standard list of groups comprises the following:

- Bride and groom plus bride's immediate family

- Bride and groom plus bride's parents

- Bride and groom plus groom's immediate family

- Bride and groom plus groom's parents

- Group photograph of the friends

- Group photograph of everyone

The groom and groomsmen can be photographed before the guests arrive. This pose, although set up, has an air of formality but with space and a relaxed feel to it.
Nikon DSLR, 24–120mm lens, 1/60sec at f/8

Directing Large Groups

Unless the novice wedding photographer has nerves of steel, it is the prospect of having to photograph large groups of complete strangers in a pressurized environment that causes sleepless nights before the wedding.

For the first-timer, the challenge is a necessary rite of passage to undergo on their journey towards professionalism.

With a little forward planning, this phase of the day will pass without a hitch and can be fun for all involved. The importance of the pre-wedding meeting is paramount. It is the opportunity to establish with the couple the names of all those to be photographed and the combinations of group photographs that they require.

Giving the group something to do together works well. Ask them to link arms, walk away from the camera then turn round and walk back. That can yield two shots, the rear view and their expressions as they return.
Nikon DSLR, 28–80mm lens, 1/125sec at f/8

The simplest method is to begin by photographing the largest group first. You can then remove those guests who are not wanted in the following group and so on, until you have worked down to the smallest number of people. It is far easier and quicker to remove people from a group than it is to add them.

Selection of a suitable location is the next step. Take care not to include the sky in group shots – it is distracting, especially if the horizon bisects the composition. Look for a location where the sun will be behind the group, preferably with a background of trees or foliage to give dappled lighting. Reflectors are very useful, especially where guests are wearing wide-brimmed hats, to throw light back into the shadows on their faces. Pay particular attention to the histogram on the camera screen to watch for correct exposure and to ensure that there is no clipping of highlight or shadow detail.

With very large groups, try to find a suitably high vantage point to position yourself, perhaps standing on a wall or shooting out of the window of a building. There are two reasons for this. First, from above, everyone in the group can be seen and, second, everyone in the group has to look upwards and therefore cannot be hidden behind the person in front. It is much easier for one person to arrange the group from below while the other directs from above. In the case of very large groups and

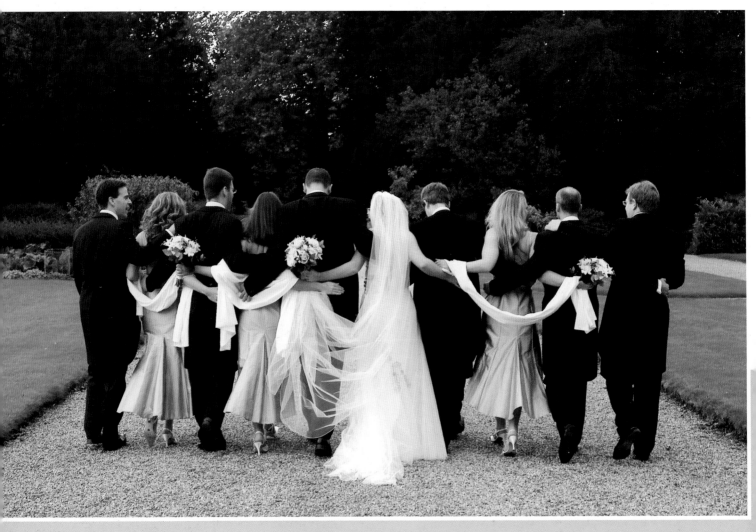

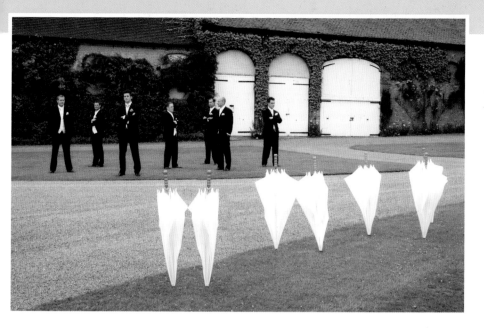

It had just finished raining when this shot was set up to create a posed *Reservoir Dogs* image. The guys put the umbrellas in the ground to avoid them getting muddy. This shot was seen and taken immediately afterwards.
Nikon DSLR, 24–120mm lens, 1/125sec at f/5.6

a very high viewpoint, try to use short-range, two-way radios to communicate with each other in this way. They are inexpensive to buy and enable the composition to be arranged without having to shout or use hand signals.

When photographing the wedding party, it produces much more lively images if they are given something to do as a group. One idea that works well is to ask them to link arms and walk away from the camera, then turn at a predetermined point and walk back towards it. If they can be persuaded to sing 'New York, New York,' then so much the better! The action of the group having to turn as one usually results in laughter and is a great chance to capture these expressions. Explain to everyone that they must remember to keep their heads up and not look down at their feet as they walk.

The 'scrum' shot of the wedding party is also a good time to have some banter with the group. By this point, the champagne will have kicked in and everyone will be enjoying themselves. Once the group is arranged, take a couple of shots and then ask everyone to squeeze in really close. This often results in the people at the bottom of the group suddenly having to take some extra load – to the amusement

of the rest. As a rule, head-to-waist length or head-and-shoulders shots of groups are more intimate and less formal than full-length compositions.

Extreme wide-angle lenses give group shots a fun aspect with exaggerated perspective and distortion. We occasionally use a Nikon 10.5mm fisheye lens for groups of friends chatting together, or to capture the groomsmen having fun before the ceremony, for example. The key to using fisheyes is not to overdo it. Any more than a couple of these shots in the album becomes

irritating to the viewer and loses the impact of being 'different'.

The main requirement for successful group photographs is pre-planning so that a schedule can be followed. It is important to set aside enough time to complete this stage comfortably and also to work quickly, efficiently, tactfully and with a smile on your face. Win the confidence and co-operation of the guests by chatting to them to put them at ease. Take a little time to adjust buttonholes, hats and cravats and the group will be working with you.

'Win the confidence and co-operation of the groups by chatting to them to put them at ease.'

For the 'scrum' shot, ask everyone to squeeze together closely and photograph their heads and shoulders. It's a fun moment for everyone and a chance to capture the laughter. Here a guest threw the groom his hat. He successfully caught it and the shot was taken at the optimum moment.
Nikon DSLR, 28–80mm, 1/125sec at f/8

Photographing Details

With the current popularity of a more relaxed, documentary kind of wedding photography and the development of magazine-style albums and design software, photographing the details at every stage of the day has become even more important. It is the detail shots that are used as background 'ghost' images in magazine albums, or for the cameo apertures in matted albums. They add interest to the story and make the portfolio personal.

During the planning of the wedding, much attention will have been given to every small aspect of the outfits, the shoes, rings and accessories, as well as flowers, cake decorations and table settings. All these and anything else that gives the wedding its individuality should be recorded. The small amount of extra work involved pays handsomely. These details play a significant part in attracting the attention of potential clients when they first view the display albums. They are evidence of attention to detail and provide reassurance that none of their carefully laid plans will be overlooked.

In this chapter, we will consider the details to look for at every stage of the wedding, advising on the timing for these shots and explaining the best techniques to execute them.

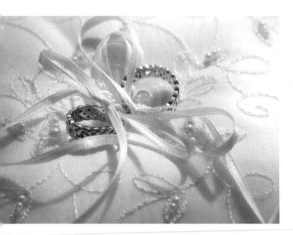

Before the Ceremony

Capturing details is a task that runs through the whole course of the day, beginning first thing during the bride's preparations for the wedding. This should afford plenty of opportunities to capture some aspects that will be harder to photograph when the event is under way. There will be numerous shots later of the bride wearing her dress and veil, for example, but now you can take close-ups of any elaborate or decorative features of her trousseau, arranging the shots to ensure the best possible light.

Use the opportunity at the bride's house to capture details, like this delicate ring cushion. A macro lens is essential to focus in really close and available light retains the shadows.
Nikon DSLR, 50mm macro lens, 1/60sec at f/4

Keep a look out for any small details that can be dropped into the album to add to the atmosphere of the day.
Nikon DSLR, 50mm macro lens, 1/125sec at f/5.6

The flowers and shoes can also be photographed as a still life at this point and both make a good introduction to the album. The bride will probably have spent a small fortune on her wedding shoes and would expect them to be photographed. They need to be placed in a well-lit position, on a windowsill or on the bed, for instance. If they have come from a well-known designer, include the label or logo, at least in part. The bride will thank you for doing this when she shows the album to her friends and sees their admiring expressions.

Look out, too, for less obvious details that will help tell the story of this part of the day – perhaps a pre-wedding glass of bubbly is served or good-luck cards are opened. At the final pre-wedding meeting, ask the bride and groom (individually), if there are any surprises planned, which you should be aware of. Quite often the groom will have arranged for a gift, usually a necklace or other piece of jewellery, to be delivered as the bride gets herself ready. It is important to be informed of such plans in advance, to capture the expression on her face as she opens the package. Take a further picture as she fastens the necklace, or puts the bracelet on her wrist.

Images like this will add depth to the opening sequence of the album design, but they also have another benefit. It is very helpful to have a few shots in the camera before the 'official' photography begins. It is reassuring to know that your equipment is correctly set and there are no problems. You can then hit the ground running with the photography that lies ahead.

Often the groom will send a gift to the bride to be opened during her preparations. A shot like this makes a valuable memento of the occasion.
Nikon DSLR, 50mm macro lens, 1/125sec at f/4

All brides choose their wedding shoes with care and it's important to photograph them before they get dirty and look worn. This was taken at the moment the bride was showing the groom her new shoes.
Nikon DSLR, 28–80mm lens, 1/125sec at f/5.6

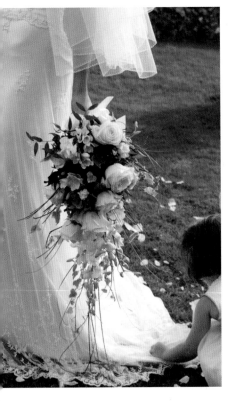

Again, available light was used to give texture, shape and richness to the white chocolate cake. The camera was supported on a tripod to ensure sharpness.
Nikon DSLR, 28–80mm lens, 1/60sec at f/5.6

The bouquet can be set up as a still life at the bride's home, but this is a natural-looking alternative.
Nikon DSLR, 70–200mm lens, 1/500sec at f/2.8

RULE OF THUMB

Use a wide to medium telephoto zoom lens to fill the frame for details. Remove distracting backgrounds by going in close to the subject, with wide apertures for shallow depth of field. Choose a lens with close-focusing capability. When photographing very small objects, such as the rings, a macro lens of around 50–105mm would be useful.

Use the bed to lay out the veil and place the shoes carefully. Available light works beautifully, retaining natural shadows and detail on the delicate fabric.
Nikon DSLR, 28–80mm lens, 1/60sec at f/4

The handbag was placed near a window for the photograph as flash would have been too powerful for the fabric and stitching.
Nikon DSLR, 28–80mm lens, 1/60sec at f/4

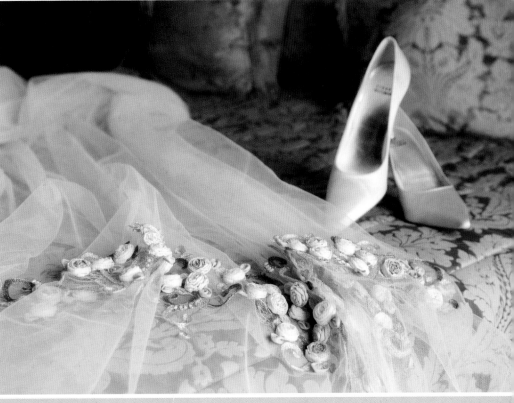

After the Ceremony

Immediately after the ceremony, all the guests are circulating, congratulating the couple and it is a great time for detail shots. The formal group photography has not yet begun and the guests have a chance to take their own pictures. You can mingle among them with a 17–55mm zoom lens at close range, looking for ties, buttonholes, hats, shoes and other eye-catching bits and pieces that have colour and interest.

For a different perspective, shoot from a distance with a longer focal-length lens and the camera mounted on a monopod.

The reflection in a hubcap of the wedding car is an example of how this can work. The couple were posing for their guests' cameras and, by stepping back a little, the image, far right, was spotted. It's not the sort of shot you would set up, but it makes an unusual, quirky addition to the portfolio. Similarly, the flowers attached to the car bonnet is a detail only briefly seen by the couple, while most of the guests will barely notice them at all. The day passes by in such a rush of adrenaline and excitement that it is only through photographs that particular aspects can be recalled.

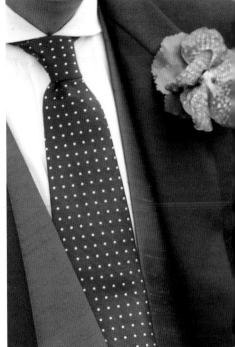

Remember it is the groom's day as well! This sort of photograph lends itself perfectly to the magazine-style album to use as part of the page design.
Nikon DSLR, 24–120mm lens, 1/125sec at f/5.6

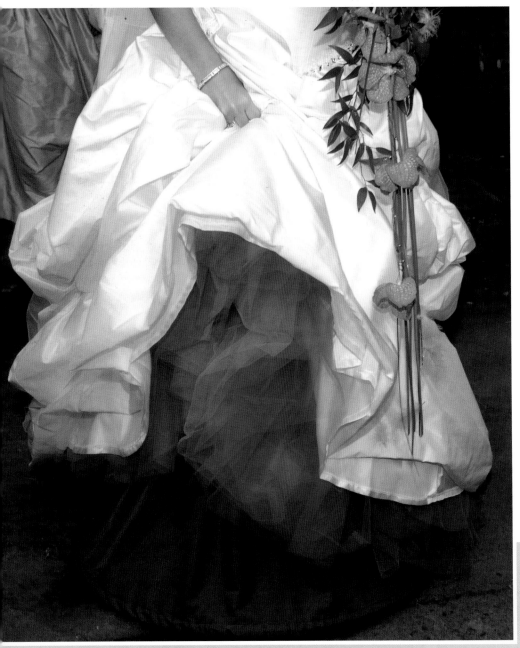

'Look for the colours or theme that the couple have chosen – how the groom's buttonhole complements his suit, waistcoat or tie, for example.'

The bride holding up her dress to prevent the bottom getting dirty is typical of many weddings. You just have to keep alert and remember that not all images happen at eye level.
Nikon DSLR, 24–120mm lens, 1/125sec at f/5.6

• THE BUSINESS ASPECT

Detail shots are important both to our clients and our business. They are invaluable for use on our website and advertising literature, to break up text and add interest to promotional brochures and leaflets. Photographing the details and passing on a few images to the car hire company or the florist, for example, is a good way to network with other suppliers who will happily recommend us to prospective clients. Rather than charge other suppliers for the use of images, you can request that, if your shots are used for their own promotional purpose, then you are credited with your business name and your website address is clearly visible alongside each image. This continues to work very well for us in helping to generate business by recommendation.

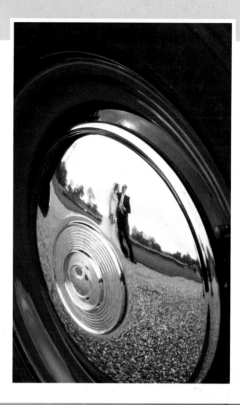

Be different and creative. Look for angles and shapes in vehicles and you can give the images an abstract feel.
Nikon DSLR, 24–120mm lens, 1/60sec at f/8

This reflection of the couple was spotted in a hubcap and the opportunity taken to shoot one of the more unusual portraits of the day.
Nikon DSLR, 24–120mm lens, 1/60sec at f/8

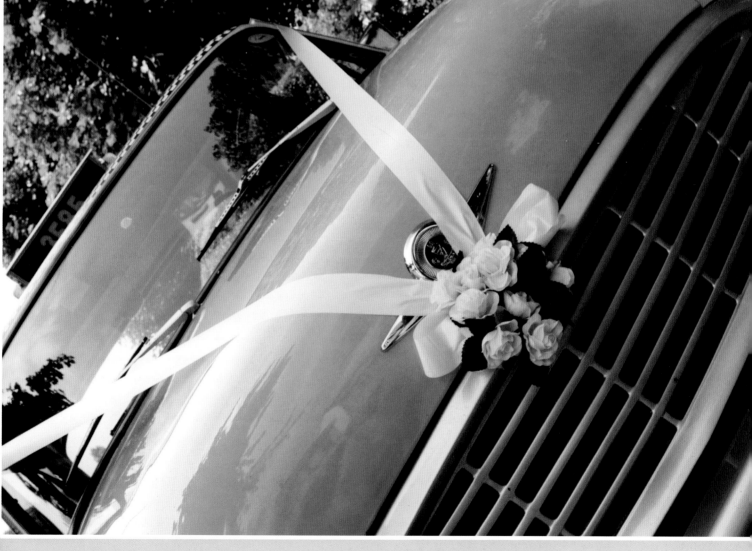

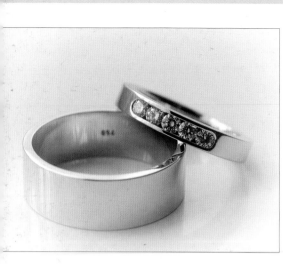

Macro lenses are great for close-ups of the rings. Use a windowsill, best man's hand, or any available surface, so long as there is enough natural light.
Nikon DSLR, 50mm macro lens, 1/60sec at f/2.8

RULE OF THUMB

Both the arranged still life and unanticipated moments have their place among the detail shots. The former, such as the rings and shoes, requires planning to ensure you shoot them at the optimum time and should be on a schedule of pictures, drawn up before the wedding.

The Rings

Whatever other details you shoot, make sure you include the rings. A good time to photograph them is when the groom is getting ready before leaving for the ceremony. Obviously, you don't want to ask the couple to remove them once they have been so ceremoniously placed on!

As with the bride's shoes, a windowsill is a good place to photograph the rings as it provides available light and a plain surface. A 55mm macro lens is useful for filling the frame when you need to pick up the details of the ring design. Take care not to include your own reflection in the rings' surface! This

This was taken as it happened. The bride put her bouquet and just married cushion down and the groom placed the glasses next to them. The arrangement couldn't have been better.
Nikon DSLR, 28–80mm lens, 1/250sec at f/5.6

type of shot is obviously contrived, but it will be meaningful for the couple and is a good opening or closing image for the album.

After the ceremony, a shot of either the bride or groom's hand wearing the ring for the first time complements the earlier one of the rings together. Think of each image acting as a stepping-stone or a link to the next phase. Remember, the purpose of wedding images is not only to record to the day's events, but also to illustrate the thoughtfulness, care and love that the couple have for each other and for their guests.

• SPONTANEOUS SHOTS

There will be many opportunities throughout the day's events to photograph unexpected details, which often disappear as quickly as they arise. Just after the ceremony, for example, guests will often pass small gifts

The shoes were placed by a window but, this time, they were overexposed by one stop to ensure detail was retained in both the shadow side and on the top and straps.
Nikon DSLR, 28–70mm lens, 1/60sec at f/2.8

and tokens of good fortune to the couple. The shot of the groom's hand holding his top hat and the corn dolly is an example, telling a small story of its own.

Later, while the couple were being photographed, their champagne glasses and the bride's bouquet had been carefully placed on the ground creating a ready-made, still-life composition just waiting to be taken. A similar image could easily be set-up but the result is much more effective and natural-looking if the moment is captured as it actually happened. All it takes is a practiced eye and constant vigilance looking for opportunities.

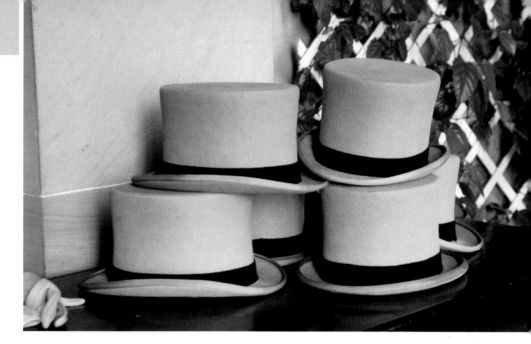

This image of the hats was taken just as the guys had left them. Keep a lookout for detail shots like this as they will always contribute to the wedding album design.
Nikon DSLR, 28–80mm lens, 1/60 sec at f/4

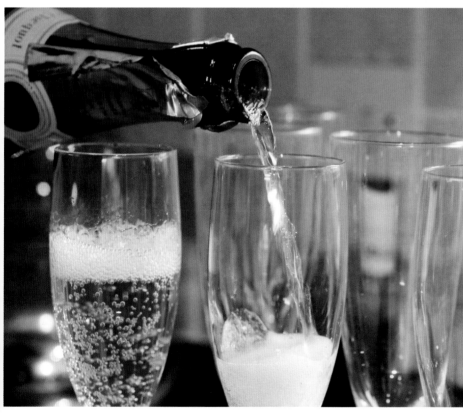

Photograph the pouring of champagne for the speeches. If it is a good quality champagne, include the label in the shot, otherwise just show the wine pouring into the glasses. This is a good shot for the album and also a useful stock photograph for the venue. Fill-in flash was used to add more sparkle to the bubbles.
Nikon DSLR, 55mm macro lens, 1/60sec at f/5.6

A shot of the groom with his arm around the bride's waist shows his caring and protective side – the bride's mother will love it.
Nikon DSLR, 70–200mm lens, 1/125sec at f/5.6

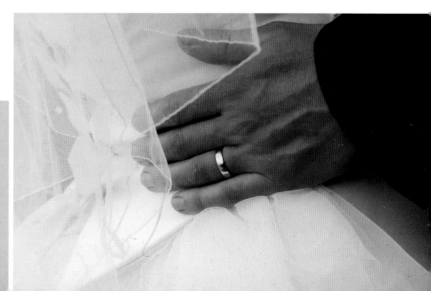

At the Reception

The reception venue is the richest vein of all for detail images, especially the dining room. It's worth allocating plenty of time to take photographs in there, when everything is ready and the tables are set for the guests. Many couples have a theme that runs through their wedding day, which will often be evident in table decorations. If there are musicians, include these, plus a close-up of a score they use, ideally showing the title of the piece.

The standard detail shots will consist of the whole cake and close-ups of its decoration. Place-settings, candelabra and the favours are all photographed and even the seating plan, which is sometimes beautifully done with elaborate calligraphy. The floral arrangements are also important, particularly those on the top table. A lot of time and thought will have gone into creating the atmosphere in the room and the photographs should reflect this. Lighting may be a mixture of tungsten and daylight, which will help add mood to the images.

An overview of the room will always be appreciated by the couple. You can also take this opportunity to photograph them with the cake. An effective approach here is to set up a differential focus shot. Using a wide-angle lens, the cake is placed in sharp focus and off-centre in the frame, while the couple is positioned in the room at a point that is out of focus, taking care to note the direction of the light. They can either embrace or chat to each other, whatever makes them comfortable. As this set-up will invariably require a slow shutter speed, explain to the couple that they must remain perfectly still while the photograph is being taken. If they understand what is required of them and why, they are more likely to co-operate happily.

It is a rule of ours not to take photographs at the tables once the guests are seated and we suggest that you never photograph guests while they are eating. However, there are still plenty of images to be found, like the line of ladies' hats that had been hung up during the meal (right), perhaps food and drink waiting to be served or some of the presents and cards that have been brought to the reception.

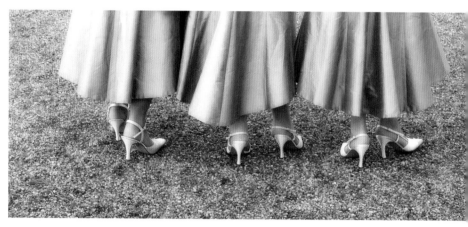

Always look out for photographs of shoes, as ladies love them when they are brand new and pristine. This shot of the bridesmaids again tells a story without the need to include their faces. The image was converted to black and white and then toned and diffused to add mood.
Nikon DSLR, 70–200mm lens, 1/60sec at f/4

All the images on these pages show the advantage of keeping shots simple and uncluttered. Just two little cakes were focused on here, bearing the initials of the bride and groom.
Nikon DSLR, 70–200mm lens, 1/125sec at f/4

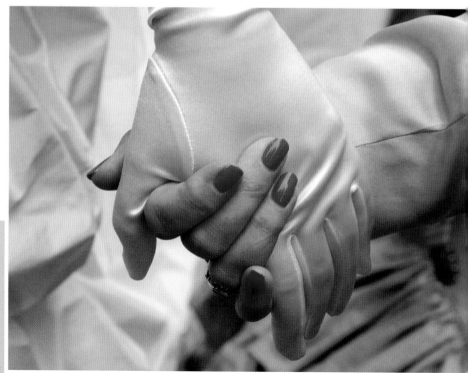

The bride's father died prior to this wedding and the mother gave her away. This image of their hands tells more of a story than a full-length shot would have done.
Nikon DSLR, 70–200mm lens, 1/250sec at f/5.6

After the meal, the ladies removed their hats
and pinned them to a line in the marquee,
which just asked for a shot to be taken.
Nikon DSLR, 28–80mm lens, 1/125sec at f/8

A detail of the black netting bag and rose is
enough for the album, without photographing
the contents of the gift – a candle.
Nikon DSLR 28–80mm lens, 1/60sec at f/3.5

RULE OF THUMB

*Allocate time to photograph the
dining room when the preparations
in there are finished but before the
guests enter, so it is looking at its
pristine best. This is also a good
time to set up a shot of the bride
and groom with the cake.*

The Wedding Story

Throughout the world, there are as many varied formats of wedding ceremony and celebration as there are ethnic and religious groups. Some are rigorously structured and very solemn occasions, others are much less restrained. Either way, the planned sequence of events and the significance and underlying gravity of the occasion must be fully understood by everyone, not least the photographer.

With the departure of traditionally formal wedding photography and the rise in popularity of the more relaxed, storybook approach, the photographer has to work even harder to provide clients with a full representation of their wedding day. Some situations require complete control to ensure the posed shots of groups or individuals are of the highest quality. At other times you will have to fade into the background, using available light rather than flash, to capture events as they unfold naturally.

This chapter demonstrates how our own approach to wedding photography changes as the day unfolds, from documentary through more formal poses to the stylized images for which we are known. We have never restricted ourselves by attempting to adopt a single 'style'. What we aim to achieve are images that are varied, have impact and tell the complete story of the day, from start to finish.

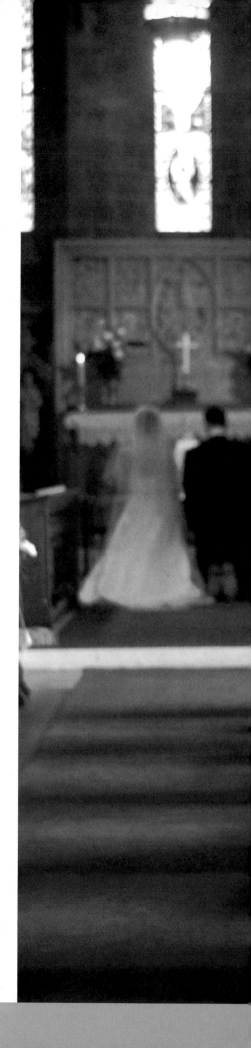

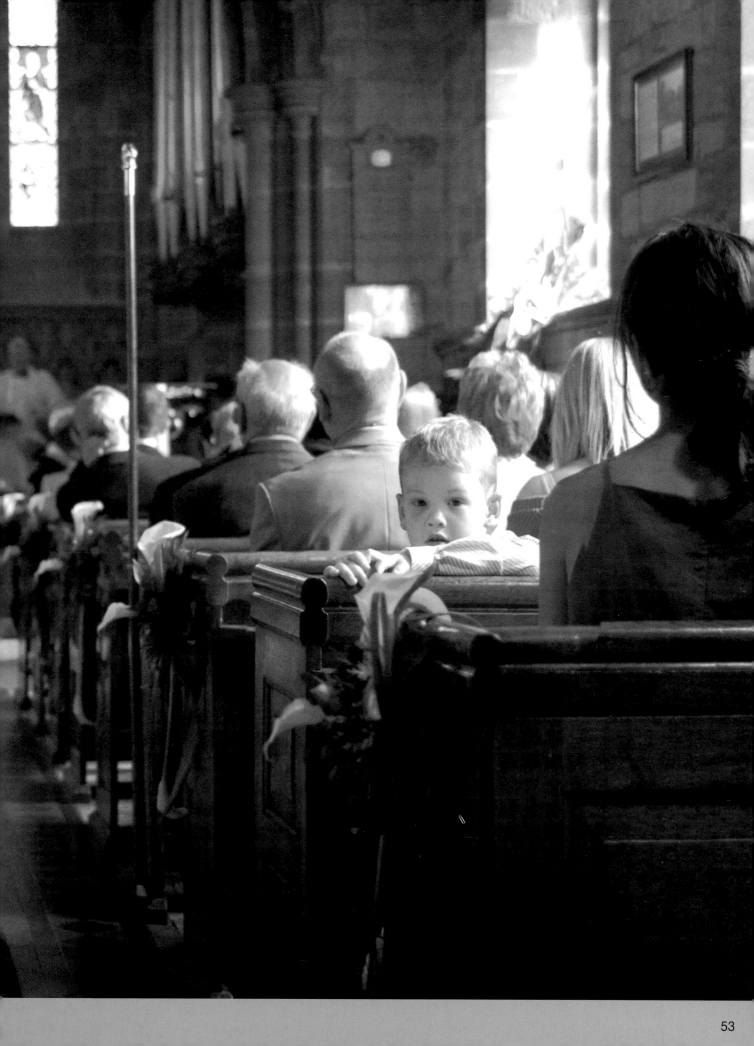

At the Bride's Home

We start the day by heading in different directions, one of us joining the groom and the other the bride. The bride's preparations are invariably a hive of frantic activity, noise and excitement, and it is an opportunity to deliver a calming influence using our experience of many similar situations.

Take every opportunity at the bride's home to photograph any details relevant to the wedding. Use a wide aperture to cut out distractions in the background.
Nikon DSLR, 28–80mm lens, 1/30sec at f/2.8

Once the bride is ready, you can take some more formally posed portraits. This image was composed to photograph the flowers in her hair and her bouquet.
Nikon DSLR 28–80mm lens and monopod, 1/30secs at f/2.8

'Window light and reflectors are better than flash, giving a soft, moody feel to the images.'

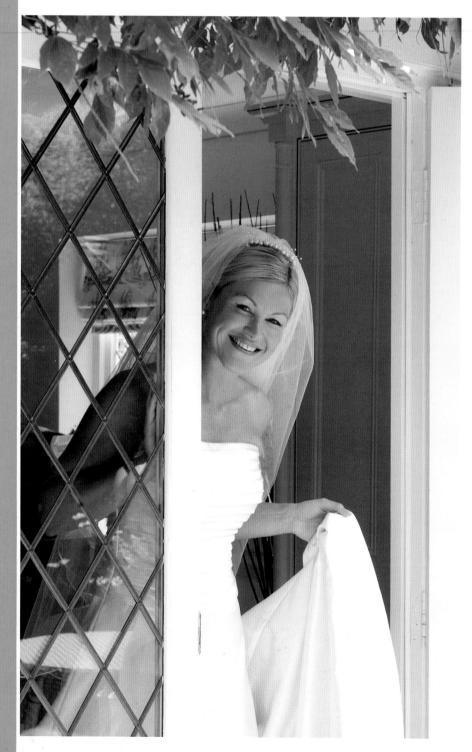

Windows and doorways make good natural frames for a portrait and convey the idea that the bride is setting out for a new life.
Nikon DSLR, 28–80mm lens, 1/125sec at f/5/6

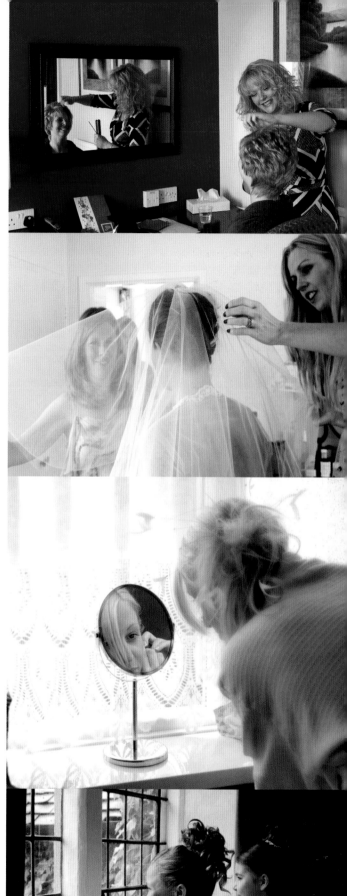

The hair, make-up and placing of the veil can all be watched and photographed as part of the story. Keep your distance but work with available light, with the camera on a monopod, where possible. If the room is on the dark side, fit a flashgun that can be used for bounced lighting from the ceiling. This will give you a couple more stops of exposure but retain a soft, natural feel.
Nikon DSLR, 28–80mm lens, 1/60sec at f/5.6

Timing is critical at this stage to keep both the wedding and the photographs on schedule. Allow an extra 20 minutes, on top of the allocated time, for the bride to get into her dress. She must be aware, though, that if the hairdresser and/or make-up artist overrun and she is not ready for formal photographs before the agreed time of departure to the venue, then those images will be lost. If the bride is late for the wedding it is the same as being late for work – the rushed feeling will remain with her all day.

While the bride is having her make-up applied, it is your chance to look for detail shots. The shoes, flowers, tiaras and veil can all be captured. We set up the shoes on the floor with the dress in the background and use a wide-angle lens with the camera at floor level (see page 58). A wide aperture will provide differential focus, rendering the shoes sharp with the dress behind a little blurred.

The same differential focus technique can be used to show the bride at her dressing table and over-the-shoulder shots of the bridesmaids touching up their mascara, both of which make a good addition to the album. A mirror is an excellent compositional device, adding interest and depth to the image. Initially, there can be some reluctance by the bridesmaids to being photographed because they are 'not ready yet', which, of course, is the whole point – it is the getting ready that needs to be recorded.

Use window light and reflectors for these interior shots to give a soft, moody feel to the images. Beware of colour casts caused by the room decor and select the most suitable white balance setting on the camera. A monopod is useful in confined spaces and is less of a hazard to everyone present than a tripod.

Bridesmaids usually love to play up to the camera. These were lying on the bed with their heads towards the window. The first photograph was of all their heads together and this, the second, was of all their feet in the air.
Nikon DSLR, 28–80mm lens, 1/60sec at f/5.6

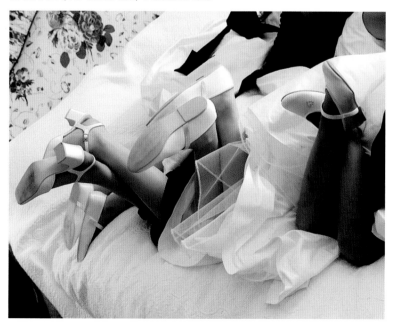

• BRIDESMAIDS AND FAMILY

The bridesmaids are often the first to be ready for departure and this is a good chance to take individual head and shoulders shots and a few of the girls together. Their excitement is high as they wait for the bride to join them. Window light, enhanced with a reflector, will produce the most flattering results. For very young bridesmaids, a window seat is better still as it is easier to contain them and arrange a pose when they are seated. Older bridesmaids often want to help the bride into her dress and there are always opportunities for photographing their hands trying to fasten delicate buttons at the back – often a tricky procedure with long fingernails.

The men of the family are often rather neglected at this stage and will appreciate a little attention. The bride's father will be around, usually calmly getting himself ready well out of the way of the general activity. Often he will struggle to tie his necktie or cravat correctly, or to pin his buttonhole to his jacket lapel and helping with these tasks is a good way of building a relationship with him.

It is possible to learn quite a lot about members of the family at the bride's home. Watch how they interact, whether they are relaxed, extrovert or introvert and this will tell you if they will need a little gentle persuasion when being photographed later in the day. Of course, it's a great chance for them to get to know you better as well.

The dress requires a good deal of attention; it is the first thing the bride will have thought of when she accepted the proposal. You should have the opportunity to photograph it before it is put on, either on the hanger, for a full-length view (top) or arranged carefully on a tidy bed (above).
Nikon DSLR, 28–80mm lens, 1/30sec at f/2.8

Do not bully the bride into posing for pictures, but photograph what you can while gently encouraging her to get dressed and keeping watch on the time.
Nikon DSLR, 28–80mm lens, 1/30sec at f/2.8

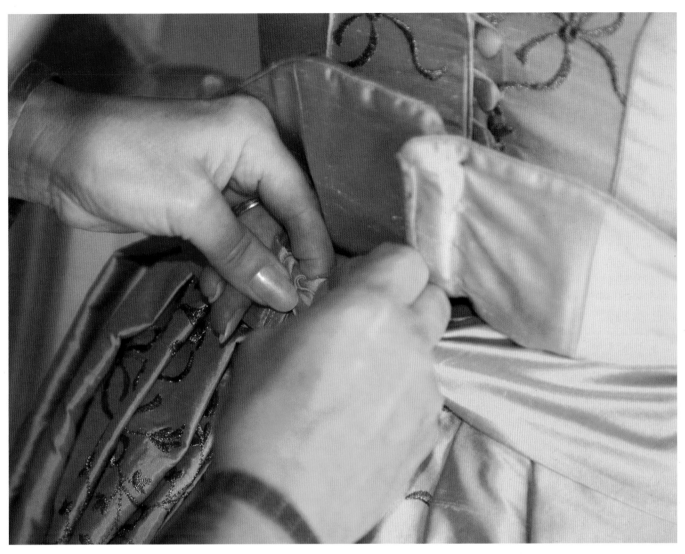

Careful observation will reward you with many beautiful images from this part of the day. The mother or a bridesmaid fastening the dress is a special moment to look out for.
Nikon DSLR, 28–80mm lens, 1/30sec at f/2.8

Do not concentrate purely on the bride at this time. The bridesmaids and close family members can all be photographed getting ready. Mirrors are a useful compositional aid, adding depth and interest to images.
Nikon DSLR, 28–80mm lens, 1/30sec at f/2.8

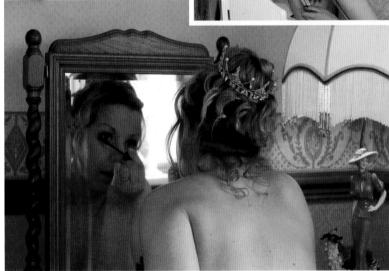

• THE BRIDE

It is the brief, passing moments that provide some of the most rewarding shots at this early stage of the day. The bride applying her lipstick, the chink of the glasses as the champagne is poured and passed, the mother giving her daughter a hug; all these combine to make the bride's preparations a vital part of the story.

Establish with her beforehand at what stage of dress or undress she will be happy to be photographed. This is a very intimate and private environment and you should always be aware of the bond of trust that your clients have in you at this time. Some brides will agree to being photographed as they are dressing, but it is advisable only to take pictures when they are completely relaxed and comfortable.

The champagne will be flowing and the excitement gathers momentum as leaving time draws closer. When the bride does appear, she will be radiant and happy. She has her dress, her new jewellery, her shoes and her bouquet. This is her day; she is no longer the girl who had a long-held fantasy – she is finally living the dream.

As well as close-up details of the outfit and accessories, we suggest you take some time to compose classic, full-length shots of the bride, back-lit by window light or in daylight outside. These images will form the opening chapter of the album and, for the viewer, they hint at what is yet to come. The aim is to capture that feeling of anticipation through the bride's pose and expression. Windows and doorways are a useful device for this, signifying a step into a different life (see page 54).

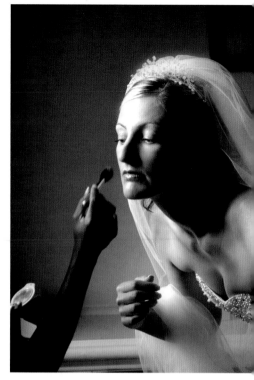

Rembrandt lighting is accentuated by strong highlights and shadows in this portrait taken by available light.
Nikon DSLR, 28–80mm lens, 1/60sec at f/4

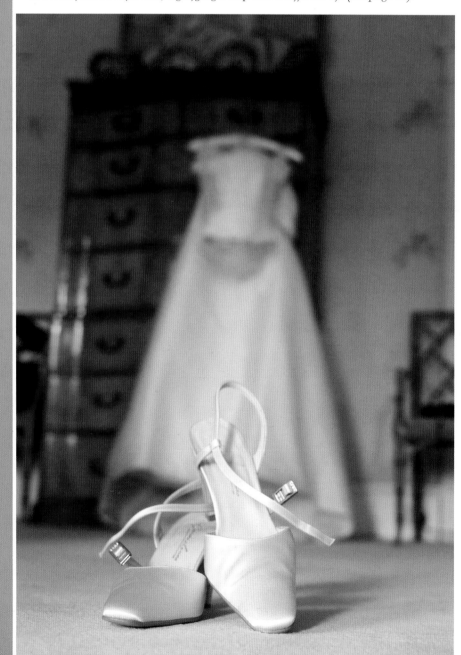

When the bride is putting on her earrings, you can often prompt her to maintain her happy expression. This type of image works well converted to black and white while retaining colour in the mirror reflection.
Nikon DSLR, 28–80mm lens, 1/60sec at f/2.8

This simple but effective image is ideal for the beginning of the storybook album. A low camera angle will ensure both the shoes and dress are included in the image. An aperture of f/2.8 will capture the differential effect of the shoes and bride's dress.
Nikon DSLR, 28–80mm lens, 1/30sec at f/2.8

To create this type of effect, use a chair to give you a higher viewpoint and ask the bride to look up at the camera. This creates a half-moon underneath the pupil, making the eyes appear larger.
Nikon DSLR, 28–80mm lens, 1/60sec at f/2.8

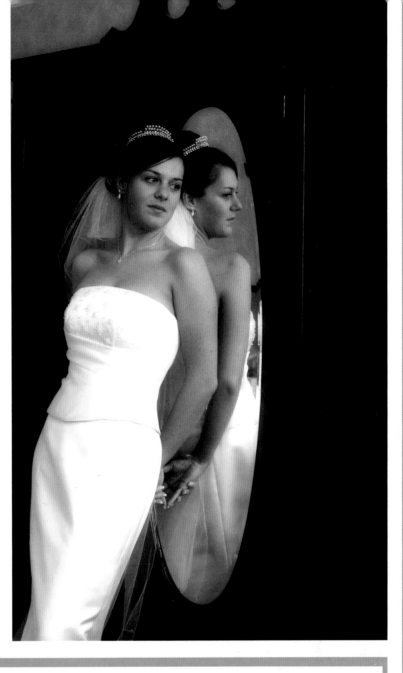

This was a controlled photograph: the bride was asked to pose with her face turned towards the light to give soft modelling. Note that her nose doesn't break the line of her cheek. A tripod was essential to use the available light.
Nikon DSLR, 28–80mm lens, 1/15sec at f/2.8

The bride adding finishing touches to her 'look' will give you many opportunities for photographing detail. Let her get on and allow her to relax and the pictures will keep coming.
Nikon DSLR, 28–80mm lens, 1/60sec at f/5.6

RULE OF THUMB

Images taken at the home are usually around f/4 to f/5.6 at 1/30sec or 1/60sec. We keep the camera set at ISO 400 at all times. A monopod is extremely useful in tight situations, to help with slower exposures.

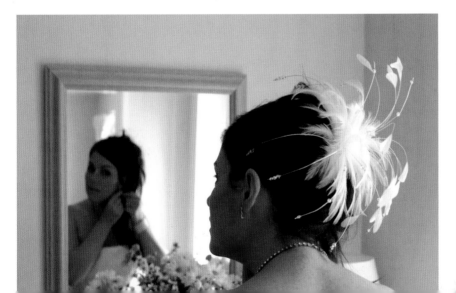

At Home with the Groom

For a photographer working alone, it is impossible to photograph both bride and groom getting ready at the same time and the bride always takes priority. As there are two of us, we can shoot the guys informally at this stage and it is a very effective selling point in our favour.

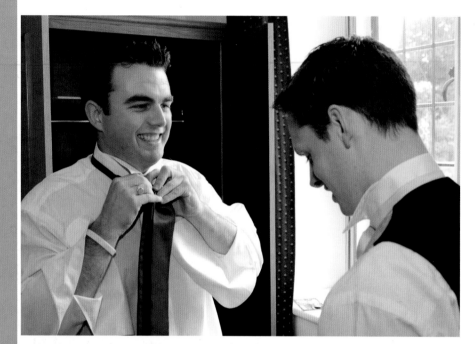

As with the bride's preparations, be observant and watch events as they unfold. Cuff links, ties and chatter are the all-important ingredients of the images you will need to capture.
Nikon DSLR, 24–200mm lens, 1/30sec at f/5.6

Go in close for small details like this, but do not try to stage them. Keep chatting, maintaining a friendly dialogue so the guys are not distracted as they get ready.
Nikon DSLR, 24–120mm lens, 1/60sec at f/5.6

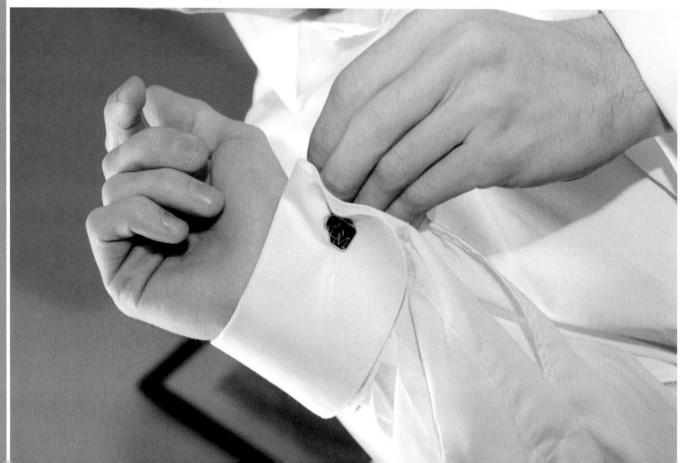

Be alert to capture details such as this shot of a groomsman holding the Orders of Service in his hat!
Nikon DSLR, 28–80mm lens, 1/60sec at f/5.6

There is always a great deal of chatter and laughter among the groom and close friends as they dress and prepare. Adrenalin is running high and you can sense the atmosphere of nerves and anticipation. Our approach is to photograph the details initially to give them time to accept that a photographer is present. The idea of this can be a little unnerving for them while they are in various states of undress, but we assure them we are not after pictures of them in their boxer shorts and that they can all relax!

RULE OF THUMB
If the subject felt uncomfortable while being photographed, they will remember that feeling when they see the picture and will not want to buy it.

Capture the guys relaxing and chatting and the photos will come. Do not try to direct proceedings, just keep track of the timetable and gently nudge them along.
Nikon DSLR, 24–120mm VR lens, 1/60sec at f/5.6, bounced flash

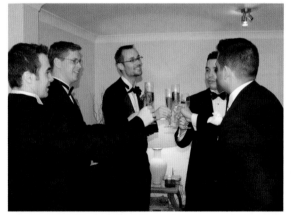

This image: Nikon DSLR, 28–80mm lens, 1/125sec at f/2.8

*Capture various shots of
the groom getting ready.*
Nikon DSLR, 24–120mm
lens, 1/60sec at f/5.6,
bounced flash

*Go in close to the subject
and photograph the groom's
buttonhole being placed
in his lapel. Balance flash
against the window light.*
Nikon DSLR, 1/60sec at f/5.6

*This pose introduces
a fun element to a shot
of a wedding ring.*
Nikon DSLR, 28–80mm lens,
1/500sec at f/2.8

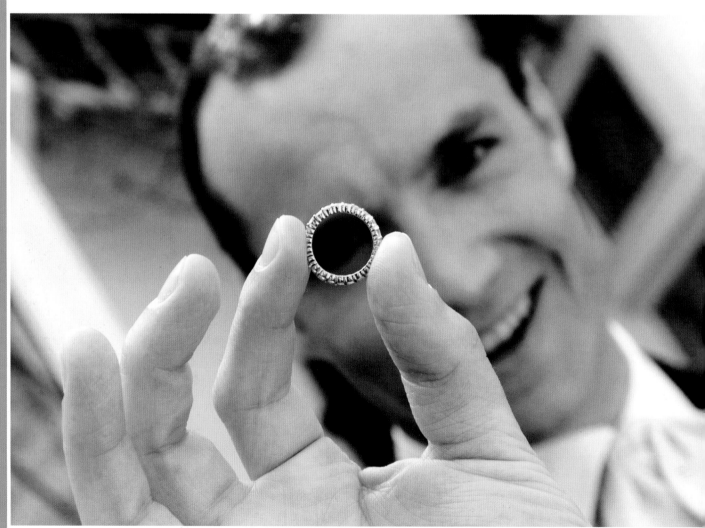

The first priority is to photograph the rings, which are easily set up on a windowsill or similar surface that has plenty of natural light. A macro lens is very useful to get really close in and pick out details in sharp focus, especially if the rings have been engraved or are set with precious stones.

For the start of the groom's story, fastening his cufflinks, putting on his waistcoat and tying his shoelaces are the type of shots you need. They will complement those of the bride in the opening pages of the album. Very often the guys do not know how to attach a flower to the lapel of their jackets and, as at the bride's house, this is a chance to step in and be helpful. A good tactic is to demonstrate on one of the ushers and then suggest the best man helps the groom, at which point the camera will be raised and the moment of interaction between them captured.

The groom putting on his waistcoat with the help of one of his groomsmen.
Nikon DSLR, 1/60secs at f/5.5, bounced flash

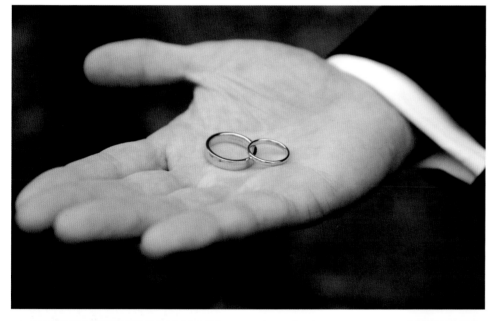

Another version of the rings. Use a macro lens to get up close.
Nikon DSLR, 55mm macro lens, 1/125sec at f/5.6

Be aware of personal details, like this gift of a watch from the bride to the groom. Small details contribute to the larger story.
Nlikon DSLR, 24–120mm VR lens, 1/125sec at f/8

Just prior to leaving for the wedding venue, the groom makes sure that everyone knows their role.
Nikon DSLR, 24–120mm lens, 1/125sec at f/8

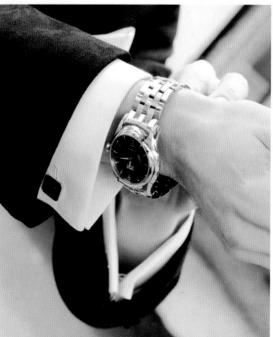

Part 3:

En Route with the Groom

The time has come for the guys to set out on their journey to the wedding venue. Plan to get there with time to spare before the guests start to arrive. This allows you to take a few formal shots outside the venue and plenty of reportage shots of the guys interacting with each other. They need to be photographed both individually and as a group, so search for a suitable location, usually starting with a doorway. Shade, top shade or back lighting is desirable to avoid the harsh shadows that direct sunlight will produce.

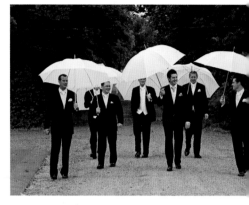

Raining again! Don't let the weather put you off, but work with it. The groom and his groomsmen had brought along white umbrellas, which are useful props in this image.
Nikon DSLR, 24–120mm lens, 1/125sec at f/8

It was raining when this was taken, but we needed a group shot of all the guys. Rather than use flash, we opted for available light, putting them inside in the dry, while we got wet! Care was take to place the groom in the strongest position in the frame.
Nikon DSLR, 24–70mm lens, 1/125sec at f/8

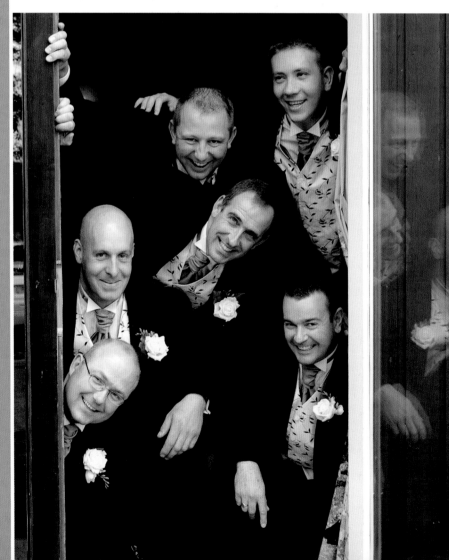

'The emphasis is on relaxed and fun photography, but it is important to work quickly'

RULE OF THUMB
Forget the clichéd shot of the groom and best man looking at their watches outside the church – it is something they would never do. Make your images believable and natural to give the album more substance.

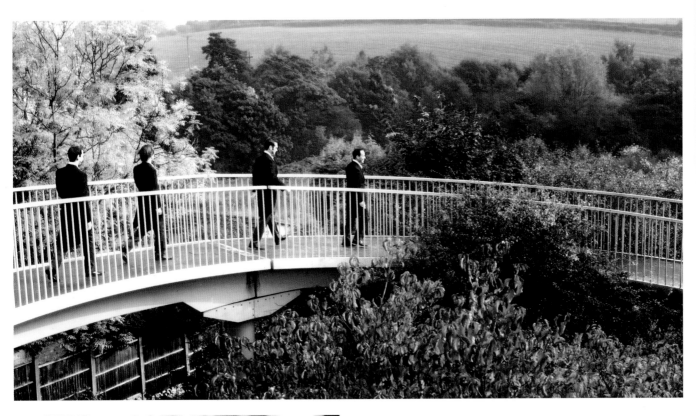

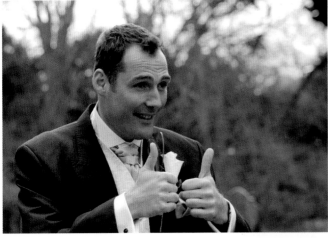

The boys walking towards and away from the camera adds a little sparkle to the album. We find that all the men love this part of the photography as they feel they are not posing, but secretly feel great.
Nikon DSLR, 24–120mm VR lens, 1/125sec at f/8

The emphasis is on relaxed and fun photography but it is important to work as quickly as possible, leaving the ushers free to perform their duties of greeting guests and guiding them to their places. Two or three shots of the guys walking towards the wedding venue give a sense of continuity to the story.

The secret to making this shot work is to give them a little coaching beforehand. They are asked to keep their heads up and not to look at their feet as they walk. This way there will be good facial expressions and interaction between them to add interest to the shots.

A group shot of the groom, ushers and best man needs to have an interesting shape and composition. It is much easier to arrange them all if the experience is made fun for them, so there is always much good-humoured banter between us. We have no qualms about directing shots in this way. In our opinion, attempting to adopt a purely fly-on-the-wall approach to wedding photography often leads to uninspiring and repetitive images that do little to reflect the spectacle and emotion of a wedding.

Arriving with the Bride

Working to a pre-determined schedule which has been approved by the couple is imperative so that you know where you need to be and the time you must be there. The bridesmaids and the bride's mother will be first to arrive at the wedding venue, where you should be ready and waiting for them. Reportage photography of them stepping out of the car and a group shot of them together by the gate are the first priorities. Next are photographs of the bridesmaids walking towards the entrance where they await the arrival of the bride and her father.

The expression of love and pride on the father's face says it all here. Be patient for this moment – if you go in too soon, the expression will be lost.
Nikon DSLR, 28–80mm lens, 1/125sec at f/5.6

Ask the chauffeur to wind down the window of the car to take away problems with reflections. Direct the bride to lean forward and look at one of the bridesmaids, then wait for the right expression. There is no time at this point to control the situation further than this.
Nikon DSLR, 24–70mm lens, 1/60sec at f/5.6

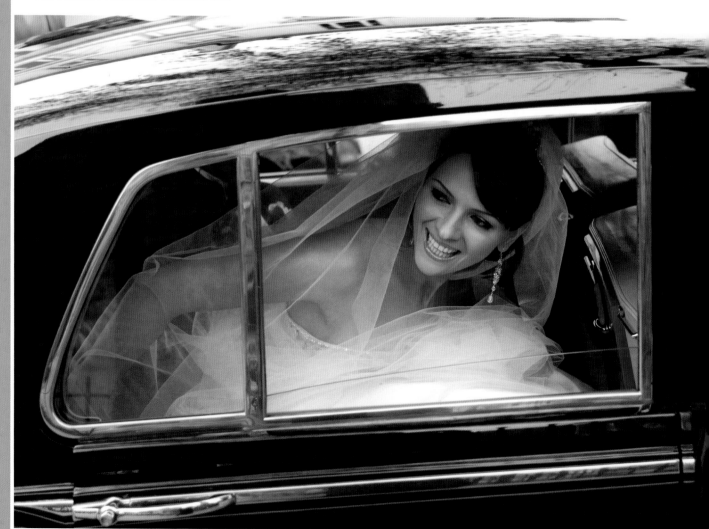

The expressions on the bridesmaids' faces as the bride finally arrives are not to be missed. Then our attention turns to the bride in the car. Our method for this shot is to ask the chauffeur to roll the window down so that her face is not obstructed and there are no distracting reflections. She is asked to lean forwards slightly to make sure that her face is evenly lit with no shadows. The shot is usually more pleasing and natural looking when the bride is looking off-camera so we encourage her to chat to her mother and bridesmaids.

It is often difficult to create images of the bride getting out of the car that make her look elegant, so a good alternative is to concentrate on a detail shot as she places her foot on the pavement. She will have hitched her dress up slightly and this gives a nice image of her lower dress, ankle and shoe. This is a useful linking shot in the album, leading to a more traditional portrait of the bride and her father by the car.

As one of us is taking this shot, the other will shoot the same subject from another angle, using a wide aperture to record the front of the car in sharp focus with the bride and father de-focused in the background. This is where two synchronized photographers really have an advantage. We are able to capture a greater variety of images for the couple, in this case, two completely different images from just one brief pose, without disruption to the continuity of the day.

The bride and her father will then make their way to the doorway of the venue where the bridesmaids will be waiting. As they walk, there are reportage shots to be taken from both behind and in front of them. The bridesmaids' reactions are great to catch before you set up poses of the bride and her father and with the bridesmaids.

Finally, there are the all-important shots to take of the bridal procession along the aisle, preferably from above. What we aim to catch, above all, is the moment when the groom turns to see his bride as she approaches him. It is an emotionally charged, brief exchange and the couple will treasure the memory of it. The bride has arrived, the wedding ceremony has begun.

This groom was spending a quiet five minutes in a corner by the register waiting for the bride to arrive and was totally unaware that he was being photographed.
Nikon DSLR, 24–80mm lens, 1/60sec at f/4

Special features, like a horse-drawn carriage, require a record shot. Use a zoom lens for precise framing and wait until the horses' ears are forward.
Nikon DSLR, 24–200mm lens, 1/125sec at f/8

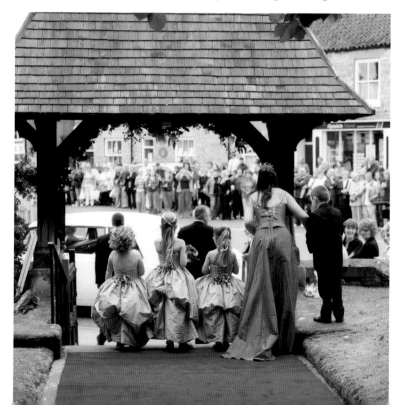

As one of us is by the road, waiting for the bride's car to arrive, the other can stand further back, looking for reportage shots that will capture the feeling of anticipation. The archway here was a perfect frame for the bridesmaids.
Nikon DSLR, 28–200mm lens, 1/125sec at f/8

The Ceremony

To a fanfare of music and the rising of the guests from their seats, the bride and her father make their entrance. As the first hymn begins, the tripod is set up at the rear of the congregation. The camera has a wide-angle lens attached for a series of shots that will take in as much of the environment as possible. These images have great impact when joined together as a panorama across two pages of the album. It always draws favourable comments from the couple and their families.

The focus here is on the flowers, not the couple. Light was low and we waited for a quiet moment during the ceremony so there would be little movement.
Nikon DSLR, 28–200mm lens, 1/15sec at f/3.5

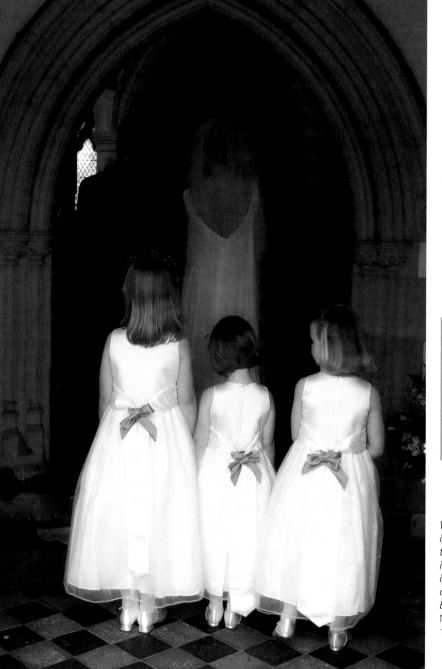

'There are many different cultures and religious denominations and you need to have a clear understanding of the particular marriage customs to avoid causing offence.'

RULE OF THUMB

Ensure you have spare storage media in your pocket when photographing from the front of the ceremony. To move about from that position is totally unprofessional.

Waiting for the organist to finish is a good opportunity to capture the image before the bride walks into the ceremony. This image is improved by the bridesmaid on the right looking at the 'chief' bridesmaid for direction.
Nikon DSLR, 28–80mm lens, 1/60sec at f/5.6

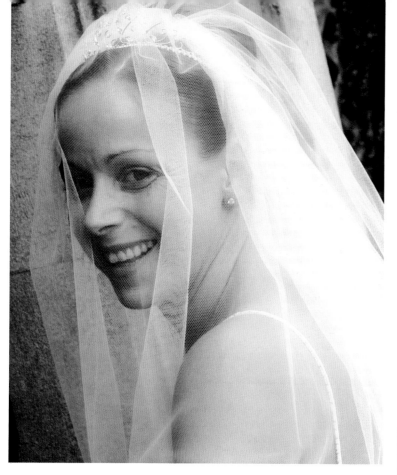

Informal images taken as the bride enters the wedding venue are a useful link to the next stage of the story, the marriage ceremony.
Nikon DSLR, 28–80mm lens, 1/60sec at f/5.6

These three shots were taken in sequence when the groom dropped the rings. If you are given permission to photograph from the front of the ceremony, be ready for anything that happens before you.
Nikon DSLR, 28–80mm lens, 1/60sec at f/2.8

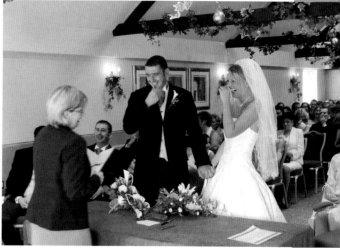

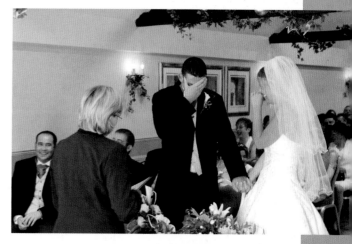

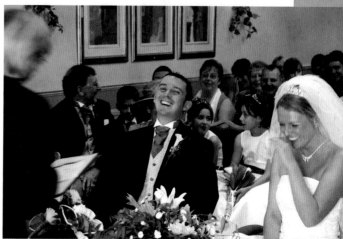

It is preferable to use available light for interior shots during the ceremony as the ambience is precious and would be destroyed by the intrusion of flash. A slow shutter speed is required so a cable release is essential.

During the proceedings, one of us will remain at the rear of the congregation, while the other will be towards the front. With the minister's permission, it is usually possible to step forward and take two, very rapid, shots during the exchange of rings. It is vital that you do not intrude in any way by taking any shots that you have not agreed in advance, or those that would be distracting for the couple and their guests.

Professional conduct is just one measure by which personal recommendation is spread and it would be very foolish to jeopardize future business. Unobtrusive work, communication with the minister before the ceremony and strict adherence to whatever ground rules have been set by him or her are the keys to success at this and future weddings.

It is also important to have a thorough knowledge, and preferably experience, of the course of planned events, whatever the denomination or culture that the wedding ceremony will follow. Some cultures demand that footwear is removed, hands washed and the head covered in a certain way, for instance.

You have to be fully aware of such requirements beforehand to avoid unintentional mistakes or behaviour that could be potentially offensive to anyone. It is our firm belief that this very solemn, though joyful, occasion should be afforded the respect that it deserves. We take great care to protect our reputation for unobtrusive professionalism in this highly charged environment.

The Signing

With the ceremony almost over, the marriage is completed with the legal requirement of signing the register. We suggest a documentary approach, photographing the signing as it happens, rather than setting up a traditional 'grip and grin' shot of the bride and groom. Everyone has seen the stereotypical images of the couple, pen in hand, with the register in front of them. Shots that are taken discreetly are aesthetically more pleasing and make a much greater contribution to the story of the wedding.

'Remember to keep an eye on the families. There will be great expressions to capture and a general air of warmth, tinged with a little relief that it all went well.'

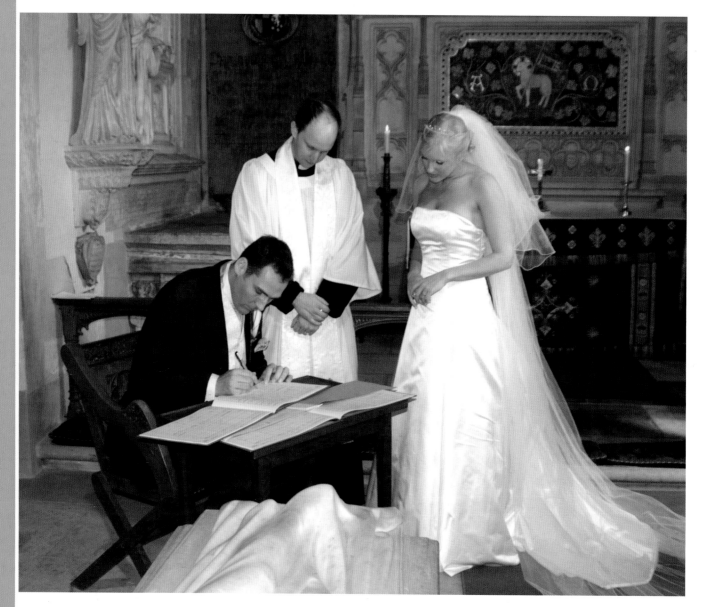

The signing of the registers is an important part of the wedding album but needs to look believable. Posing for this photograph can look too staged especially if the bride or the groom are signing an important document yet looking at the camera. The shot has so much more impact if you as the photographer are allowed to capture the moment 'live' as it happens.
Nikon DSLR, 12–24mm lens, 1/60sec at f/5.6, flash

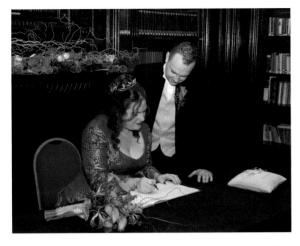

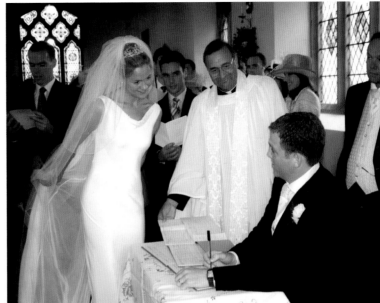

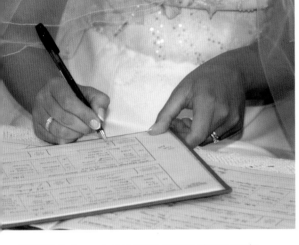

ABOVE: A close-up shot of the signing always works but unfortunately the style of the pen in this instance is not ideal – a gold or silver pen would have made this image stronger.
Nikon DSLR, 28–80mm lens, 1/60sec at f/5.6, flash

BELOW: Available light adds lovely backlighting to the bride's veil, and the register and tablecloth work as a reflector, bouncing soft light back onto the couple's faces.
Nikon DSLR, 28–80mm lens, 1/60sec at f/2.8

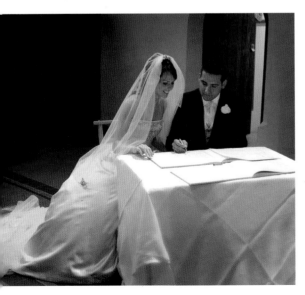

It is imperative to seek permission for photography from the minister or registrar before the ceremony. Communication with key people always pays off, and, at the very least, we feel it is a simple courtesy to introduce ourselves before the beginning of the marriage proceedings.

It is important for these pictures to find the best camera angle without disturbing those present. The environment is often cramped and it is annoying for people to have to step around us. Available light is preferable, but flash is sometimes a necessity if the light is too low. The 12–24mm and the 28–80 mm lenses are used to take in a wider scene, as well as frame-filling close-ups of both bride and groom holding the pen at the important moment.

There is much more to photographing the signing than recording the act itself. This is a significant part of the ceremony and at least a full page is allocated to it in our albums. While the minister is completing the legal paperwork, there will be exchanges and interaction between the couple and their families. The groom shaking the hand of his new father-in-law, or a kiss for the bride from her mother-in-law are the kind of moments that make reportage shots. The presentation of the certificate to the couple is, again, photographed as it happens rather than set up.

Once the marriage is formally completed, take up position to photograph the couple as they walk down the aisle together. By pre-arrangement, one of us will step forward when they reach a certain point to take a couple of very quick shots. Many of the guests will take their own pictures at this point and, from experience, it is best to attract and hold the attention of the couple.

At the doorway, there is a posed head and shoulders shot of the newly-weds. This completes the limited amount of formal photography that we take at the wedding venue. The next phase provides the scope for reportage and photojournalism as the guests follow the couple outside.

Reportage Shots

The bride and groom step out into the world as a married couple for the first time. The guests are close behind and this is their time to share in the joy of the newly-weds, pass on their good wishes and celebrate this coming together. If the photographer were to step in at this point to take posed photographs, the ambience and sense of occasion would be destroyed at a stroke. Instead, this is the best opportunity for reportage images that arises during the whole day.

Hats are difficult to work with as they create a shadow across the face. This image was taken using available light with fill-in flash for the face. The flash was set to two stops under allowing for a ratio of 1:4, enough additional lighting to gently lift the shadow areas and the face under the brim.
Nikon DSLR, 70–200mm lens,
1/60sec at f/5.6

The bride turned just as she was about to go into the ceremony and this moment was captured. The pride in her father's face speaks volumes in the image.
Nikon DSLR, 28–80mm lens, 1/250sec at f/5.6

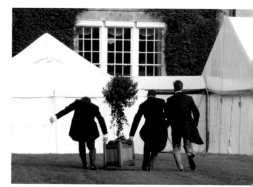

Always remain aware of what is going on to capture photographs that keep the storybook going. The ushers had to take the bay tree from the ceremony over to the marquee before the guests arrived there.
Nikon DSLR, 70–200mm lens,
1/250sec at f/8

RULE OF THUMB

Avoid snapping away in the hope that a few of the pictures will come out well. Like any other images, reportage shots rely on the elements of composition, light, shape and form combining together.

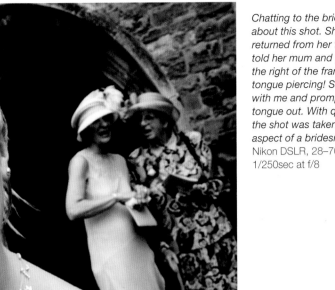

Chatting to the bridesmaid brought about this shot. She had just returned from her travels and hadn't told her mum and grandma – to the right of the frame – about her tongue piercing! She was laughing with me and promptly stuck her tongue out. With quick responses, the shot was taken. A truly different aspect of a bridesmaid, but fun.
Nikon DSLR, 28–70mm lens, 1/250sec at f/8

A proud father and his son share a moment after the ceremony. A telephoto lens allows these moments to be captured from a distance.
Nikon DSLR, 20–200mm lens, 1/250sec at f/5.6

Photojournalism, or reportage-style wedding photography has many similarities to press photography with a human interest. It is about recording events as they happen, with limited or zero interaction between the photographer and the subject. The skill of the photographer lies in his or her ability to anticipate the outcome of a situation as it unfolds and to be in the best position to capture the sequence.

Reportage photographs should have a natural but professional feel to them, reflecting expression, enjoyment and emotion. Without these elements the images will be lifeless and dull. A considered approach – making every image count – will be much more successful than 'machine gun' tactics and will reduce editing time on the computer later.

Although reportage photography is about capturing 'the decisive moment', as Henri Cartier-Bresson described it, anticipating the sequence of events greatly increases the chance of success. However different or avant-garde the couple may believe they are in their wedding plans, there is invariably a subtle adherence to the standard format.

By liaising diligently with a couple prior to their wedding and finding out as much as possible about them and their guests, we can ensure we are as prepared as we can be for any opportunities that arise.

As the couple left to have some romantic photographs taken, they used a golf buggy that was lent to them. We ran behind, but captured this shot first.
Nikon DSLR, 28–80mm lens, 1/250sec at f/8

• REPORTAGE CONSIDERATIONS

After the ceremony, there is a brief window of open emotion that is pivotal to the story of the wedding day. It's a time to work quickly, watching and anticipating the next move or expression from our targets and ready to release the shutter at the defining moment.

One camera is fitted with a 70–200mm lens, mounted on a monopod if necessary, to use from a distance. The other has a 28–70mm zoom for mingling with the guests at closer range. Both have a maximum aperture of f/2.8, which is important as the narrow depth of field helps separate the subject from the background, particularly for a tight crop on head and shoulders.

Expressions are captured without the subject's awareness. The point is not to try to catch people out or make them look foolish, but to reflect the essence of the wedding day. There is the joy and happiness that lights up the bride's face when she spots an old school friend, the antics of young bridesmaids, the couple's delight that the hard part is over and the celebrations have begun. Again, it comes back to telling the story of the day.

As well as looking for the really special moments that make wonderful stand-alone images for the album, such as the bride embracing a guest, far right, it's always worth keeping the camera trained on subjects as they interact. A short sequence of shots works well as a grouping, as the bride and groom's kiss (right) demonstrates. Her expression in the final image was a real bonus, adding a natural touch of humour.

Do not 'machine gun' the guests outside the ceremony. Learn to control your camera and be selective with the photographs you take. Rattling off 50 shots hoping to get one good one is unprofessional and results in missing spontaneous moments. If you have the camera glued to your face for the whole time, you will not be aware of what is going on elsewhere. Use your peripheral vision as well as the viewfinder.

'Observation, patience and anticipation of the moment are the keys to this style of documentary photography.'

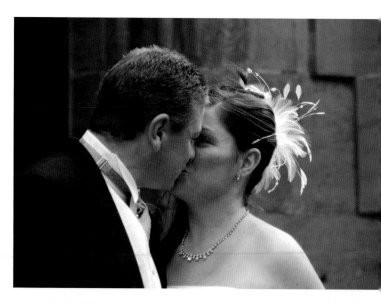
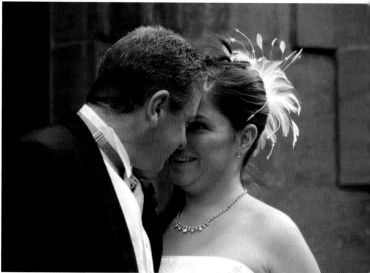
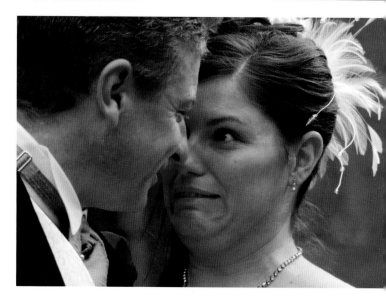

This sequence was only possible with a fast zoom lens on an SLR. As the couple came out of the ceremony they spontaneously kissed, leading to the last, fun shot where it looks like they are saying 'We're married now!' Traditional wedding photography would have missed these expressions as the couple would have been posed full length.
Nikon DSLR, 70–200mm lens, 1/250sec at f/5.6

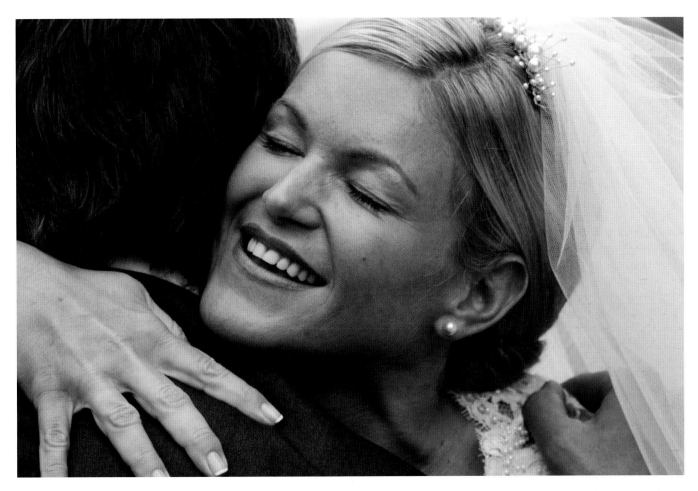

Even though the bride's eyes are shut, the emotion is clearly evident on her face. The hand is perhaps too big in the frame but to correct it would have resulted in this lovely expression being lost.
Nikon DSLR, 200mm lens, 1/500sec at f/5.6

Watch as the bride and groom greet guests after the ceremony, using a telephoto lens to get close to the action while standing well back from the guests. Even if someone looks directly at the camera, only take the shot if the expression is right.
Nikon DSLR, 70–200mm lens, 1/250sec at f/5.6

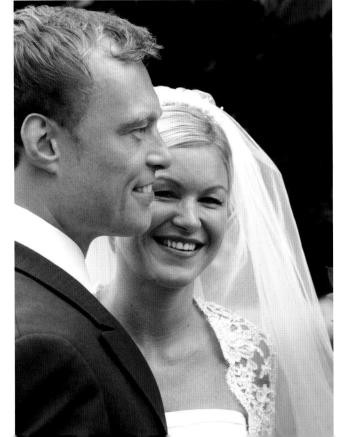

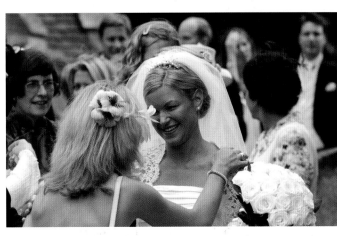

• REPORTAGE AND CHILDREN

The short period of time immediately after the ceremony is perfect for reportage shots of the couple, family and guests but younger members of the party can be overlooked among the celebratory hubbub. The reception venue is often a better place to focus on children, especially if there is space for them to run around and enjoy themselves more freely.

Sometimes a degree of direction by the photographer will make all the difference between a mediocre shot and one for the album. This may be as simple as asking a child to stand still for a second, or move slightly for better light. It is always good to capture interaction between children and often this happens quite naturally as they play or talk together. There is nothing wrong, though, in asking children to hold hands or link arms, so long as it doesn't make them feel awkward or look forced and twee.

The children running towards the lake in the image in the middle, far right, was a totally spontaneous act on their part, but involved a little foresight on ours. They had just been posing for some shots with the bride and groom and, when it was finished, they were told they were free to go off and enjoy the rest of the day. Little children, especially girls, always run away from the camera and so all that was needed was to wait for the moment to happen and then take the photograph.

The two shots of the girls in lilac involved a little more choreography. They were first told to walk up the steps and face away from the camera. The oldest girl in the middle was asked to whisper a nursery rhyme to the others – a tactic that always ensures little ones bunch together. After a couple of shots were taken, the girls were instructed to look over their shoulders at the camera. The eldest was the most serious, but the other two collapsed into a fit of giggles. With three or four shots quickly taken, the girls could then be photographed in individual poses, with their giggles and shyness of the camera over.

Sometimes children need a little direction to ensure the best shots. Asking a group of young girls to whisper together is a good way of producing this close, huddled pose, which is well suited here to the style of the dresses.
Nikon DSLR, 28–80mm lens, 1/125sec at f/5.6

Asking small children to hold hands is fine, so long as they are comfortable doing so. Placing them in the environment adds a sense of scale.
Nikon DSLR, 24–120mm lens, 1/250sec at f/5.6

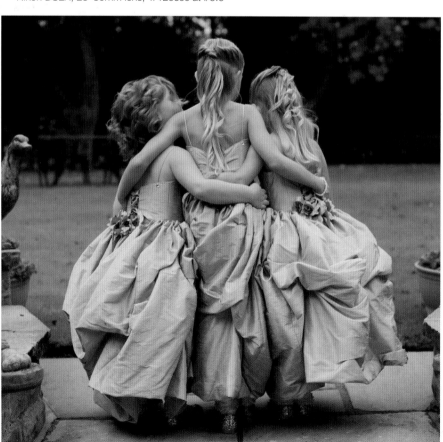

This small boy was captured as he wandered back to the marquee. He was totally unaware that he had been photographed.
Nikon DSLR, 28–80mm lens, 1/125sec at f/5.6

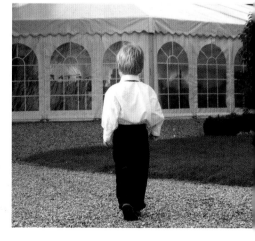

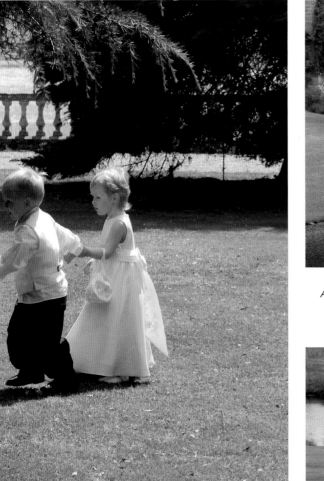

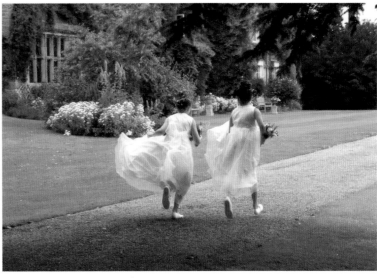

Anticipating that children will run and play at the first opportunity will allow you to capture the event. Be ready with a fast shutter speed to catch the action!
Nikon DSLR, 24–120mm lens, 1/500sec at f/4

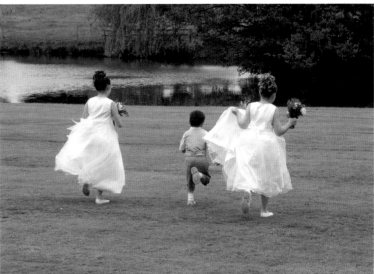

'It is always good to capture the interaction between children and often this happens quite naturally as they play or talk together.'

The follow-on shot to the rear view of the girls. This time, the two on the outside have a spontaneous fit of giggles.
Nikon DSLR, 28–80mm lens, 1/125sec at f/5.6

● SHOOTING REPORTAGE FOR THE ALBUM

The post-ceremony reportage is an important part of our album layout, providing a change of pace to the more formal or stylized images. It also personalizes the portfolio for the couple, reminding them what they and their guests were doing through a series of brief, defining moments that are missed or forgotten among the post-ceremony excitement and emotion.

In the album, try to devote at least one double-page spread to the reportage photography after the ceremony. In matted albums, we use 16-up multi-aperture layouts of 3x2 inches, typically covering a double-page spread but often extending to two or more double-page spreads. In magazine style albums, we suggest you design at least four pages of reportage taken after the ceremony.

Most of these pictures will have been taken in black and white mode in-camera, or converted to it in Photoshop. The reason for this is that black and white adds impact, timelessness and poignancy to reportage. This is especially true immediately after the ceremony, when brightly coloured clothing and hats can distract attention away from the emotional content that we have sought to capture.

However, colour has its place in the stand-alone reportage shots and we will make a special feature of these by using larger and fewer images on the page. Spot-colour is used sparingly and we avoid clichéd and dated effects such as spot colour on the bride's bouquet or the groom's tie.

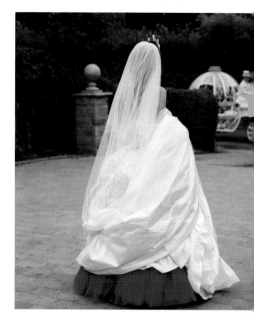

*Cinderella as she goes to the ball!
The coach is waiting at the bottom
of the drive to take her to the church.
Expressions are, of course, important
but add a sense of the location as well.
Nikon DSLR, 28–80mm lens, 1/125sec at f/5.6*

RULE OF THUMB

When photographing a wedding, always create a photograph to start the album and photograph an end. You are producing a storybook of the wedding day and it needs to read like a book from start to finish.

*Inside the marquee, the couple appear to
be walking off into the distance. This is just
the kind of image that can finish an album.
Nikon DSLR, 28–80mm lens, 1/125sec at f/5.6*

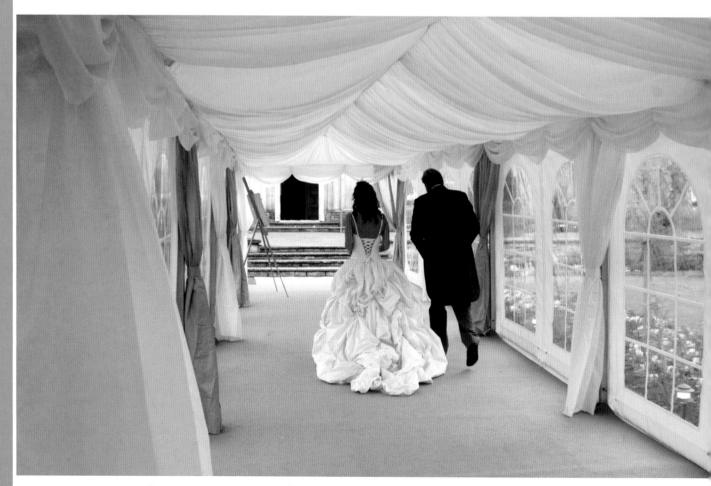

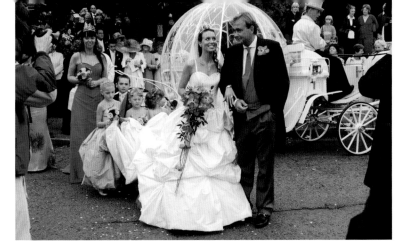

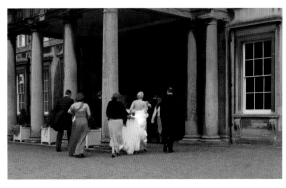

Back views are not to be missed and can be made more interesting by including the architecture.
Nikon DSLR, 24–120mm lens, 1/125sec at f/8

The same village wedding as on page 67 but this time the viewpoint is the same as the villagers, watching the couple as they emerge from the ceremony.
Nikon DSLR, 28–80mm lens, 1/125sec at f/5.6

This shot was composed to bring into the frame the shop that the bride and her mother own, and the people who had come to see the her arrive at the church in her fine coach with white horses. To complete the composition the expression between mother and daughter had to be captured.
Nikon DSLR, 28–80mm lens, 1/125sec at f/5.6

Part 8:

Group Shots

If there is one single aspect of wedding photography that will invite comment from guests as to what they thought of the photographer, it is the group shots. There are no half measures in these opinions and no middle ground to hide in. Either the photographer was absolutely wonderful or appalling.

A 'girlie' shot of the bride and chief bridesmaid, heads touching, reflects the warmth of their friendship. The green foliage is an ideal background, providing a contrasting colour but no distraction.
Nikon DSLR, 28–80mm lens, 1/250sec at f/8

RULE OF THUMB

Backlighting is our preference for groups. Reflecting the light back towards the faces ensures that the subjects are separated from the background and the faces are beautifully lit. Expressions then become vital. A little chatter with the subjects before taking the photograph helps these. When using a digital SLR, do not keep the camera towards your face when you speak as eye contact is important.

A group of three makes a pleasing, balanced pose. The bridesmaids are asked to lean in slightly towards the bride to form a triangle shape.
Nikon DSLR, 28–80mm lens, 1/125sec at f/8

The length of time taken over these images and the degree of creativity displayed by the photographer can make or break reputations. Prospective clients will study the display albums for evidence of regimented rows of relatives standing before the camera with fixed grins of the type that show a distinct cheek wobble on the video footage. They will be looking for elderly relatives who are propped up by burly grandsons for the sake of the family portrait and a hurried technique on the part of the photographer, no doubt borne out of his fear that his subjects are losing patience.

How we all hate it – the bride, groom, photographer and guests alike. Stilted group shots are anathema to the wedding story and contemporary wedding photography. We all hear the same thing from our first meeting with prospective clients, 'We don't want a lot of formal group photographs.' Our response is, that's great, because we don't do a lot formal photography, we do some. So let's look at another approach, let's make the experience fun. After all, that's what a wedding should be remembered for, as a joyous, happy and fun occasion for all involved. Let's truly reflect that memory in the wedding album.

There is no doubt that if the process is enjoyable for the group, the whole mood will be relaxed and creativity will flow.

Our advice is to take these portraits half-length as it helps give the feeling of intimacy and avoids the awkwardness people sometimes have with their hands. Asking couples to place their arms around each other at the back will bring them closer naturally.
Nikon DSLR, 28–80mm lens, 1/125sec at f/8

● GROUP SHOT CONSIDERATIONS

Trust in the photographer is the catalyst for successful group photographs. That trust is gained from a confident and sound technical approach combined with refined people skills. Diplomatic handling of people is essential, as is clear guidance when arranging poses. It is the photographer's responsibility to guide, direct and make the right decisions instantly. Any display of indecision or weakness will be exploited greedily by the group and the situation will deteriorate.

People in an unfamiliar environment often look for direction and are lead by example. The photographer should exploit this to take control. If he appears to be confident and capable and is able to communicate effectively with the group, he will easily capture their attention. The aim is to ensure that all eyes are open and everyone has a natural-looking, happy expression on their face. You can make the groups intimate by bringing the heads closer together, especially on the 'girlie' shots of the bride and bridesmaids.

When there are adults and children in the same group, the heads are brought down to the same level as the children, otherwise the composition looks unbalanced. Cropping tightly on heads and shoulders also conveys intimacy. There are many other photographs taken during the day that will show their outfits full-length.

Take care over the choice of location for the group shots. It is important for this style of photography to have a background without any unwanted intrusions. Nor do you want to include a bland, featureless sky as that is also distracting and destroys the sense of intimacy and upbeat mood of the image.

Rather than lining them all up like soldiers, it is preferable to photograph the bridal party doing some kind of action. This gives the impression of a 'team', which is exactly what the bridal party are. A simple technique is to ask them to link arms and walk as a group away from the camera to a pre-determined point, wheel round and walk back without breaking formation. Before they set off, ask them to decide in which direction they will wheel around. The 'wheel' always creates good humour and exuberance amongst the group and this results in pleasing expressions. It is a straightforward task to set up this kind of shot, but is always fun and nearly always a winner. It is an album shot that will be enjoyed for many years ahead; a reminder of a happy group of young people with their whole lives and the world before them.

We think of our style for groups as cuddly, warm and friendly. The bride and groom will have selected close family and friends to make up the bridal party and we want to emphasize this relationship between them. As children were involved here, the adults were asked to get down to their level to achieve a balanced composition.
Nikon DSLR, 28–80mm lens, 1/250sec at f/8

Communication is the key to getting lively, happy expressions. Chat to your subjects, make them laugh and then press the shutter when you have caught the moment.
Nikon DSLR, 28–80mm lens, 1/250sec af f/8

Walking shots with the bridal party will reward you with natural expressions and a relaxed group.
Nikon DSLR, 28–80mm lens, 1/125sec at f/8

Always make sure the bride is in a prominent position in the group, never on the outside. The flowers here signify her role and also add interest to this part of the frame.
Nikon DSLR, 28–80mm lens, 1/250sec at f/5.6

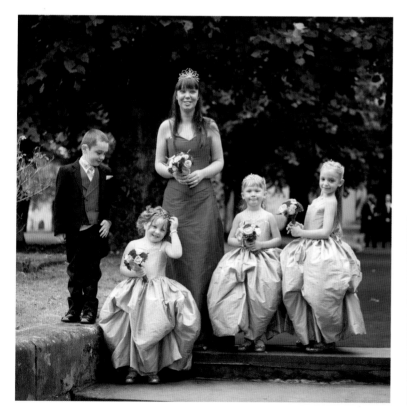

Bridesmaids and a pageboy waiting for the bride. Make use of any steps to create a pleasing composition.
Nikon DSLR, 28–80mm lens, 1/125sec at f/8

For a shot with the parents, place the couple in the middle with mother and father either side. The bride and groom should always be together in the most prominent position.
Nikon DSLR, 28–80mm lens, 1/250sec at f/8

• MANAGING GROUPS

Another option to use for fairly large groups is to arrange them into a tightly packed bunch. The bride and groom face each other with the ushers and bridesmaids arranged around them. The idea is that the photographer shoots from directly above the group, filling the frame with them as they lean outwards. It gives an interesting composition, almost flower-like in shape and, best of all, it's again fun for those participating.

There are times when a more formal group shot of the bridal party is appropriate. In this case, place everyone close to each other and go for a three-quarter-length composition in a panoramic format. The aim is to give the group an intimate feel. The bridal party usually consists of long-standing close friends and siblings of the couple, so this approach is appropriate.

Try to arrange a group photograph of all the guests. You can select a suitable location for this at the pre-wedding meeting with the couple at the venue. Look for a high vantage point, from which you can take the shot, above a space large enough to arrange the group without unwanted intrusions or distracting elements. First- or second-floor windows and balconies are ideal for this. A viewpoint with an acute downwards angle is ideal as everyone in the group will need to look upwards to the camera. Faces are not hidden by hat-brims and tall people do not obscure short people as they would if the group was photographed from a lower level. Ideally the sun should provide backlighting.

You can make use of the ushers to gather everyone together for the photograph. The manoeuvring of a large number of people into a pleasing composition needs to be done quickly and efficiently so that everyone's attention is maintained.

Take too long in setting the shot up, and the mood amongst the guests will change, with their irritation obvious on the photograph. When one of us is composing and taking the shot from above, the other is organizing on the ground. At the last moment, we bring the bride and groom forwards by a couple of paces so they are prominent in the composition. A witty comment directed at the crowd will capture their attention and the photograph is taken. This is the last shot we take of the groups. It means that we only move the guests once, immediately before they are asked to be seated for the meal and the day can then flow without disruption.

The group shot of everyone is what many guests will remember the photographer for at the wedding. It is the only point during the day in which everyone is involved at the same time. It has to be done efficiently and on time. Future business generated from recommendations by the venue management and guests alike will depend on the impression that you leave with these people.

A different angle of a group of guys in kilts, this time running away from the camera. Strong sunlight has created shadows on the ground, which add to the composition.
Nikon DSLR, 28–80mm lens, 1/250sec at f/8

Sometimes a more formal group line-up is appropriate and a panoramic format suits the half-length composition. To set up a shot like this, put the bride and groom in the position you want them in and then add the bridal party on either side, turning each member towards the couple. This results in natural-looking body language.
Nikon DSLR, 12–24mm lens, 1/125sec at f/8

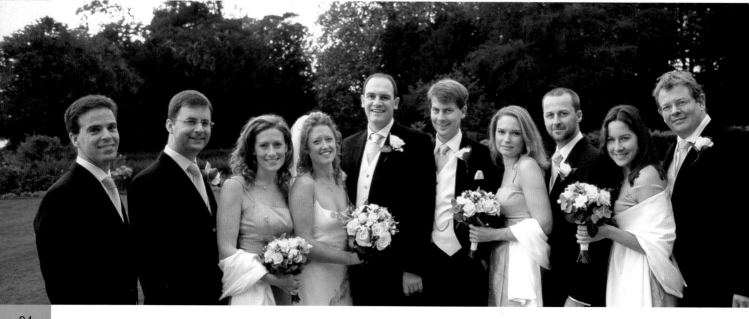

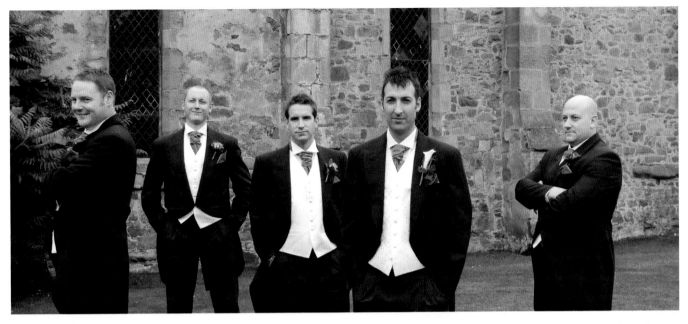

The guys always love to pose like this – they look powerful and strong. Separate them out about a metre apart so that you can clearly see each individual pose.
Nikon DSLR, 12–24mm lens,
1/125sec at f/8

These two shots were a case of using long lenses and waiting for the right moment. Do not be tempted to overshoot as you will only lose the crucial shot.
Nikon DSLR, 200mm lens, 1/250sec at f/8

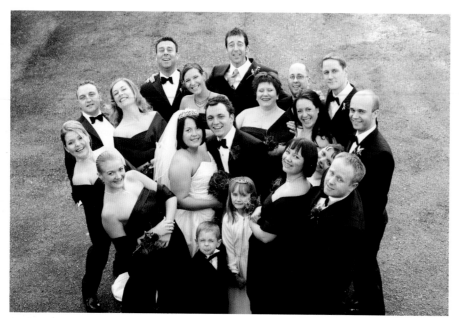

This 'petal' photograph was taken using a high vantage point. Asking the bridal party to lean back slightly has opened up the group shot. Always be aware of little children and the expressions they pull.
Nikon DSLR, 17–55mm lens, 1/60 sec at f/8

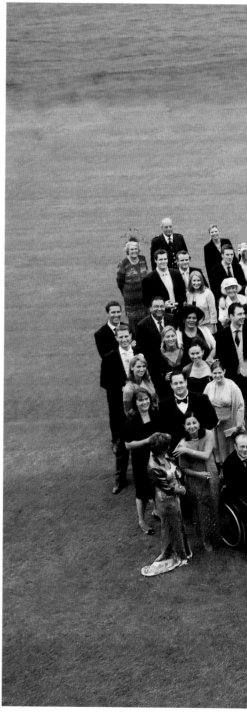

There are approximately 250 people in this shot. Communication is the key to get everyone's attention but there will always be a couple of people at the back, busy talking. Make sure that the key members of the wedding are placed towards the front and that the expressions on these faces are good before you take the picture. This is where refined people-skills are paramount. You have to be able to persuade people to allow you to arrange them as you want and listen to instructions. Be aware of the needs of disabled guests. Always bring those in wheelchairs to the front of the group.
Nikon DSLR, 12–24mm lens, 1/125sec at f/11

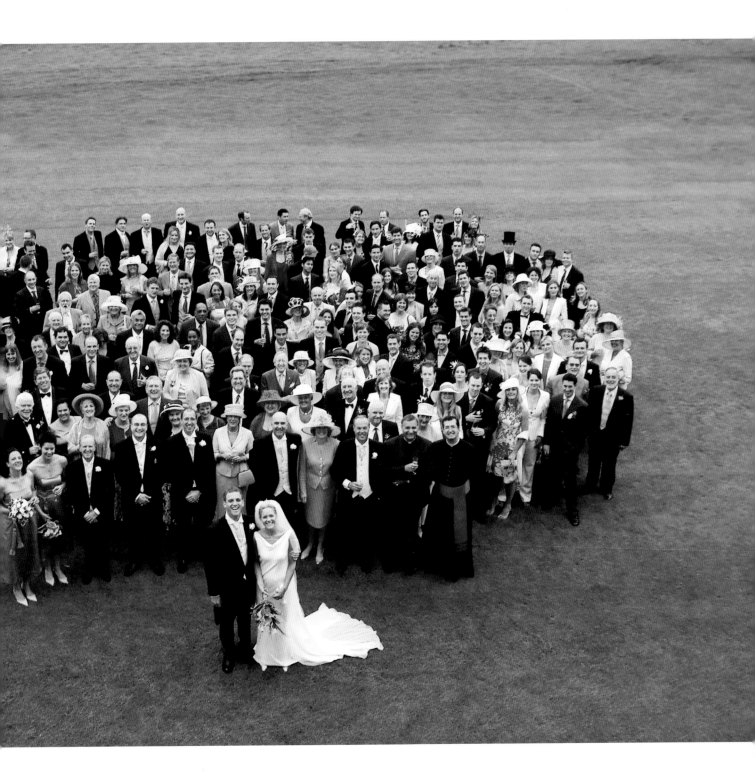

The Bride and Groom Leaving

After the ceremony, the outpouring of noise and emotion eventually subsides to conversation level as the time for the couple to depart for the reception draws closer. This is one of those stages of the wedding that generally seems to take its own course without the intervention of either an organizer or photographer. You will have spent the last 15 minutes or so taking reportage pictures and you can now prepare for the couple's exit in the car or carriage, the photography en route and the arrival at the reception.

Ready to leave in the coach. The image was composed with the bride placed according to the rule of thirds.
Nikon DSLR, 28–80mm lens, 1/125sec at f/8

First, though, comes the confetti ritual. Not too long ago, it would have been the photographer's role to organize the guests into two parallel lines, between which the bride and groom would run the gauntlet of confetti-throwing guests. No doubt there are still photographers who are only too willing to set this up, secure in the knowledge that they will get this shot in the bag.

However, this approach has its drawbacks. The couple run towards the camera as they are being showered with confetti, with their shoulders hunched, heads down and looking at their feet. It will make a passable image for the album, but one that is quickly skipped over. Clichés and the contemporary are not a comfortable combination. We prefer to let events flow. The guests will throw their confetti when they are ready and that will make the images much more believable than if they are told to do so on the count of three by the photographer.

This VW Beetle was hired as a wedding car; the couple drove it to the reception. The bride's pose in front of the car gives the whole image a strong composition.
Nikon DSLR, 28–80mm lens, 1/125sec at f/8

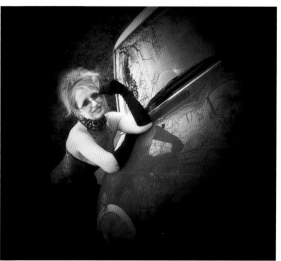

Using the mini as a prop has added drama to this shot. The image has been toned red with a heavy vignette to draw the eye to her face.
Nikon DSLR, 28–80mm lens, 1/60sec at f/5.6

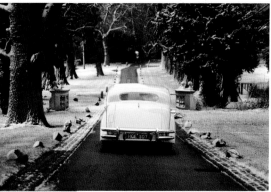

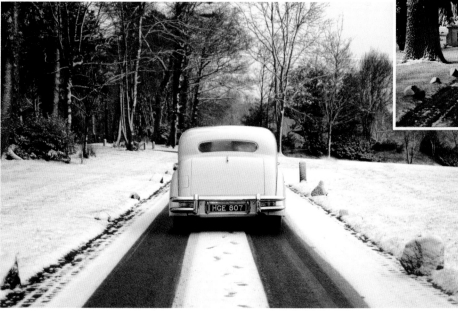

To continue with the story through the album it is important to establish the link with the image of the couple leaving the ceremony. Try and leave the wedding ceremony at the same time as the couple and stay close behind so you can photograph them in the car. These images were taken through the windscreen of our vehicle as we followed the couple to the reception.
Nikon DSLR, 28-80mm lens, 1/125sec at f/5.6

● SHOOTING CONFETTI

The couple surrounded by the crowd throwing their confetti makes a much more pleasing image than a staged line-up and has a natural, documentary feel to it. However, many guests do need guidance on how and when to throw the confetti. They need to be in a position so that the confetti falls onto the couple and is not blown back onto themselves by the breeze. Ask a nominated usher to advise them on this rather than interfering yourself.

Our own position is important, too. A high vantage point will create a good perspective for a wide-angle lens. If that is not possible, then a monopod is useful for taking overhead shots with a wide-angle or fisheye lens attached to the camera. It seems to be Murphy's Law that the best ever confetti image that you ever took is spoilt by the largest piece landing on the bride's nose as the shutter was pressed. Worse still there is a ball of confetti that has been turned practically solid by an excited flower girl who has held it tightly for too long and it has obscured the groom's face. But that is reportage. By it's nature, control is not an option. Confetti is indiscriminate and such images will raise a chuckle at the first viewing, even if they are ultimately not used in the album portfolio.

Using spot colour on confetti images in the wedding album is a technique that is almost as old as photography itself, but it remains popular. The days of hand colouring black and white prints are gone, but the digital method is much easier to achieve and less messy. Of course, it is possible to buy software that will create this and other effects for you. Rather than risk too many similarities between confetti shots, we only ever work with the material that we actually took at the time.

Small apertures and quick shutter speeds will result in capturing the moment the confetti is thrown. Do not try to set up this but gently inform the groomsmen to guide the guests to the area where confetti throwing will be permitted. Put a mid-range lens on the camera and then wait for the decisive moment.
Nikon DSLR, 28–80mm lens, 1/250sec at f/8

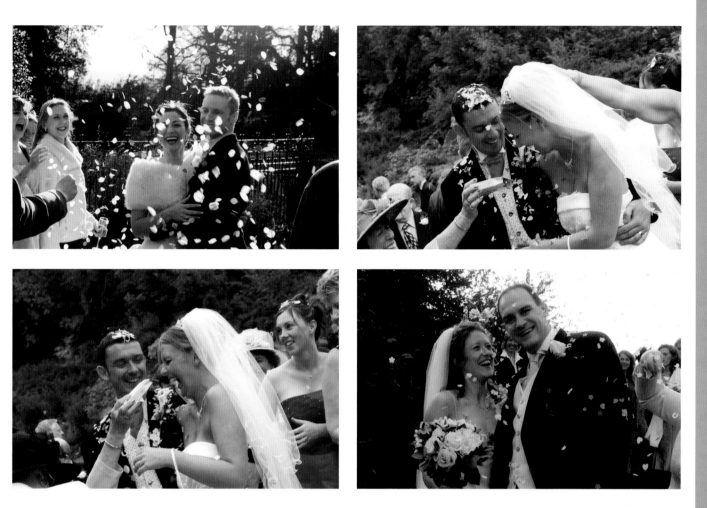

Reportage-type shots of confetti-throwing capture the fun, spontaneous element of it. The guests may have been primed for the moment but it still comes as something of a surprise to the bride and groom.
Nikon DSLR, 28–80mm lens, 1/250sec at f/8

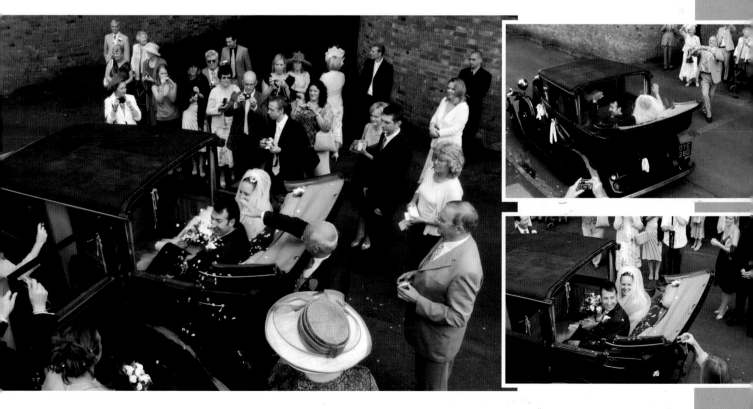

Choose a high vantage point to give an overview.
Nikon DSLR, 12–24mm lens, 1/250sec at f/8

● *THE CAR*

Many couples will have hired a car or carriage to take them from the wedding venue to the reception. Be sure to include it in the reportage content as well as the set-up shots as it will have been a significant part of their wedding plans.

As soon as the couple have taken their seats in the vehicle, opportunities arise. Whichever one of us has the most suitable lens on the camera will take a couple of shots inside the car or through the window and then pull back while the other takes some overview images of the couple being photographed and waved off by their guests.

Sometimes you will have found a great location en route to the wedding to take some more creative, posed shots of the couple with the vehicle. Otherwise, do these as soon as they arrive at the reception. Either way, you can arrange with the chauffeur to position the car as you want it. Classic or unusual cars make great props for a romantic style of portrait, adding to the fantasy element of the whole day. Ideally the background, whether beautiful architecture or countryside, will complement this, too. Choose your angles carefully, including the ribbon, any flowers and the grille of the car, if it is elaborate, in the composition. Try out different viewpoints, below and above, rather than shooting every picture at eye level.

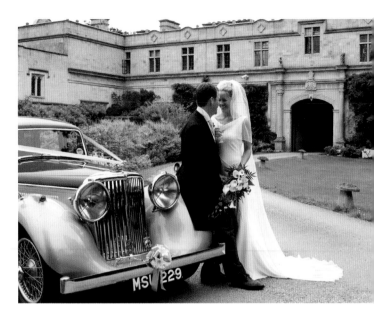

A more traditional photograph of the couple with the car, except that we waited for the expressions on their faces to come naturally, rather than have them posing towards the camera.
Nikon DSLR, 12–24mm lens, 1/125sec at f/8

You can be a little adventurous with these images. Turn the camera, work with the diagonals and encourage an interaction between the couple and the camera to give a lively quality to the photographs.
Nikon DSLR, 28–80mm lens, 1/125sec at f/8

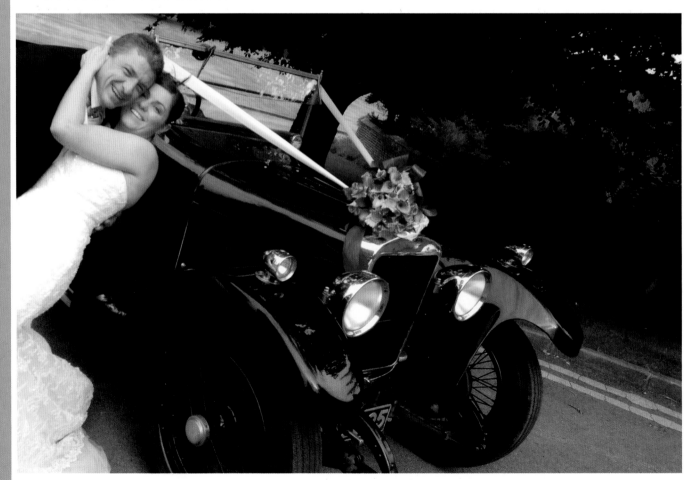

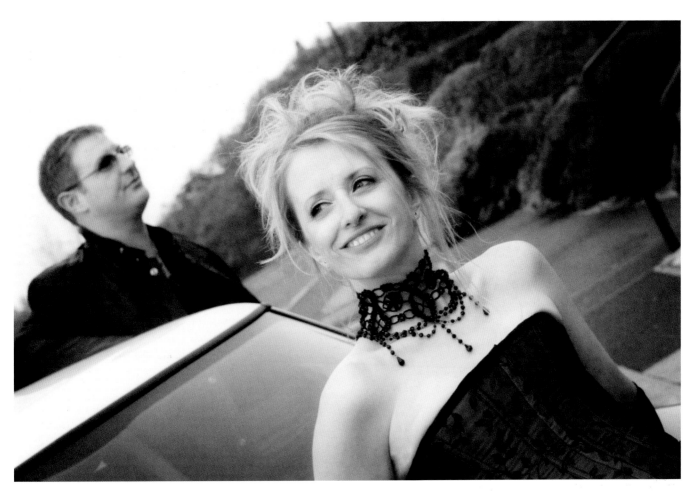

A differential focus effect using the couple's own vehicle. Posing the couple in this way has placed the bride in sharp focus with the groom slightly out of focus in the background.
Nikon DSLR, 28-80mm lens, 1/60 sec at f/5.6

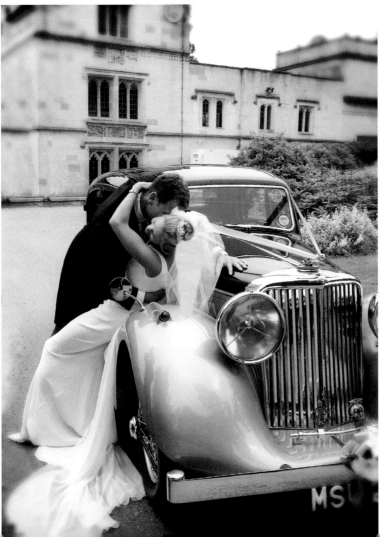

Use the car as a prop for the couple to give a sense of romance. It is far more meaningful than the traditional posed photograph of the couple standing full length next to the car.
Nikon DSLR, 28–80mm lens, 1/125sec at f/8

The Reception

The arrival of the bride and groom at the reception venue takes us into the next phase of the wedding day. The venue manager will be waiting to greet the couple, usually with champagne, and we suggest you photograph in reportage style. There is a more creative shot to be taken, too. The couple are placed together, champagne in hand, with the tray of filled glasses in the foreground. The aperture is set to its widest, ideally f/2.8, and there is a good differential focus image of the tray rendered sharp, with the couple slightly blurred in the background.

'The bride and groom have spent a lot of time and energy on their wedding details and it is your job to capture them for the album.'

The inside of a marquee can look great in natural light, with soft shadows falling on the fabric of curtains and table linen.
Nikon DSLR, 12–24mm lens, 1/60sec at f/5.6

As the guests arrive, they will be greeted with canapés and champagne. We suggest you do not photograph people eating, but there is scope for reportage and detail shots. Close-ups of a tray of glasses or canapés serve as background ghost images in magazine albums.

While the guests are preoccupied with food and drink, take the opportunity to take interior detail shots of the marquee or dining room. A wide-angle lens, or even a fisheye, is useful for overview shots. The room will look its best at this point, before the most inquisitive guests begin exploring the venue.

We use a 55mm macro lens for the close detail shots of the cake decorations and place settings. The menus, table centrepieces and flowers are also photographed as they often have great importance for the couple, especially if they have been handmade. There are also marketing opportunities for us here, by taking pictures for various suppliers.

Photographs of the decorations, flowers and table settings are a priority at the reception venue. Before long, guests begin wandering in and catering staff get busy.
Nikon DSLR, 28–80mm lens, 1/60sec at f/2.8–f/5.6

A photograph of the outside of the marquee is really a record shot to capture the location and setting of the reception.
Nikon DSLR and tripod, 12–24mm lens, 1/15sec at f/5.6

• *RECEPTION CONSIDERATIONS*

The schedule of photography that was prearranged with the couple at the final meeting takes on even greater importance at the reception to ensure the continued smooth running of the day. We liaise with the venue manager to establish that their timings and ours concur. It is our golden rule that we conclude all formal photography at least 10 minutes before the receiving line begins and under no circumstances do we ever run over our scheduled time for the end of photography.

All of the suppliers have a responsibility for the seamless flow of the day's events and a policy of co-operation and awareness of the needs of the venue and caterers has always been high priority for us. This has had positive benefits in the willingness of venues to recommend us as preferred photographers. The importance of this source of business cannot be overstated.

The wedding story continues through reportage images of the guests and the couple enjoying each other's company, taking care to include overview shots that show the venue and location. After a suitable time, begin the formal, family group photographs, unless these were scheduled earlier where the ceremony took place. Around 15 minutes is usually ample time to complete these group shots (see pages 80–87) and the family members are then free to continue to mix with the other guests.

Try to leave the couple to mingle for a while at this point. It is important, both for them and for you, that there are occasional breaks while they do this. If they are seen to be happy and relaxed, then their mood permeates through the entire wedding. This will reflect on the photographer who is unobtrusive and can be recommended. It often happens that some guests at a wedding are also making plans for their own wedding day and will be taking careful note of how you work. Many of our own bookings are secured this way. This break is also an important opportunity for you to step back and look around. You will need the time and space to be able to capture those all-important documentary shots.

RULE OF THUMB

Depending upon their religion or denomination, we suggest you advise your couples to allow two and a half to three hours from the start of the ceremony to when everyone is seated for the meal. Emphasize that this time is not for photography, but for the couple to have the time to absorb and enjoy their day and to be able to mix with their guests. After all the months of planning and anticipation, there is a very real danger that the reception will seem to pass rapidly. If everyone is relaxed and the event is without stress, then good images are much easier to obtain.

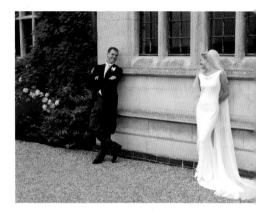

Although the couple are separate in this photograph they are connecting with each other through their body language. The architecture of the building adds to the composition. Work with your surroundings and use the venue as a record for the couple.
Nikon DSLR, 28–80mm lens, 1/125sec at f/8

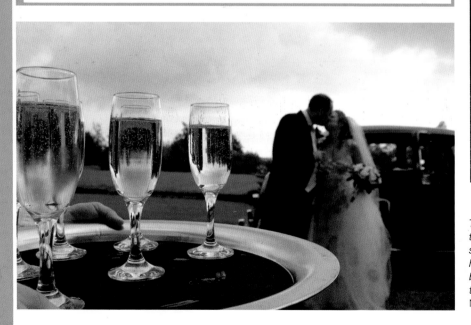

The couple have arrived at the ceremony and the drinks tray awaits them. Position yourself so that you can focus on the glasses and also have the couple in the shot but out of focus by using a wide aperture. Instruct the couple to kiss – they are always pleased to oblige!
Nikon DSLR, 28–80mm lens, 1/250sec at f/2.8

Our planned schedule resumes with some informal shots of the couple with the bridal party and then we ask the others to leave us so that we can have 15 to 20 minutes alone with the couple in the grounds of the venue. We do not allow any guests to be present at this time. This is when we create the editorial, stylized images for which we are well known. We use these in our advertising and publicity and that is what will have attracted the clients to us in the first place. It would be impossible to create artistic and intimate images with guests present, so at the very first meeting we make our couples aware of the need for us be alone with them for this short period. It is our chance to make a fuss of them and they always appreciate it. It allows them to take a break away from the event and catch their breath. Once we are happy that all the required images have been taken, they are asked to make their way back to the dining room. They walk ahead, we follow, and there is usually a final shot to be taken then.

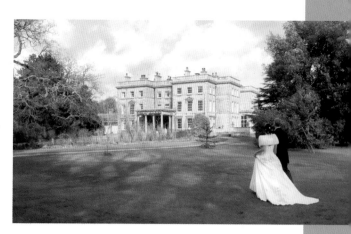

When you have finished photographing the couple, ask them to walk slowly away from the camera towards the reception venue. You will have an image that will end the storybook and place them in the location of their wedding.
Nikon DSLR, 28–80mm lens, 1/125sec at f/8

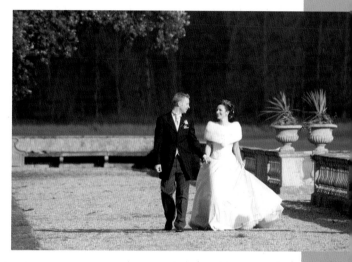

You do not always have to show the couple in a loving embrace, just connecting to each other by chatting is enough.
Nikon DSLR, 200mm lens, 1/250sec at f/8

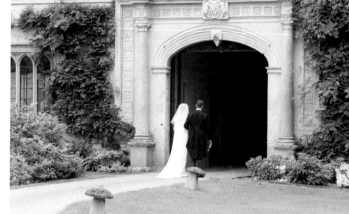

A flowing veil is always a great shot to capture. If you are working alone, get a groomsman or willing guest to help you. Position the couple, ask them to hold the pose and get the veil to be lifted and dropped. At the same time tell the person helping you to run like mad away out of the shot. You have only got a split second to capture the image and it may take a couple of attempts but the rewards are well worth it. The couple will love the result and you will have a sense of satisfaction from the perfect timing of a great shot for their album.
Nikon DSLR, 28–80mm, 1/60sec at f/5.6

Even though this is your private time with them, allow the couple some space. This is a good shot for the end of the album. Find locations like this well in advance.
Nikon DSLR, 12–24mm lens, 1/250sec at f/8

● INTERIOR RECEPTION SHOTS

When your time outside with the couple is over, head to the dining room to take shots of them with the cake. Our preferred method is to create a differential focus effect using the 28–80mm zoom lens set to its widest aperture of f/2.8 (see image top right). The focus will be on the cake, offset to one side of the composition, with the couple de-focused several meters behind. Invariably, there will be soft tungsten or incandescent lighting that will create a warm, rich mood to the image, without recourse to flash. When you have the shots, ask the couple to re-join their guests.

Finish by taking any further detail shots that could be used in the portfolio and this is when we make a quick edit of the files. By now we are about 15 minutes from the time for the receiving line to be called. While our basic wedding photography package finishes at the point where the couple enter the dining room to be greeted by their guests, our clients are offered the option of extending the coverage for additional photography during the evening celebrations. If they choose this, it will begin with the after-dinner speeches. In addition to the extra fixed cost that evening coverage will incur, we request a cooked meal and refreshments while the guests are eating.

Traditionally, the bride's father will be called upon to give the opening speech. This is when we are sometimes forced into using on-camera flash. Light levels are often insufficient to photograph the speeches by available light but units such as Nikon Speedlights are powerful enough to bounce flash off the ceilings to give more even lighting. Direct flash will produce harsh shadows and even redeye in dimly lit venues and should be avoided.

One of us will work with the 70–200mm lens and concentrate on the speaker while the other uses a shorter zoom, typically the 28–80mm, to take shots of the guests as they react to the comments made in the speeches. We are looking to capture the amusement in the guests' responses, which a good speech will provoke. Often there are also moments of great emotion during the speeches and you need to be vigilant for these. They may come as the bride's father is talking about his daughter, in which case, keep an eye on the mother and the bride herself – there will be damp eyes and tears wiped away. Or they may come from the groom, as his pride in his new wife overspills into emotion. Be ready, this is what the couple will treasure in their wedding album.

Not all wedding photographs should be full-on happy, smiling faces. The day is a roller-coaster ride of emotions for the couple and family. Record these for posterity.
Nikon DSLR, 28–80mm lens, 1/60sec at f/5.6

Placing the couple by the window allows the available light to lift them. Without it, they would have blended in with the shadows. A tripod was required for this slow-exposure shot and the widest angle of the lens was used to include table settings.
Nikon DSLR, 28–70mm lens, 1/30sec at f/5.6

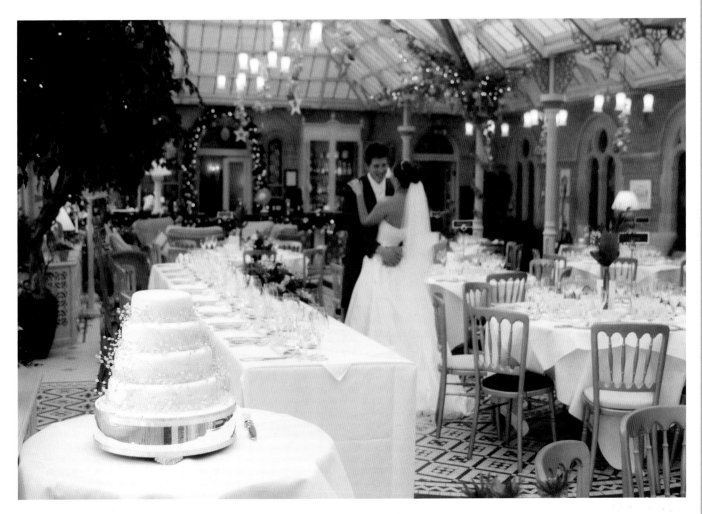

Creative use of depth of field enhances images here. The cake is in sharp focus while the room is defocused.
Nikon DSLR, 28–80mm lens, 1/60sec at f/2.8

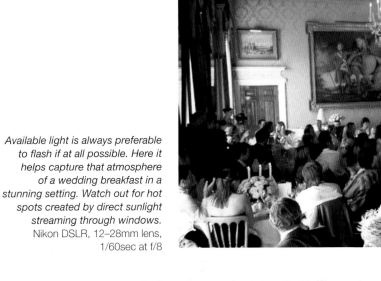

Available light is always preferable to flash if at all possible. Here it helps capture that atmosphere of a wedding breakfast in a stunning setting. Watch out for hot spots created by direct sunlight streaming through windows.
Nikon DSLR, 12–28mm lens, 1/60sec at f/8

Brides sometimes make a speech. Capture the varying emotions of the bride's parents and the groom.
Nikon DSLR, 70–200mm lens,
1/30sec at f/5.6 with flash

RULE OF THUMB

If you mount your camera on a monopod, this will steady it enough to enable you to set the shutter speed to 1/30sec, while using flash. This will allow some of the ambient light to record in the image and retain a more natural atmosphere. Monopods are an asset when you are working in and around the tables and guests. A tripod is not a good idea as it can trip up the waiters and guests.

Often during the speeches, the bride's father pays tribute to his daughter. Wait for the emotion to show on her face and then take the shot.
Nikon DSLR, 80–200mm lens,
1/60sec at f/5.6 with monopod and flash

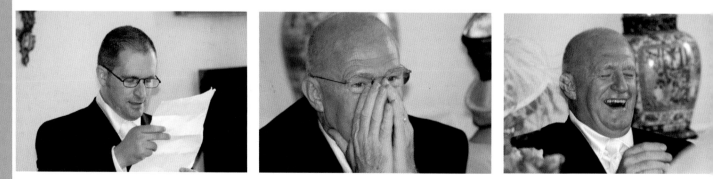

When the speeches take place, tune in to what the groom or best man is saying and wait for the expression to happen. There are only so many speech photographs you can include on one page in an album and you will need each image to be strong enough to either stand alone or work in a sequence. Flash will be required to enhance the lighting. Watch for shadows created by this and, where possible, use a diffuser over the end of the flash. This softens the light and takes away the harsh shadows.
Nikon DSLR, 28–80mm lens, 1/60sec at f/5.6

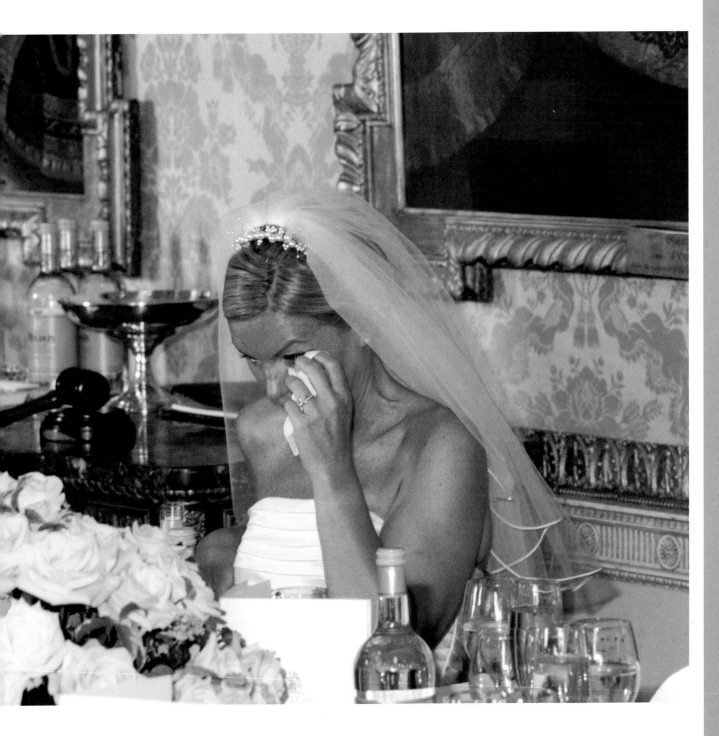

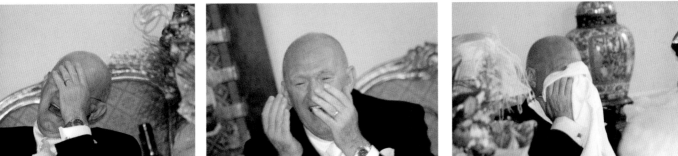

Cake and Party Time

After the speeches and toasts, the couple will be called upon to cut the wedding cake. Many photographers will take the standard 'grip and grin' shot of the couple holding the knife and looking towards the camera. We would rather photograph the couple holding the knife and looking at the cake. We have never felt that it would be normal for two people to hold a potentially lethal weapon and not actually look at what they are attempting to slice. While one of us takes this shot, the other concentrates on a close up of the couple's hands holding the knife as the cake is cut. This gives us two different perspectives on the same theme, without having to set up another shot.

When photographing the cutting of the cake, it looks more believable if the couple are looking at what they are doing, rather than at the camera.
Nikon DSLR, 28–80mm lens, 1/60sec at f/3.5

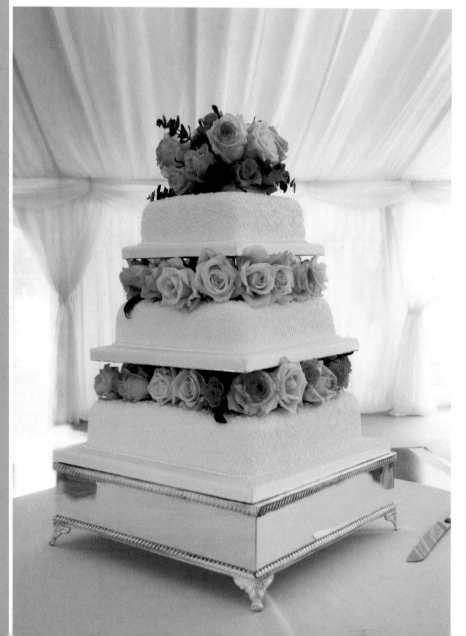

The cutting of the cake usually signals a quieter period for the guests and the photographers until the final phase of the celebrations begin. This consists of the first dance, the band or disco and sometimes a fireworks display. Before the couple are called upon for their first dance, talk to them to find out how they will approach it. Some couples will have gone to great lengths to perfect their ballroom technique, others will simply shuffle around to the music, absorbed in each other. Either way, we always suggest that, as a finale, the groom bends over his wife and kisses her neck, while she throws her head back. They should perform this with as much passion and exaggerated mannerism as they can muster. It will take the assembled guests by surprise and is their cue for spontaneous applause, once again leading to a believable image.

Available light in a marquee is great as it acts as a giant diffuser and softens the light. If you use flash on a cake, you not only lose detail but the harsh light flattens the image and blows away its warmth.
Nikon DSLR, 28–80mm lens, 1/60sec at f/5.6

• LIGHTING

There are only two light sources that we use for the first dance shots, one is the lighting that is provided by the band or the disco, the other is a simple battery powered 35-watt video light. Flash would completely kill the atmosphere of the dance images by 'freezing' the couple and most likely rendering the background completely black. Our way is to use one camera mounted on a tripod with a 12–24mm wide-angle lens fully open at f/2.8, setting the ISO speed to 800. This is positioned in front of the stage or disco so that the watching guests are in the frame. This is the camera that will be used to capture the 'finale' shot of the dance, as described above. It is important that the reactions of the assembled guests are caught at the point when the groom throws his bride back.

The other camera is hand-held with either a fisheye or 28–80mm lens attached. The object is to record movement in the dance and the vibrant colours of the stage or disco lights, so slow shutter speeds are set. The hand-held video light is sometimes used to create rim lighting and silhouette effects. One of us holds the light trained on the couple and the other photographs from directly opposite, so the couple are in silhouette. For such a small outlay, this simple light can produce stunning effects, especially if the disco has a smoke machine.

A record shot of the chocolate fountain before it gets eaten is always a good idea!
Nikon DSLR, 10.5mm fisheye lens, 1/60sec at f/2.8

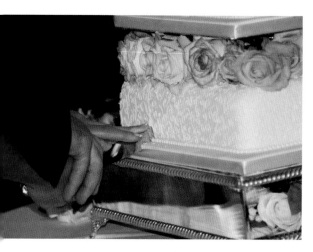

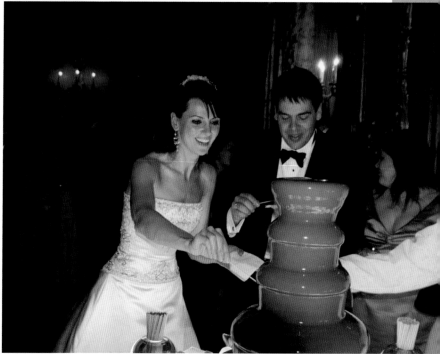

This cake-cutting took place after dark so a flashgun had to be used. Drag the shutter at 1/30sec or less to limit the harsh shadows and hard lighting. The flash will always freeze the moment and the longer shutter speed will let ambient light into the image.
Nikon DSLR, 28–80mm lens, 1/30sec at f/5.6 with flash

Chocolate fountains are now very popular at weddings, replacing the desserts. This is great for photography as the light from the fountain is strong enough to light the subjects' faces. Set the camera's ISO to the higher speed of 800.
Nikon DSLR, 28–80mm lens, 1/60sec at f/2.8

• FIREWORKS

The firework display will signal the end of the formal, planned celebrations. Again, two cameras are better than one for capturing the display. Camera one is positioned directly behind the couple for the perspective of the fireworks exploding above their heads. The second camera, with a wide-angle lens, is used to capture the fireworks alone, as they explode and light up the night's sky.

Photographing fireworks has always been a tricky one – especially as you really don't know where and when they will explode. Ideally you set your camera to manual on the bulb setting, locked open with a cable release, and hold a piece of black card in the other hand. The card is effectively used as a shutter, held in front of the lens when there is no activity, and taken away for each burst of fireworks. Back in the studio, the images are then montaged onto one image to create the atmosphere of the fireworks – which is all you need for the album.

This image was created by montaging several bursts of fireworks. Flash was used to illuminate the couple.
Nikon DSLR, 12–24mm lens, 1/30sec at f/4

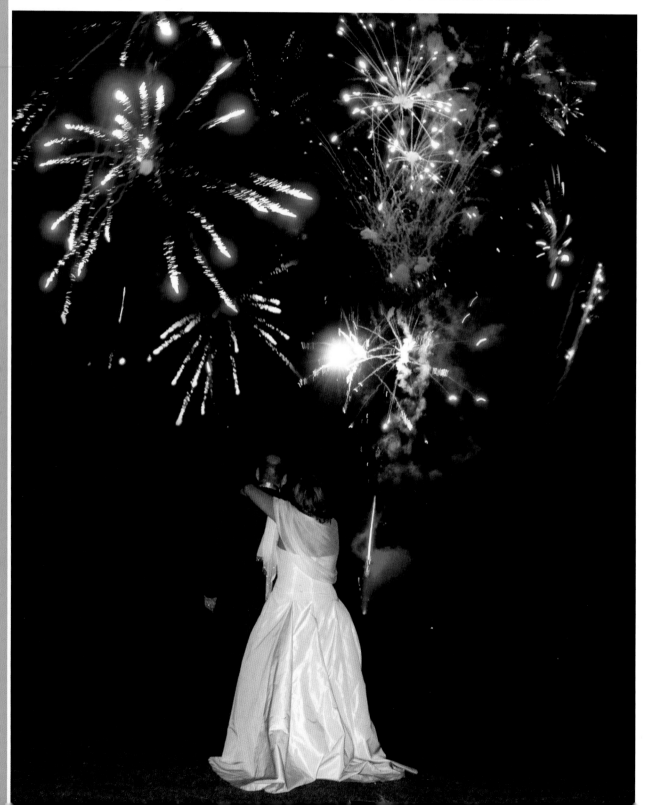

● PARTY TIME

Low camera angles and wide-angle lenses are great for taking in the ambience and the colourful stage lights. High viewpoints are just as effective, especially when guests join the couple on the dance floor. A fisheye or wide-angle lens combined with a slow shutter speed will give a great sense of movement on the dance floor.

Chocolate fountains are now very popular and always keep the guests entertained. Use a wide-angle or fisheye lens from a high viewpoint to photograph the guests milling around it. You can also zoom in close on their faces as they concentrate on soaking up as much of that gorgeous chocolate as they can with their marshmallows. You will almost see their mouths watering in anticipation and the lighting will be colourful and highly atmospheric.

Sometimes you can get away with just the disco lights but a tripod or monopod will be essential. Flash is occasionally useful, though, especially to freeze the movement of a flowing dress. Capture the overall ambience of the dancing, as well as the bride and groom in action. Even a shot of the drum kit can add to the storybook.
Nikon DSLR, 28–80mm lens, various exposures

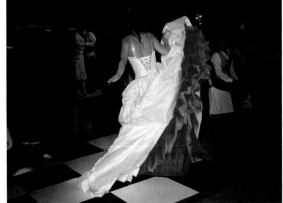

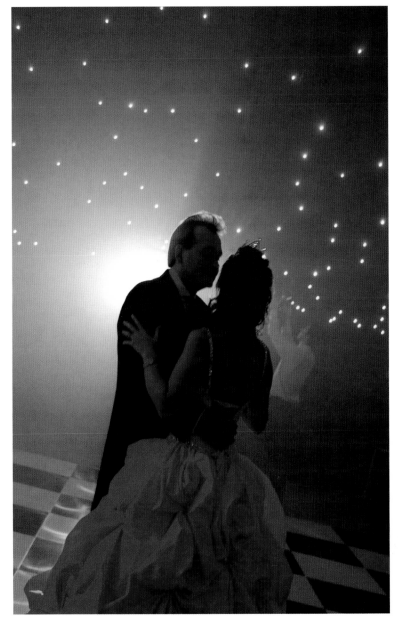

This shot has been enhanced by a small compact video light. It is one of the most useful pieces of equipment that we have. One of us holds the light while the other takes the photograph from the opposite side of the dance floor. This will produce a rim-lighting effect and create a great atmospheric shot.
Nikon DSLR, 17–55mm lens, 1/15sec at f/2.8 with monopod

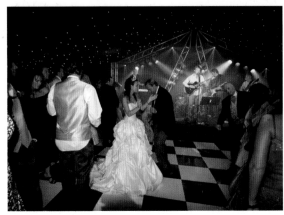

Editing and the Digital Darkroom

The ability to view an image almost immediately, on the back of a camera or on a computer screen, has been like a breath of fresh air – especially in the wedding photography business. Gone are the days when you would have to wait a week for the negatives and prints to come back from the lab. You can now leave a wedding confident in the knowledge that you have all the requested photographs.

One of the downsides to digital photography, however, is that it is very tempting to take many hundreds of images at a wedding, hoping that a percentage will turn out good enough to use in the album. This approach is dangerous as it is very important to maintain a high quality of work throughout the wedding. Digital imaging has not taken away the necessity to learn the craft of taking correctly exposed, well-composed and technically proficient photographs. If you follow this approach, you will not have to spend hours at the computer, sifting through an overload of images and attempting to repair technical defects.

This chapter looks at some basic editing techniques, with advice on storage, presentation and printing. Simple adjustments, such as cropping, balancing contrast, converting to black and white and adding a tone are also covered. With a computer program such as Photoshop and plenty of practice, these procedures will take minutes, or even seconds, and can considerably enhance (not rescue) your images.

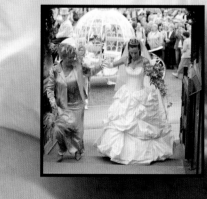

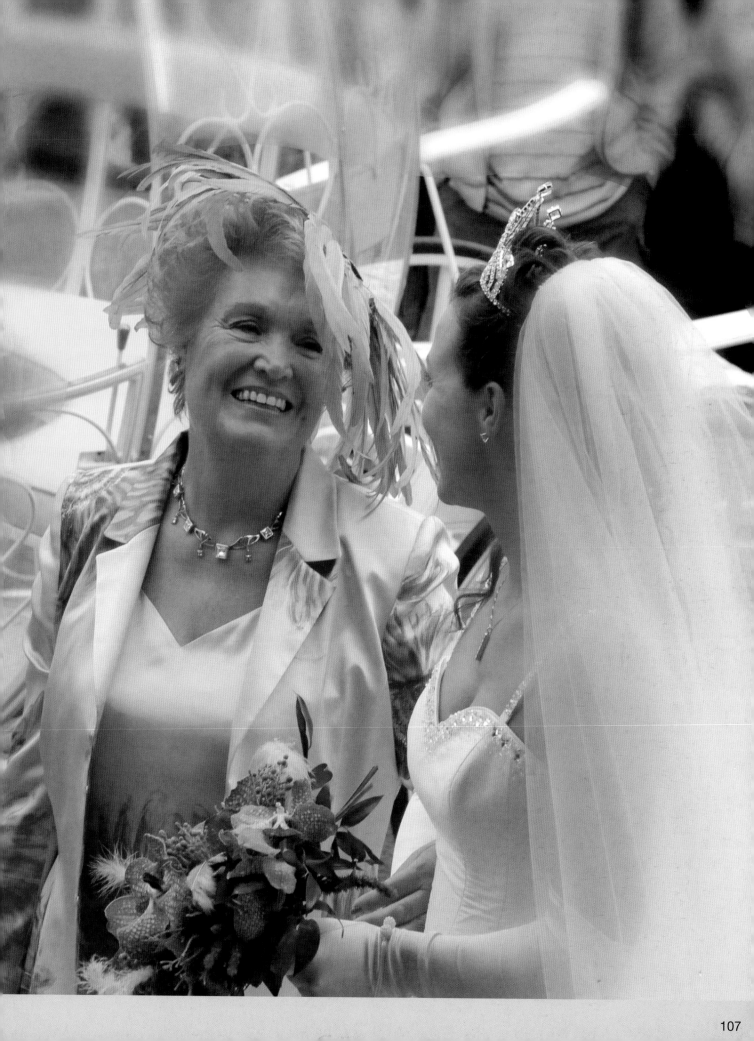

RULE OF THUMB

Work smart. Learn your craft to get the best possible image as you take it, rather than too much time trying to recreate an image on the computer. Remember, an underexposed image will always look underexposed, no matter how many fancy actions are created on the computer.

Editing Your Photographs

During the shoot, it is a good idea to delete and sort images as you go along, using a quiet time to go through the images on the camera. That way, you can ensure you have covered the events of the day as requested by the couple and also see if anything is missing, or if additional photographs are required, say for a magazine-style album.

On return from the wedding, files should be downloaded onto the computer immediately. The images need to be sorted so that any that have been duplicated, show people blinking or with the wrong expression can be deleted. For safety's sake, it is essential that the images are written to two DVDs and stored. The working files can be kept on the server until the job has been completed.

Images need to be edited as quickly as possible, ready for viewing either on the Internet, on a CD-ROM or as hard proofs. Time is at a premium and we try not to spend any longer than 30 seconds per image – our aim is to get the first edit completed and the images online on the Monday after the wedding. This could entail 300–500 images in total. It is therefore vitally important to get the technical aspects of

the photograph right when it is taken, rather than spend valuable time on the computer, correcting individual files.

The first stage of editing, using Photoshop, includes Levels, Curves and cropping. The conversion to black and white of selected shots is also done at this time (see pages 116–117), as well as any toning (see pages 118–119). Once the image has been edited, select a clear crop – no target size or dpi is set at this time. All the tabs are clear (see below).

The next step we take is to make a duplicate copy of all the images and clearly mark the folder with 'copyright'. The images are then batch processed, resized for the Internet and watermarked with our copyright logo. These are then placed on our website ready for viewing, usually one week after the wedding.

An imaging-editing program is essential for post-production work on images. Adobe Photoshop is currently the market leader in the industry.

CROPPING

Cropping an image has the effect of tidying up for viewing. The process should take very little time and effort, but it will remove unwanted details from the photograph and improve the overall presentation.

When taking a photograph, especially in the 35mm format, the image will not always fit the standard photograph size, i.e. 10x8in or 8x6in. Full frame of a 35mm format is 6x4in and 12x8in. To create a standard size of, say 10x8in, you will need to lose two inches of the image in order to complete your customer's order, so you need to keep this in mind at all times. If you have taken the image full frame, a person or object will either be cropped in half, or cropped out altogether. When shooting, always remember to leave space around the subject for cropping.

CROP, STRAIGHTEN OR ROTATE A PHOTOGRAPH

1. Increase the size of the document so that you have some space around the photograph. Position the pointer on the bottom right corner of the document window. When the pointer changes to a double-headed arrow, then drag.

2. Select the Crop tool in the toolbox.

3. In the options bar at the top of the work area, make sure Width, Height and Resolution contain no values. These settings constrain the dimension of the crop rectangle. Click the Clear button to clear them.

4. Drag over the part of the photograph you want to keep. To straighten or rotate the photograph, drag the cropping rectangle over the entire photograph.

If necessary, adjust the cropping rectangle as follows: Drag a corner or side handle. To nudge the cropping rectangle slightly, press an arrow key. To move the cropping rectangle to a new location, place the cursor inside the cropping rectangle and drag it to the new location.

To rotate or straighten the area, move the pointer outside the cropping rectangle (the pointer becomes a curved double arrow) and drag. The cropping rectangle rotates, but the image remains stationary until you crop it. You may need to reposition and resize the selection box.

Note: If the cropping rectangle is hard to adjust because it sticks or seems to jump to set locations, make sure the Snap option on the View menu is not enabled. A check mark indicates the option is on. Choose View > Snap to turn off the option and resolve the problem.

When you are satisfied with the size and location of the cropping rectangle, press enter (Windows) or return (Mac OS) to crop the photograph. If you rotated or straightened the cropping rectangle in the previous step, the photograph will adjust to the angle you selected.

Photoshop can automatically crop and straighten a photograph for you. Chose File > Automate > Crop and Straighten.

Cropping post-production is a quick and easy procedure that can tidy up your composition and give your image more impact. Set up as an 'Action' in Photoshop.

• STORING YOUR PHOTOGRAPHS

Storage of your images must involve a good back-up system. It is advisable to copy and save the work shortly after you return from the wedding, depending whether you prefer to store every image you have taken, or whether you write disks after your first edit.

We will always sift through the shots once they are downloaded, immediately deleting any we consider unusable. All files are then re-numbered and written to DVD. Duplicate disks are also written at this time and clearly marked as 'back-up' and are stored safely with the paperwork. All the paperwork and DVDs are stored in zipped A4 pockets, which will keep everything dust-free and all together.

The images on the computer are then stored onto our server. These will be edited,

resized and prepared for the Internet. Edited files are backed up onto a DVD, which is stored with the others, and the images will remain on our server as working files. Storage on a server, which can be accessed via our Ethernet system, allows easy access to those images for orders that come via the Internet.

At every year-end, the server can be cleared of previous weddings and the files written to a second DVD, which is then stored with the other files. We would recommend that periodically, depending on how long you keep them, you check to make sure that the files can be easily opened and that the disks have not become corrupt in any way.

If you are updating your equipment, it is advisable to make sure that your stored disks can be used on your new equipment.

A personalized CD label is another marketing tool to give to clients.

All images from each wedding should be backed-up onto external hard drives and DVDs. clearly labelled and stored in a dust-free environment. As we only photograph one wedding on any given date, we file our work in date order with the groom's surname.

'Keep up to date with your equipment, but do not forget your old files.'

Presenting clients with their prints in good quality, ready-to-frame mounts will add class and distinction to the product.

• PRESENTATION AND MOUNTING

Just like everything else to do with your business, and even if you are an amateur, the presentation of your photographs should be professional and not shabby or cheap looking. Good-quality images should be displayed in good-quality products. Potential clients will judge your professional standards by the evidence that you show them at the first meeting, be it albums, framed or mounted photographs. Invest money on your finished albums as these are your main advertisement for future work.

For individual print sales, there are a number of options to choose for the presentation. The least expensive is a simple paper folder, with the photograph placed in pre-cut corners. A more expensive choice is a window-cut mount made of stiffer material, which can then be placed straight in a frame.

There is no doubt that the latter is a better product. You or the client can choose from a range of colours to suit the tones in the image, or pick a double mount, say black with white edging on the inside, for added impact. A photograph mounted like this will always look impressive in a frame. It will fit in neatly, without the client having to chop bits off or squeeze edges in. Remember that, once your photograph is hanging on a customer's wall, it is in effect another advertisement for your services. To reinforce your brand and personalize the print, you can sign it in pencil on one corner.

If you have a studio or office where clients are received, you will, of course, want to display your work in frames on the walls. Again, this is not the place for compromising over quality. Make sure the frames have immaculately joined corners that are not jagged or misaligned. Offering ready-made frames, or a framing service to clients is another potential source of profit, especially if you are on good terms with a trusted supplier.

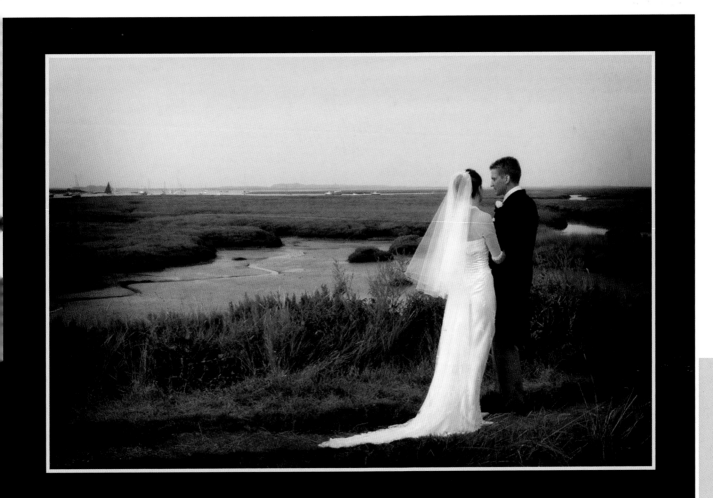

Digital Darkroom

Gone are the days of working in a confined space, in the subdued lighting known as the darkroom. Today our digitial darkroom or 'lightroom' is a far more pleasant working environment. No chemicals and light-sensitive paper to worry about. The only downside is that if you do not learn your craft and get the images correct at the taking stage, you will be penalized by additional work at post-production on your computer.

• READING A HISTOGRAM

A histogram gives a quick picture of the tonal range of the image. If you use a digital SLR, you can use the histogram on the back of your camera to help you analyse the exposure when taking photographs. It is also useful to refer to the histogram when working on your computer. A low-key image has detail concentrated in the shadows; a high-key image has detail concentrated in the highlights and an average-key image has detail concentrated in the mid-tones. An image with a full tonal range has a number of pixels in all areas. The histogram reveals much more information than the human eye can see and learning to read it, both in-camera and on the computer, will help with picture composition and allow you to determine appropriate tonal corrections.

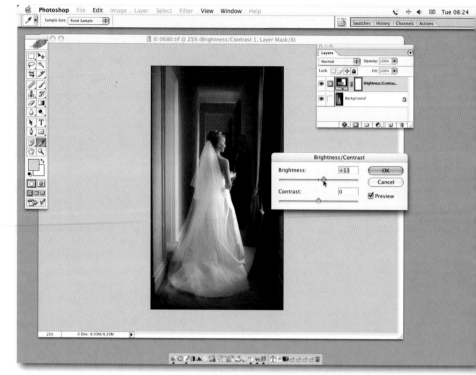

In the Layers palette, select the layer containing the image you want to change. Choose Image >Adjustments > Brightness/Contrast. Arrange the Brightness/Contrast dialog box so that you can see as much of the image as possible. In the dialog box, make sure that the Preview box is selected. Drag the Contrast slider to the right to increase contrast. Drag the Brightness slider to the right to increase brightness. When you are satisfied with the adjustment, click OK.

This shot is overexposed, as you can see from the histogram.

This is a properly exposed photograph with full tonality.

This is underexposed, with the dark tones bunched up on the left of the histogram.

• LEVELS, BRIGHTNESS AND CONTRAST

The Levels dialog box displays the tonal range of the image. The sliders are easily moved to just inside the histogram limits. This is the first adjustment to an image and it is quick and easy to perform. It is more acceptable to lose detail or tonal separation in the shadow areas than it is in the highlights. Once a digital file has lost highlight detail, you are unable to put it back; digital files are similar to transparency film.

To add contrast to an image, you use the Brightness/Contrast command. This lets you increase the difference between the dark and the bright areas of a photograph, which in turn lets you see more detail and often makes the photograph more realistic.

RULE OF THUMB

Making all the contrast adjustments on an Adjustment Layer, rather than directly onto the image, allows you to experiment with the image without altering its actual pixels. Because the settings are on a separate layer, you can view the image with and without the changes by clicking the Adjustment Layer's icon. To adjust the contrast on a separate layer, choose Layer > New Adjustment > Layer > Brightness/Contrast.

ADDING A VIGNETTE

To give an image depth and a quality professional look, a very simple vignette is all that you need. Be careful not to overdo it.

1. Open your image.

2. Select your square Marquee tool and make a selection around the edge of your image.

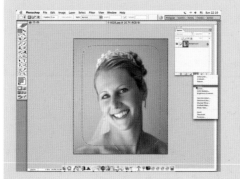

3. Select > Feather >. Type in 200 pixels.

4. Select > Inverse.

5. Select > Layers Palette > Levels. Adjust the levels to darken the vignette to your personal taste.

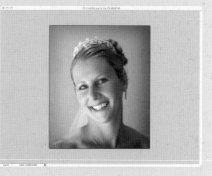

• CLONING AND REMOVING HIGHLIGHTS

There is no excuse for carelessness and sloppiness when taking photographs and you should always be vigilant for distracting elements and objects in the viewfinder, before you press the shutter. Having said that, you may sometimes see a great shot in front of you with no possibility of avoiding an unwanted highlight, for example. There is no reason not to take the shot, or to discard the afflicted image, when a few minutes spent on the computer will clone the highlight out so no-one will ever know it was there. This is one of the really great advantages of digital editing – faster, easier and more accurate than the old methods of re-touching by hand. This is also a good way of restoring old or damaged prints, which can be scanned into the computer.

1. Open the image. Select the Clone tool. Make your selection to the side of the highlight to be removed, carefully choosing an area with the same amount of density and colour.

2. Soften the outline of the selected area by choosing >Feather.

3. Gently clone over the highlight.

4. Use the Marquee tool to clone the wall to the right of the bride and to copy and paste the selection over the distraction. Once you have pasted the selection onto the wall, select Free Transform and transform the selection. Flatten and save.

5. These two images show the finished result, one in colour and one in black and white. Note how your eye is now drawn towards the face of the bride, rather than to the highlight in the original image.

• CONVERTING TO BLACK AND WHITE

While many digital SLR cameras allow you to select a black and white mode before taking the picture, it is better to leave your options open and shoot everything in colour. If, while viewing the image on the computer, you decide it may look better in black and white, it is a simple procedure to convert it. If you don't like the effect, you can simply return to the original. There is little time during the wedding to make instant decisions and it is not wise to alter camera settings unnecessarily as you may forget to switch them back again at the right moment.

There are many ways to convert your image to black and white and our advice would be to try all the numerous methods and then select the one that you find suits your style of photography. You can then set it up as an 'Action' and use that method all the time. All photographers prefer different black and white styles of image making, Some like a really punchy black and white, others prefer it to be softer and more controlled. Below is the method of conversion using Lab Color. This is a simple and straightforward way of producing a good clean black and white image from your original colour file.

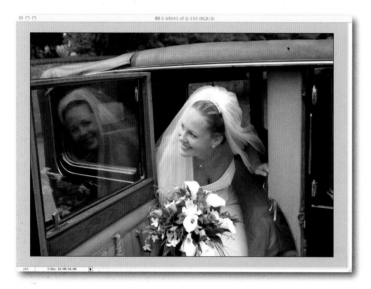

1. Open your image. The colours, although quite subtle, were thought to be a little distracting, especially inside the car.

2. Select Image > Mode > Lab Color.

3. Open >Channels. Delete both A and Alpha B Channels by dragging them to the bin.

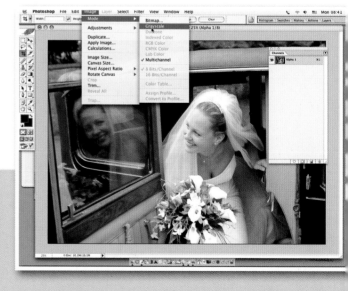

4. Select Image > Mode > Grayscale.

5. Select Image > Mode > RGB.

6. Adjust the layers and the contrast to your personal taste.

The final image has a much clearer and more graphic feel to it. Attention is drawn to the bride's reflection in the window, rather than the details on the car door.

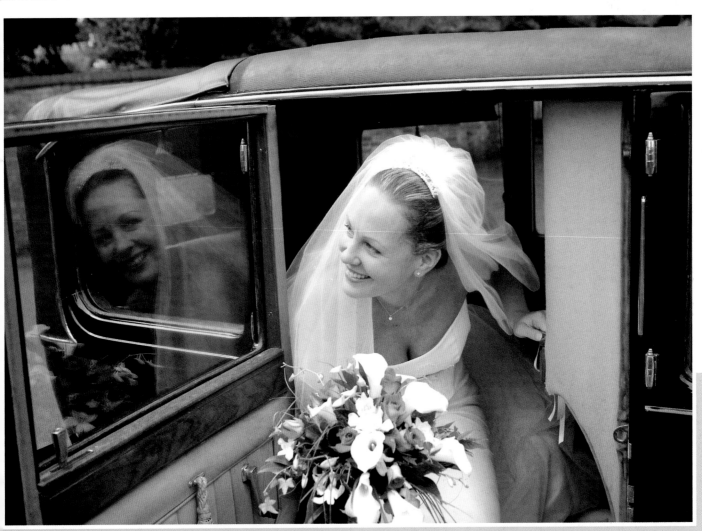

117

• TONING YOUR IMAGE

Once you have converted an image from colour to black and white, you have the option of toning it. Sepia and blue-toned images, in particular, are currently very popular with customers and photographers alike and some of our blue-toned images, including the cover of this book, have been award winners.

You will find some people who loathe the effect of toning however. Always try to gauge the clients' views on this when you show them display albums at the first meeting. Alternatively you can give them the option of different versions – colour, black and white and toned – for certain images they have selected, before you place them in the album. Toning is a very straightforward

SEPIA TONING

To add a sepia tone to images, Curves is used.

1. Select the image that requires toning. Enlarge the image so that you can clearly see the faces.

2. Go to Layers > Curves. Select the Red Channel.

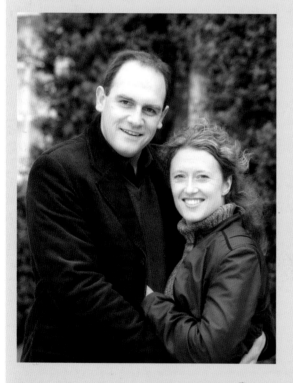

3. Select the middle of the line and push upwards along the straight line until you have an input around 129.

4. Keeping the Curves box open, select the Blue Channel and, this time, drag the curve downwards so that you have an input of around 129.

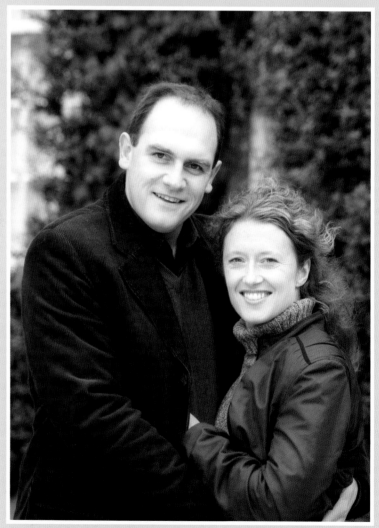

5. The finished sepia image has more warmth and richness than the pure black and white version.

process and offering this extra choice should take up very little additional time. Obviously, if clients have a preference for an entirely black and white or entirely colour album, then you must respect their wishes. In our view, a combination of colour, black and white and toned images adds interest and variety to the album.

RULE OF THUMB

Once you are happy with the tone of your sepia and/or your blue, set this up as an Action. This will give you the same tone consistently throughout your photographs and, ultimately, in the album.

BLUE TONING

Adding a blue tone to an image is a quick and easy alternative to sepia.

1. Open your black and white image. Select Layers > Hue and Saturation. Tick the Colorize box

2. Slowly move the slider across the Hue until the blue tone you like appears, usually around 222. Then adjust the saturation to your own personal preference. Click OK.

3. The resulting blue-toned image will be balanced and is a refreshing, more contemporary alternative to sepia.

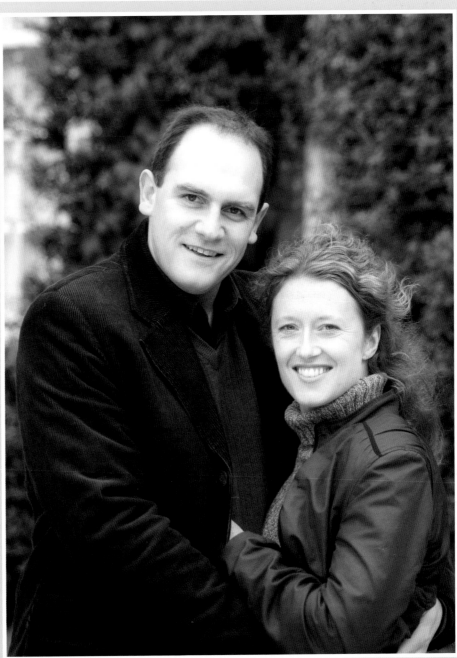

Printing Advice

As technology has evolved, so has the accessibiilty to control the quality and output of your photographic images, either in-house or at a professional lab. Colour-profiling is paramount for success.

• COLOUR MANAGEMENT

If you intend to output from a desktop printer or other device, it is imperative that a linear colour-managed workflow is implemented to ensure colour management is predictable and constant. Your monitor needs to be profiled and regularly calibrated and your choice of ink, paper and printer needs to be profiled. Do not rely on the manufacturers' generic profiles. It is far better to have custom profiles created for each of your combinations of printer, paper and inkjets.

Working with profiles is the key to colour management. Print information is delivered from the computer to the printer through an interface, the 'printer driver'. If either, or both, ink and paper are substituted, then the output will show inaccurate results in colour or density without the use of correct profiles.

To take account of the change of ink and paper, the profile is a special computer file containing information that modifies the data passing from computer to printer. The colour profile not only modifies the colour balance of the print, but the amount of ink the printer lays down. This is important, as different papers take different amounts of ink.

There are two forms of colour profile: generic and custom. Custom profiles are written for a specific printer by a colour management specialist. A generic profile is one that is written to work on all printers of a certain type, for example an Epson 4800. The potential downfall of generic profiles is that they cannot take into account the inherent differences between Epson 4800 printers and variations in batches of paper or ink. Consumer inkjet printers of the same model are not necessarily identical from one to another, and one printer can deliver very different results to another printer of the same model and make. Colour and density rendering characteristics are liable to vary from printer to printer, each producing prints with their own particular bias and curve, which would require corrections to be applied to every image run through a specific printer.

For correct colour management, you will also need to pay close attention to your work environment. Consistent ambient light, ideally D65 (daylight balance lighting) and neutral grey walls, floor and ceiling are recommended. Avoid brightly coloured clothing that can cause apparent colour casts by reflection on your monitor

With the Epson Pro Portrait System, you have all you need to give you complete control from capture to print. We like this system because you can print what you want, when you want it, enabling you to improve your workflow and drastically reduce your turnaround time by up to 50 per cent. The Gemini 3 gives us consistently high-quality results and this is guaranteed through Epson service and support.

> ## RULE OF THUMB
> *The advantage of using a RIP, is that your computer is then free for you to work on other tasks whilst the RIP is operating your output.*

screen and ensure that your monitor, especially cathode ray tube monitors, has had a sufficient 'warm-up' period before commencing work. Ideally have your monitor timed to switch itself on a good 30 minutes before you start work.

When a screen-saver is active, it has the effect of 'cooling down' the white point of the monitor. This means that it will need time to reach the correct colour temperature before work can continue. For this reason we disable the screen savers from our Macintosh system. Predictable results need colour management and a controlled environment.

• PAPER TYPES

The most common paper surface finishes are lustre, glossy, pearl and matt. There are also many beautiful fine art papers available from specialist paper mills. Choosing your finished paper type will depend on which album you would like to produce. If you want an all-monochrome finished product, then an album made up of pure top quality fine art rag paper, printed to the highest standard, would look stunning.

Try various sorts of finishes and then when you are happy with the finished result, put together a display album ready to show potential clients. Customers will only buy what they can see. Make sure that you have several options for them to choose from.

• PRINTING SOFTWARE

Ideally, if you are going to do a lot of printing with a desktop printer, it is advisable to set up a RIP (Raster Image Processor). A RIP is a separate computer and specialist software that processes the printing data. The software takes your image and text and tells the printer where and how to place each droplet of ink on the paper.

One of the big issues with digital files is the time it takes to process them. If ever there was a good example of the 'time is money' principle, digital imaging is it. Every computer operator who has ever output images, will have experienced the nightmare when a job that has taken hours to process is lost when the computer crashes. It is not something you let happen again.

If you do not have a RIP, you rely on the printer driver to communicate between your application and your desktop printer. In some cases, this works fine. Nevertheless, it is like using gestures and facial expressions to convey complex ideas – not very efficient and some thoughts are misunderstood. The RIP offers additional features and functions not found in your standard printer driver.

Think of the RIP as a translator between yourself and your printer. You give it instructions in the language of your desktop publishing application and the RIP translates your instructions into the language of the printer.

Balanced window and ambient light gives a pleasing, warm effect to this image.
Nikon DSLR, 17–55mm lens,
1/60sec at f/2.8

Designing the Album

The album is the final product of wedding photography and designing it is when all the hard work you have put in during the build-up and on the day itself comes to fruition. Some photographers prefer to outsource the album design to another professional but, with the increased availability and sophistication of design software packages, it has become much easier to take control of this yourself. The benefits of doing this are great. It allows you to put your own signature on the finished product, using the insights you have gained while you were present, taking the photographs at the event.

There is also a real sense of personal satisfaction to be gained from the album design. When you present the finished product to the couple, there is nothing more rewarding than watching the emotion on their faces as all the happy memories of special moments or funny incidents come flooding back. If the client is one hundred percent happy, it is the best kind of job satisfaction you can get.

This chapter looks at how to begin the process of design with the couple's selection of pictures. The different styles of album and software packages available are also examined.

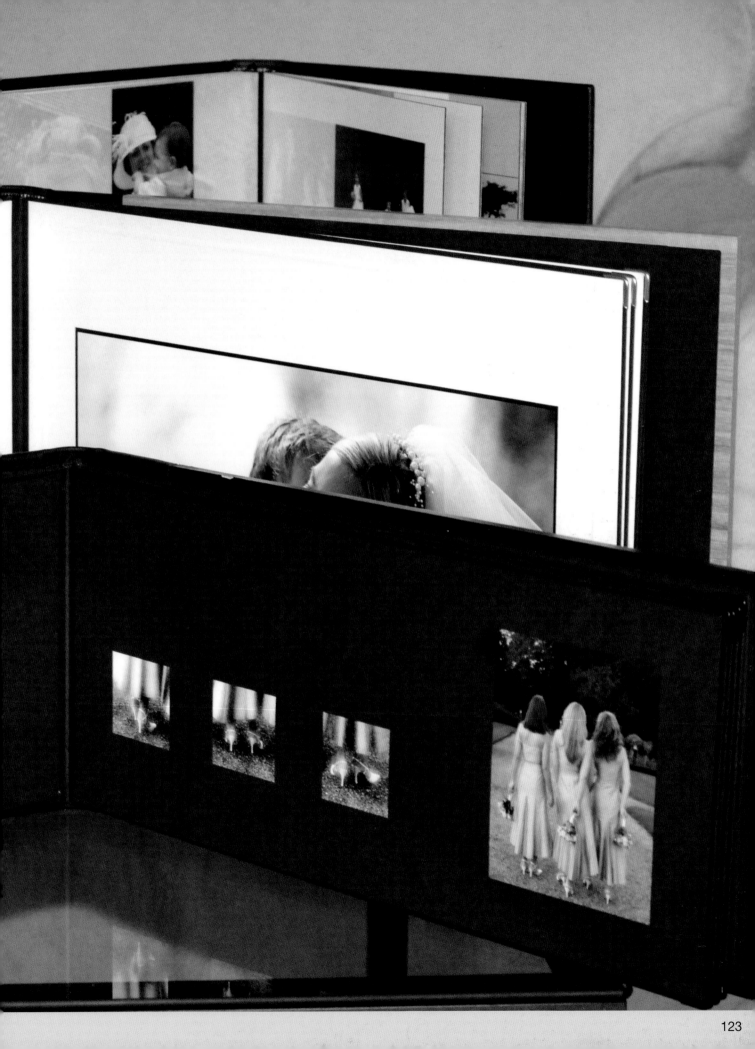

Album Styles and Choices

Now that digital imaging has become established in mainstream wedding photography, album designs and presentation have also evolved rapidly. As wedding photographers we need to develop our design skills in order to take advantage of the many different styles of wedding albums and design software packages that are available. It is imperative to put the album together with feeling and care in a romantic style, and to show the couple in this light. Simply cramming the images in without chronological order or flair will result in a busy album that doesn't portray your work well. Remember that this is a showcase for your next wedding!

Different Approaches

There are two different design styles in the modern wedding market, the magazine style (one photographic image is the actual page in the book) and the traditional kind of album with overlays or mats (the images are underneath cut mats). Both are planned in the form of a storybook. We always start the album with a calligraphy page, ideally the pre-wedding portrait image and date, followed by either the bride or the groom. The magazine style is designed as a double-page spread with all the images looking towards the spine and not out of the edge of the book. The pages should not look too cluttered but have a natural flow and it is always better to add a couple of

An example of a traditional style album layout. This has a mat, or overlay, which is the card frame with cut-outs for the photographs, that is laid onto the page base (the two-sided page).

Albums are available in many different shapes and styles from a number of specialist suppliers. The couple make their choice of album from samples in the studio, before the wedding takes place.

extra pages to the book, rather than cram images in.

The couple choose the style and design of their wedding album at the final interview stage. This is important because it will have a bearing on the format and subject matter of the pictures taken during the day. For a traditional album with overlays/mats then you would keep most of the images rectangular. For the magazine style, images can be taken on the angle so that you can montage several together. This style also requires more background images to be created on the day to work as fillers.

There are many different manufacturers of the albums themselves and a good way to research these is to attend one of the major wedding shows or exhibitions that take place. We use a company called Jorgensen, which offers a number of different shapes and sizes, bound in a choice of metal, leather, vinyl and even wood!

Selecting the Images

Using the Internet is the first stage in the selection of images to include in the album. This is where most couples will have first

sight of the photographs taken on their wedding day. We aim to have the entire wedding edited and posted on the Internet within seven days so that the clients can access their wedding pictures while on their honeymoon.

The bride and groom are invited to choose a minimum of 90 images for their wedding album. They should include 20 of the family groups and principle images that they requested before their wedding, as well as their favourite shots from the

day. These are the pictures that will become the backbone of the album, giving it substance and reflecting the couple's personalities.

The remaining images are used to build the storyboard design. If they have chosen the 'magazine style' album, then they are asked to select a further 20 images for backgrounds and ghost images for the pages. Customers can, of course, select more images for the design than this, but these will be priced individually as an extra.

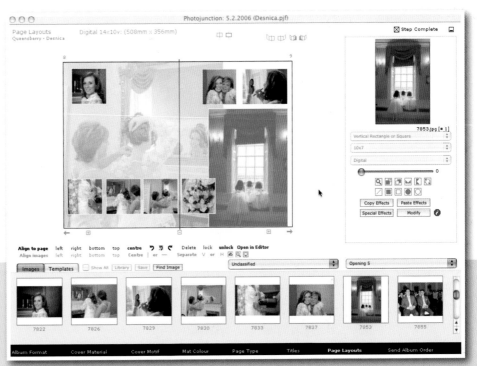

Although album manufacturers provide album design software packages, do not disregard third-party design software.

Designing the Album

After the pictures have been selected, the next stage is to create a design with those photographs. Start by separating images into different folders on the computer, broken down into the following categories:

1. Bride at home.
2. Groom in preparation with groomsmen.
3. Before the ceremony – guests arriving, bridal party at the wedding venue etc.
4. Ceremony itself, during, signing.
5. Reportage after the ceremony, at the venue, at the drinks reception.
6. Family groups plus key images requested by the couple.
7. The bridal party (groomsmen, best man and bridesmaids).
8. Photographs of the couple.
9. Detail shots i.e. table decorations, flowers, shoes, invitations, seating plan, favours etc.
10. Speeches.
11. Evening guests/party-time, first dance, live band and dancing.
12. Fireworks.

Once you have the images grouped in this way, you can start to place them on individual pages, arranging some together if they are complementary or form part of a sequence and others individually over a whole page if you feel they need that space to do them justice. The whole process is partly intuitive, having the eye to understand what works well on a page, and partly a matter of trial and error and practice.

The album design should stick to a chronological order and not jump about from one section to another and then back again. Every turn of the page must deliver something different in size, shape and content so that viewers really get involved with the album and it is not boring to look at. At the end of it, they should be eager to see more.

The image you select for the final page should be a closing photograph of the couple alone that will give the story an ending. The couple walking off into the distance would be ideal but, whatever you do, avoid the old-fashioned cutting the cake shot!

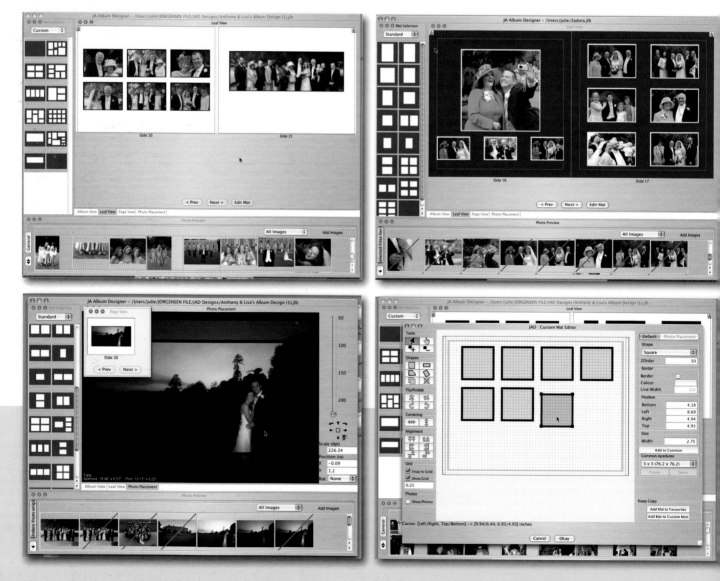

A complete designed album – in the traditional format.

🍎🍎🍎 Page 027+28.psd @ 12.5% (Background copy, RGB/8)

12.5% Doc: 139.0M/264.3M

'From each wedding you photograph, your future clients will see how you conduct yourself, the photographs you create and more importantly, the album that you have designed.'

A double-page design in the magazine style album.

Magazine Style Albums

With a magazine style album, the photographs are designed and montaged together as one image that becomes the page in the album. There are no overlays with this style. Software for the design is downloaded onto your computer system, usually at a price, and there are several programs to choose from. Once the album is designed, the whole pages are sent to the album manufacturer to be bound in a book. Most of the software available on the market is universal, so that you can use if for most album suppliers and it doesn't tie you in to one manufacturer.

If the couple choose this style of album, they must do so before the wedding takes place. It will require you to take additional photographs, which you wouldn't need for traditional albums, to use for ghost images as the backgrounds to the pages. As a result, this is usually a more expensive option than the traditional album.

Once the couple has selected their images and 20 extra background shots, you can import them into the computer program. Decide on the number of pages you will require. We generally start magazine albums with 24 sides (12 pages). Allocate so many pages to each part of the storybook, for example:

- Groom preparing, two pages.
- Bride at home, two pages.
- Guests, bridesmaids and bride arriving at the church, two pages.
- The ceremony, signing the register and couple exiting church, two pages.
- Reportage photography outside the ceremony venue, including the confetti and the couple leaving, two pages.
- The arrival at the venue, drinks reception, images of the venue, two pages.
- Group photographs, four pages.
- Bridal party, two pages.
- Bride and groom in and around the grounds, four pages.
- Reception room, table decorations, place settings, cake and details, two pages.
- Total: 24 pages.

This is a rough plan of the wedding album. Obviously, if you feel that more pages should be added, then by all means add them to the design, but advise the couple that they will either have to remove other pages or pay extra for the additional ones. Sometimes the photographs will require more space and the finished album will need more pages. Explain this to the couple at the six-week pre-wedding meeting, so that they are aware of the fact. Remember to communicate initially so that you do not have to keep selling. All the selling should have been made at the initial wedding meeting. If the couple employ your services for the speeches, first dance and the evening party, then the initial album design will increase to 30 pages.

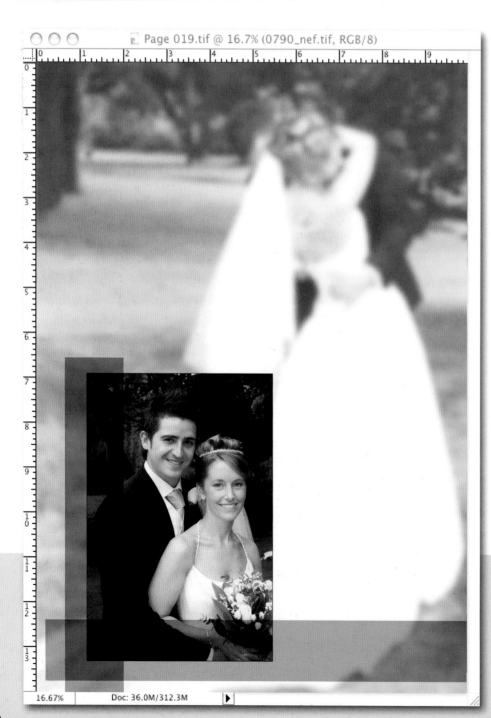

Try to make the background 'ghost' images complementary to the main photograph and similar in subject matter. Here there is a fairly formal portrait of the couple with a romantic moment between them behind.

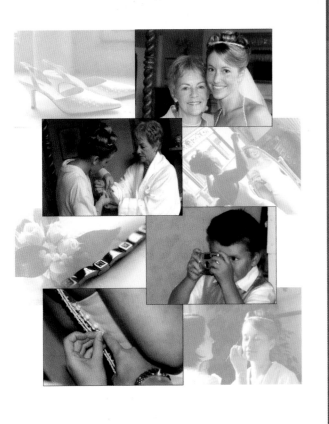

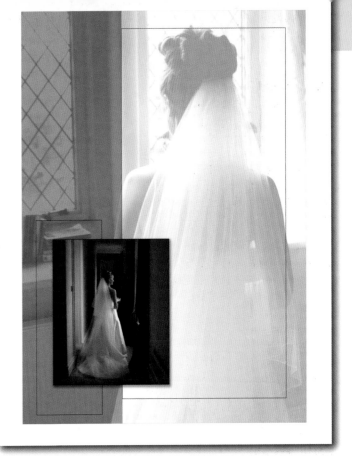

The bride's preparations work well as
a montage, mixed in with some details.

Again, two complementary pictures are used.
Neither of them show the bride's face but both
capture the mood and atmosphere of the day.

The magazine style is designed as a double-page spread, so you need to ensure that people
in the pictures are looking in towards the spine of the book, to keep the viewer's eye contained.

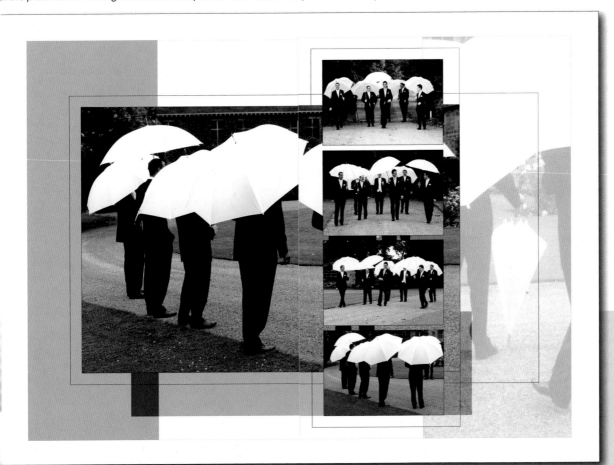

Traditional Style Albums

The so-called mat or overlay kind of wedding album comes in various styles and shapes but the distinguishing feature they all have in common is that the photographs are placed behind overlays – also known as mats. These come pre-cut and designed by the manufacturer and are produced in standard print sizes, ie 10x8, 5x6 and so on.

The alternative, quite recent, concept is provided by special software (wedding exhibitions are a good place to research the options). This is downloaded onto your computer system, enabling you to design every page of the album yourself, with individual overlays cut to order and size by the album manufacturer. This is the way that we choose to produce our overlay album designs. It means that each, individual album is unique in layout and content, which

is a great selling point to customers. It also allows much more freedom in the design, as you can crop images as you see fit, to produce panoramas, for example, without having to conform to fixed dimensions. The albums are made to fit the photos, not the other way around.

Designing the album may seem daunting at first, but it can be a really enjoyable and satisfying part of the wedding commission. As you have a personal involvement in the images, you will know which ones represent special moments in the day and those that can play a smaller part in the design. The most important thing to remember is that the album should flow from one page to another, telling the story as you have photographed it, with each image given the space it is due.

'After the blood, sweat and tears that go into producing the photography, presenting the album gives you such a great feeling of satisfaction that it makes your job worthwhile.'

Album design software makes it easy to move images around the page until you have the best position.

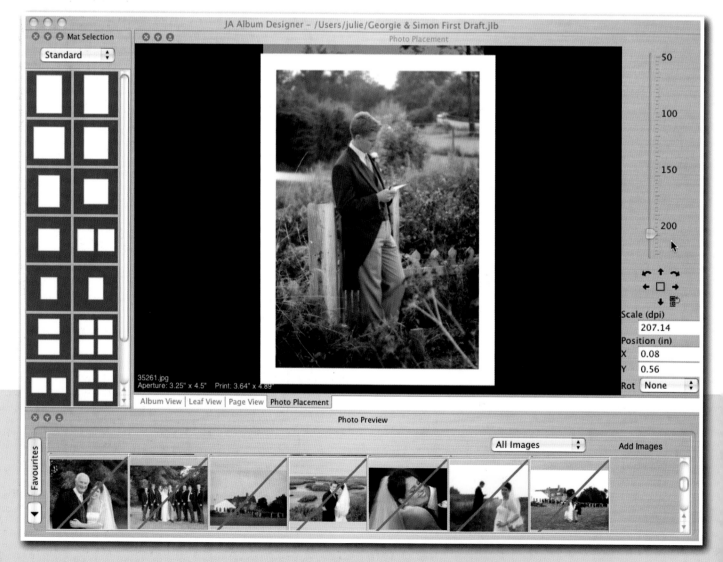

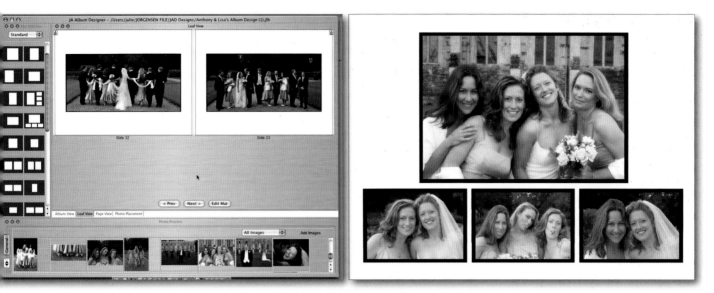

An overview of a finished album design in the traditional style.

One finished page showing the layout. Note that a black stroke is keyed in around the image, which, when offset against a white mat and black pages, gives great impact.

The Business of Marketing

So far, we have concentrated on ways of ensuring you deliver the best possible product to your clients – that is the wedding photographs themselves, and the album they are presented in. It should not be forgotten, however, that, for most practitioners, wedding photography is a business and, like any other, it must attract customers and it must be profitable.

You can have the most fantastic range of display products, leaflets and stationery on the market, but if your customers do not know of your existence, how are they going to find you? Marketing is a very important tool in this respect and must be taken seriously. If you market your photography properly, customers will know where you are and what it is you can offer. As a guide, it takes three years to establish your business and that period is crucial. Even after three years, you need to keep promoting yourself to keep your name at the front of the queue.

The following pages look at ways of building up the business side through marketing, promotion and the all-important website. We also offer strategies for assessing the success and weaknesses of your marketing campaigns and business tools, so you can take action where needed and build on areas that are doing well.

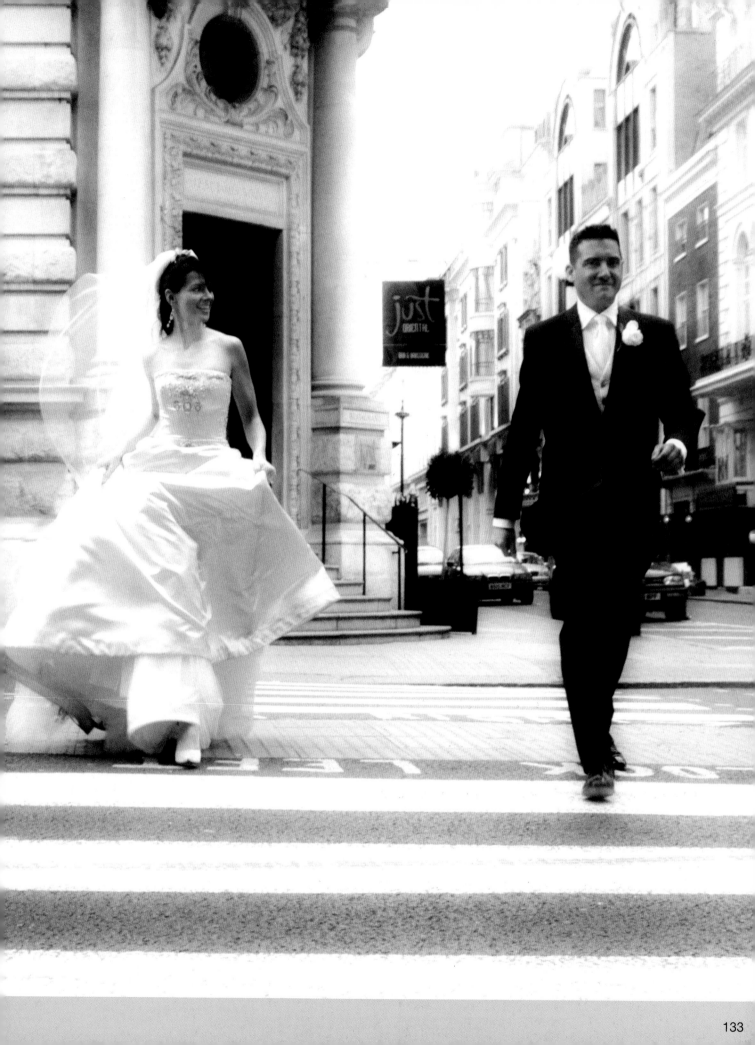

Above and below: When exhibiting, it is worthwhile photographing your stand, and any others that catch your eye, for future reference. Take a small compact camera with you to the shows.

Marketing

The essence of marketing is to understand your customers' needs and to develop a business plan that will surround those needs. In reality, anyone who has a business will have the desire to develop it successfully.

The most effective way to grow and expand your business is by focusing on the most important areas of growth, market research and development of your customers' needs.

Marketing glossary

There are four different key ways that you can increase the growth of your business. They are:

• Acquire more customers.
• Persuade each customer to buy more products.
• Persuade each customer to buy more profitable products.
• Persuade each customer to buy more expensive products or up-sell to each customer.

All four of these will increase your revenue and profit. Concentrating on the first of these four will increase your customer base and your revenues will then come from a larger base.

How can you use marketing to increase your customer base?

• Target your product to develop customers that you are not currently attracting.
• Price your products competitively.

A traditional style album page design.

• Spend time researching and create a strategic marketing plan.

Remember that only a proportion of people are likely to purchase any products or service. By pitching your sales and marketing efforts to the correct niche market you will be more productive and not waste your efforts, time or money.

Running a small business, you will have a limited marketing budget, if any at all. Does that mean you can't run with the big dogs? Absolutely not. Just market your business by doing one of the following:

• Work with venues/companies.
• Take some time to send your existing customers referrals and buying incentives.
• Introduce yourself to the media. Free publicity has the potential to really boost your business.

• Invite people into your business by piggybacking onto a local event – trade photographs in exchange for products/ advertising space.

By being diligent in your marketing and creating an manageable strategy such as deciding to contact at least 10 customers or potential customers each week, you will see your business grow. The great thing is that if you focus on your product and maintain high standards of presentation, not only of your product but yourself, then your business will get more successful and you will not need a large marketing budget to make it happen. Look after your existing customers – keep in touch with them by using a marketing database. These customers are loyal to you, they have experience of you as their photographer and will at every opportunity tell your future

This couple had their wedding reception at a restaurant called 'Bank'. the separation of the pair by the 'K' enhances the composition. Restaurants may wish to purchase images such as this to market their venue to other couples.
Nikon DSLR, 28–80mm lens, 1/60sec at f/8, reflector

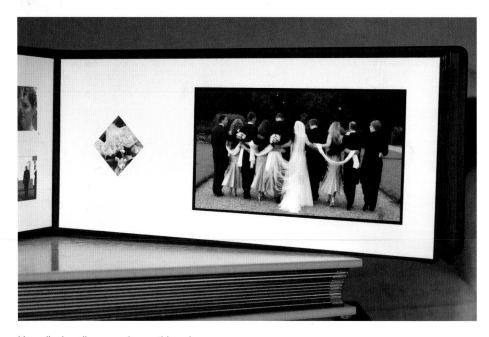

Your display albums and everything else you do within your business must portray a professional approach.

• List all of your current marketing ideas/activity.
• The percentage of wedding activity.
• Evaluate the seasonal calendar to monitor when your business is the most pro-active, and when it is least pro-active.
• Assess the financial value of all your promotional campaigns.

Marketing Tools

• The photographer.
• The product.
• The studio environment – customer care and customer service.
• The studio location.
• Stationery – brochures and leaflets.
• Customer's information packs, price lists and so forth.
• Display products – display albums, frames. etc.
• Camera equipment.

customers about you. Use your database to record customers' wedding anniversaries, birthdays and so on – this will allow a more personal approach in the future and again increase your client base.

To gain a good understanding of the needs of your business, whether it is to develop solely the wedding arm of the business or to introduce another product into it, such as portrait photography, it is worth evaluating your marketing activities to assess where current and future activity lies.

There is very little point in spending money on beautiful colour brochures and leaflets and then giving your customer a photocopy of a price list! Everything you do within your business must portray a professional approach and be part of your business objectives. These objectives should incorporate both creative and financial goals. Remember you are the biggest selling point of your business.

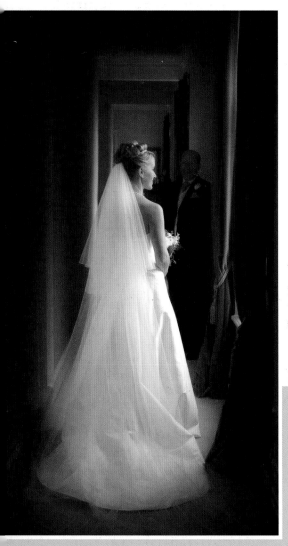

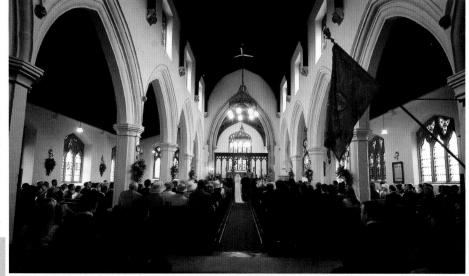

With the camera mounted on a tripod, a wide-angle lens was used to capture the atmosphere of the church during the wedding ceremony.
Nikon DSLR, 28–80mm lens, 1/30sec at f/5.6

This lovely bridal portrait was captured with available light through a window. The bride's gown reflected light along the corridor and just lit her father who was watching his daughter being photographed.
Nikon DSLR, 28–80mm lens, 1/30sec at f/5.6

Business development and marketing together with PR should work without conflict and you should pursue any agenda decide you adopt. A S.W.O.T. analysis is designed to focus on the real issues within your business.

Follow this simple plan and complete a S.W.O.T. analysis. Remember that you may place the same subject in all categories; i.e. you are the greatest strength and you take the opportunities, but you can also be a weakness with unforeseen dangers like ill health.

STRENGTHS: Include all the current strengths of your business. For example, your customer/client base, your reputation, your style of work.

WEAKNESSES: Areas within your business that do not contribute effectively enough. For example, advertising, products.

OPPORTUNITIES: Your future – planned or unplanned, opportunities that have not yet been explored, such as awards, qualifications.

THREATS: Unforeseen threats and dangers that may occur within the business, such as ill health, cash flow.

It is worth time spending a little time just working with the Boston Box to decide where you want to be in five years' time. It is a great way to analyse your products. What you will do if, for example, you have no bookings for three months and have little income during this time, but you still need to pay the rent on your studio? This will help you to focus on your products and where you are in the marketplace.

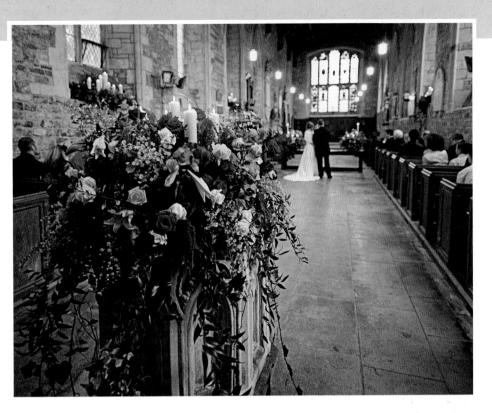

Differential focus on the flowers in the font during the ceremony provides a record shot of the flowers as well as capturing the atmosphere. This image could be sent to the florist with your website printed on the bottom.
Nikon DSRL, 28–80mm lens, 1/30sec at f/5.6

The Boston Box

Rising Star
New products that are not yet financially stable.

Cash Cow
These are the products your business was built on.

Problem Child
List here products that require a lot of attention and nourishment to grow.

Dead Dogs
Make a list of yesterday's products that the market has lost interest in.

Websites

Without doubt, the World Wide Web has been revolutionary in the business of wedding photography. A website is your shop window and the first port of call for future customers to view your photography and make the initial contact with you. This is far more effective than paying for advertising space in the local press or national magazines and waiting for customers to phone you, as used to be the case. Websites save time for the customer and the photographer by giving them a good idea of the style and standard of photography you offer, before making contact. This makes the initial inquiry so much easier (see pages 18–19).

You can have the most impressive website of them all, but if it takes a long time to download, the prospective customer will simply leave and move on to the next available site. It is vital to the marketing of your business that your website is quick to download. It should look clean, not too cluttered, and be very easy to navigate. All the important details must be included; for example, your name, your address and relevant contact details. Above all, there should be very little text. People are not interested in reading pages and pages about how wonderful you are. The photographs are by far the most important element. We have found that the more

images we have on our website the better, especially if they cover every aspect of the wedding day's events.

Make sure your website address is available to clients through the maximum number of outlets – even on the office voicemail. Business cards must include your website and contact details, as should elegant, well-printed brochures. We ensure that many wedding suppliers (florists, car companies etc) have our website listed as a link from their own websites. By keeping a record of our statistics on the server reports, we can see where our traffic emanates from and have found this a worthwhile source of publicity.

There are so many software packages enabling simple website design that a do-it-yourself approach is increasingly an option. If you are not confident about it, though, employ a professional to design and set it up. It is such an important tool that it is worth the investment. As well as a gallery of images, our own website has a form that a customer can fill in, submit and allow us to check our availability for their wedding date. We email back within 24 hours.

JULIE OSWIN PHOTOGRAPHY

home | profile | gallery | contact | view online images

wedding photographers of distinction

If you would like us to check the availability for your wedding day, please complete the few details below and submit them directly to us. We will confirm whether we are available for the date you give us within 24hrs. Should you wish to book our services, we can offer you a no obligation consultation at your convenience. All fields are required

Julie Oswin Photography
6, Springfield Close
Loughborough
Leicestershire
LE11 3PT

Tel : 01509 268008
Email : info@julieoswin.com

Opening Hours :
Monday ~ Friday 9.30am to 5.30pm
Evening appointments are available.

To get directions to our studio enter our post code: LE11 3PT and your own post code into the route planner found here: Route Planner

Name :
Wedding Date :
Venue :
Reception :
Contact No :
Email :

How did you hear of Julie Oswin? : Please Select

Comments/Questions :

Send Form Reset

Julie Oswin Photography ~ 'Windrush', 6 Springfield Close ~ Loughborough ~ Leicestershire ~ LE11 3PT
Tel: 01509 268008 ~ e-mail: julie@julieoswin.com

The A–Z of Professional Wedding Photography Tips

A – Aperture
Control the depth of field successfully with your aperture. Make your images different to those of the bride's uncle, who was taking photographs over your shoulder.

B –Batteries
Always keep spare batteries in your camera bag and make sure that they are fully charged.

C – Care and Communication
Communicate with your clients before, during and after the wedding. Offer a personal service throughout and look after them. Remember, you might have already photographed dozens of weddings, but this is their first time.

D – Dress for a Wedding
If you are a female photographer, it is important that you do not out dress the bride's mother. Black suits are a good choice, as you blend into the background. Male photographers should also dress for the occasion.

E – Expression
Without good expressions on the subject's faces, your pictures will not sell. Ensure that you keep up communication with the people in your viewfinder. Always chat to the guests in a friendly manner to create a good rapport between yourself and them.

F – Fun
Help create a good atmosphere around you and make the photography sessions fun. You need to make the couple and guests look like they are having a fantastic day. Weddings are a special family event and you are there to capture the day as it unfolds.

G – The Groom
Never neglect the groom. He is as important as the bride.

H – Heirloom
Wedding images of today will provide the memories of tomorrow. You are the one that will preserve these in the album, for generations to come.

I – Impression
Be a professional at all times. Always work efficiently and never shout or make a lot of noise at a wedding - there is no need to. It shows a loss of control of the situation and, consequently, you will lose the respect of the wedding party and guests. Concentrate on putting people at ease and work with the family and friends to create a happy environment.

J – Job Satisfaction
If you are not getting job satisfaction from photographing weddings, then wedding photography is not for you.

K – Kit
Keep your camera equipment in pristine condition at all times. Have your cameras regularly serviced. They are the tools of your trade. Make sure your bags are packed the night before a wedding, ensuring that you do not forget anything.

L – Love
This is what it is all about. It is important that the love and happiness of the day should be portrayed in the images. No one wants to see an unhappy bride and groom.

M – Money
Remember you are in this business to make money, earn a living and feed your family. Work out the cost of running your business, running your home and updating your equipment. Divide this by the months in the year, and then divide this total by the number of weddings you would like to photograph. This will give you an estimate of how much to charge for individual weddings at. Do not try to compete with you competitors. Be different.

N – Natural
Your photographs should look believable and natural. Talk to the couple, ask them what they would like. The image on the front cover of this book came about through discussion with the bride and groom. The bride had designed her wedding dress and requested that her 25-foot train was not photographed all laid out, but with a *Wuthering Heights* feel to it. The location was en route to the reception and the image took only a few minutes to achieve.

O – Organization
It is important that you keep to the agreed schedule. Nominate the groomsmen to help with the organization of the day – they have

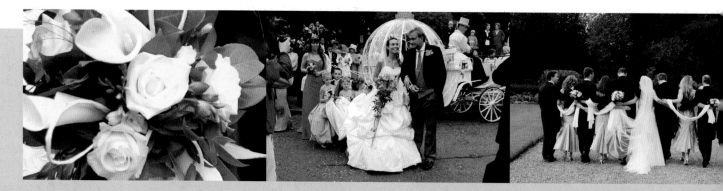

been chosen by the groom to support the couple and not just to look great in their suits. Treat them with respect and they will help you organize the group photography. Communication is the key.

P – Poses
Keep any poses natural, relaxed and not too staged. People need to feel comfortable, not stupid, in the photographs.

Q – Quality
The quality of your work must be of the highest standard and above all maintained at all times.

R – Respect
Treat family and friends of the bride and groom with respect and do not throw your weight around or be rude to anyone. Remember, you are only as good as your last job!

S – Space
Space is ace! This is a great saying. Leave a little space around your image to allow for cropping and to correctly fit the paper sizes that are required for framing.

T – Time
You need to be able to work quickly, quietly, and efficiently throughout the day. Keep to your schedule and do not go over the allotted time. This will not only make you appear professional, but it will allow the chef to serve the wedding breakfast at the optimum time.

U – Under-Promise
Under-promise and over-deliver.

V – Value
Give value for money. Always exceed your customer's expectations. They will have put a lot of trust in your ability to capture their wedding day. Deliver the goods.

W – Weather
Be prepared! Weather can change, no matter what the forecast. Always have a back-up plan if the weather turns nasty. Carry studio lighting in the winter months as support. Always keep a back-up camera and spare batteries in your car. You never know when you might need them. Extreme cold weather can reduce battery charge quite considerably.

X – Roman numeral for 10
Learn 10 standard poses for the wedding couple that can be photographed in minutes. Choose your location first and then take the couple to it, or arrange to meet the couple there. Suggested quick poses are:
1. Close-up of their heads.
2. Head and shoulders (front to front).
3. Three-quarter length (front to front).
4. Full length (front to front).
5. Head and shoulders (front to back).
6. Three-quarter length (front to back).
7. Full length (front to back).
8. Bride sitting, groom standing with his arms around the bride's shoulders.
9. Groom sitting, bride standing but with her arms round the groom's shoulders.
10. Both sitting, either on the floor (make sure you have a rug for this) or sitting on a bench.

Y – You
Maintain your professionalism at all times. Dress for a wedding. Listen to what your customers are saying and what they are asking for. Do not promise to do certain types of photography for them if this is not your style. If you were looking for a photographer for your own daughters wedding – would you be the kind of photographer you would book?

Z – Zealous
You should be filled with intense enthusiasm and zeal for the couple's wedding day. Stay in tune with the proceedings and capture the day to the very best of your ability.

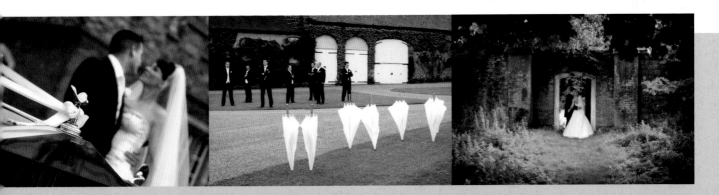

Index

album 122-31
 album styles 125, *125*
 calligraphy page 124
 chronological order 126
 designing 126-31
 design software *125*, 128, 130
 display albums 18, 19, *19*, *136*
 first and last images 48, 78, *78*, *97*, 126
 ghost images 42, 95, 125, 128, *128*
 image selection 125
 magazine style 78, 108, 124-5, *127*, 128-9
 overlays 124, 130
 reportage shots 78-9
 traditional format 124, *124*, 125, *127*, 130-1, *135*
aperture *21*, *54*, 55, 74, *90*, 94, 98, 140
architectural backdrops 22, 36, *79*, 96
association membership 25

back views
 bride and groom 30, *32*, *33*, 38, 78, *79*, *97*, *136*
 bridesmaids *38*
 children *76*, *77*
 groomsmen *65*, *84*
batteries 25, 140, 141
black and white, conversion to *58*, 108, 116-17
black and white photography *19*, 34, 78
blue toning 8, *13*, *36*, 119
bride
 arrival at the wedding venue 66-7, *69*, *72*
 at home 54-9
 car, photographs with *35*, 36, *37*, *66*, 67, *89*
 detail images *46*, *59*, 67
 dramatic images 8, *12*, 36, *36*, *37*, *89*
 dress *56*, *58*
 dressing 56, *56*, *57*, 58
 flowers 44, *45*, 48, *54*, 55
 formal portraits *54*, 55
 formal protraits 58, *59*
 hair *55*
 make-up 55, *55*, 58, *58*
 natural images 30-2
 shoes 44, *44*, *45*, 48, *48*, 55, *58*
 tiaras 55
 veil *11*, 36, *36*, *45*, 55, *55*, *97*
bride's home 54-9
bridesmaids *6*, *50*
 at bride's home 55, 56, *57*
 awaiting the bride 67, *67*
 bride and bridesmaids images *31*, *32*, 39, *80*, 82, *83*
 flowers *6*
 poses, directing *38*
 quirky shots *15*, *55*, *73*
 wedding ceremony 68
buttonholes *46*, *62*, 63

cake/cake cutting *45*, 50, *50*, 51, 95, 98, *99*, 102, *102*, *103*
camera and accessories 24-5
cars *35*, 36, *37*, *66*, 67, *89*, 92-3

champagne *48*, 49, *49*, 94, *96*
changing conditions, responding to 22
children
 in group shots 82, *82*
 natural images *6*, *30*, 31-2
 pose, directing 76, *76*
 reportage shots 76-7
chocolate fountains *103*, 105
city and urban environments 34, 35, *35*
clichéd shots 64, 70, 78, 88, 102
cloning 114-15
communication skills 26, 28, 71, *82*, *86*, 140
Compact Flash cards 24
competitions and awards *15*
confetti 88, 90-1
contrast, balancing 112, 113
costs 20, 98
cropping images 82, 108, 109, 130
cross-processing 34
cufflinks *60*, 63

dancing 102, 103, 105
depth of field *22*, 99
detail shots 42-51
 after the ceremony 46-7
 before the ceremony 44-5
 bride *46*, *59*, 67
 bride's home *54*
 groom *46*, *49*, *60*, *62*
 groomsmen *60*, 61, *61*
 reception 50-1, 95, 98
 rings 48, *48*, *62*, *63*
 spontaneous shots 48-9
differential focus 50, 55, 94, 98
digital darkroom *see* image editing; printing images
dining room 50-1
 detail images 50
 overview 50, 95
disabled guests 32, *86*
documentary style 12
dramatic images 8, *12*, 22, 36-7, *36*, *37*
 bride 8, *12*, 36, *36*, *37*, *89*
 groom 36
 groomsmen *41*
dress code for photographers 140

equipment *see* wedding photographer's kit
expression *6*, *11*, *13*, *32*, *33*, 36, 74, *75*, *79*, 140

family group photographs 12, 38, 39, *83*
 see also group photographs
father of the bride 56, *66*, 67, *72*, 98, *136*
father of the groom *73*
favours 50
fireworks 104, *104*
flash 24, *26*, 35, *35*, 36, 55, 71, *72*, 98, 103, *105*
flowers
 bridal bouquet 44, *45*, 48, *54*
 bridesmaids *6*
 buttonholes *46*, *62*, 63
 car *46*, *47*

reception 50, 95, *95*
 wedding ceremony 68, *137*
framing photographs 111
fun atmosphere 65, 81, 140

ghost images 42, 95, 125, 128, *128*
gifts between bride and groom 44, *44*, *63*
groom *67*, 140
 at home 60-3
 detail shots *46*, *49*, *60*, *62*
 dramatic images 36
 dressing 62, 63, *63*
 en route to the ceremony 64-5
 natural images 30-2
groomsmen 61, *61*, *64*, 65, *65*, *84*
 detail shots *60*, 61, *61*
 directing poses 65
 dramatic images *41*, *85*
 enlisting help of 26, 84, 90, *90*, 140-1
 groom and groomsmen shots *39*, *63*, *64*
 walking shots 65, *65*, *85*
group photographs 12, 26, 38-41, 80-7
 backlighting 80, 84
 blinks and distractions 40
 bride and bridesmaids *31*, *32*, *39*, *80*, 82, *83*
 children in 82, *82*
 directing poses 38-41
 formal shots 84, *84*, 96
 groom and groomsmen *39*, *63*, *64*
 head–to–waist/head–and–shoulders shots 38, 41, *81*
 intimate compositions 38, 82
 large groups 40-1, *40*, *41*, 84, 86-7
 locations 23, 40, 82
 management 82, 84-6
 overhead shots 40-1, 84, *86-7*
 panoramic format 84
 photographer/guests friction, preventing 38, 84
 'scrum' shots 41, *41*
 standard list of images 39
 tripod–mounted camera 39
 walking shots 41, *41*, 82, *83*
 see also bridesmaids; groomsmen

hats 38, 40, 50, *51*, *72*
height differences, dealing with *31*, 32, 34, 82, *82*
highlight removal 114-15
histograms, reading 112
horse–drawn carriages 67

image editing 11, 106-19
 black and white, conversion to *58*, 108, 116-17
 cloning 114-15
 contrast, balancing 112, 113
 cropping images 82, 108, 109, 130
 highlight removal 114-15
 image storage 108, 110
 presentation and mounting 111
 software 108, *108*
 toning images 34, *50*, *93*, 108, 118-19
 vignettes *13*, *19*, 113
informal photography *see* natural poses
insurance

equipment insurance 25
professional indemnity and public liability cover 25
intimate photography 12, 97
pre–wedding shoot *20, 21*
see also romantic poses
larger bride/groom 33
lenses 24
fisheye lens *12*, 24, 41, 90, 95, 105
macro lens 44, *48*, 63, *63*, 95
telephoto lens *24*, 31, *75*
wide–angled lens *21, 23*, 24, 36, 41, 55, 68, 90, *93*, 95, *98*, 104, 105, *136*
zoom lens *67*, 74, 98
lighting 22
backlighting 23, *71*, 80, 84
directional lighting 23, 24, 34
flash 24, *26*, 35, *35*, 36, *55*, 71, *72*, 98, 103, *105*
natural lighting 22, 50, 55, 69, *98, 99*
reflectors 24, 34, 35, 38, 40, 55
Rembrandt lighting *58*
video light 24, 103, *105*
locations 22-3, 32-3
group photographs 23, 40, 82
romantic images 32-3

marketing 18, 95, 96, 132-9
Boston Box analysis 137
databases 135-6
exhibitions *134*
growing the business 134-5
marketing tools 136-7
networking with other suppliers 47, 95
promotional brochures and leaflets 47
S.W.O.T. analysis 137
telephone enquiries 18
website design 138-9
marquee *94, 102*
mirrors as compositional aids 55, *57*
monopods 24, 55, 59, 90, 100
mood 22, 55
mother of the bride 50, 58, 98
mounting photographs 111, *111*
movement, creating *8, 11*
musicians 50

natural poses 30-2, *30, 31*
networking with suppliers 47, 95

outdoor poses 34-6
see also dramatic images
overhead shots 23, 40-1, 84, *86-7*, 90, *91*

panoramic shots *23*, 68, 84, 130
parents
divorced parents 38
see also father of the bride; father of the groom; mother of the bride
people-skills
building relationships 16, 20, 41, 56, 82
communication skills 26, 28, 71, *82, 86*, 140
guests/photographer friction, preventing 38
names, familiarity with 26
rapport 18, *18*, 20

physical hang–ups, dealing with 30-1
place–settings 50, 95, *95*, 98
poses, directing 28-41, 141
children 76, *76*
dramatic poses 36-7
groom and groomsmen 65
group photographs 38-41, 84, *86*
natural poses 30-2
outdoor poses 34-6
romantic poses 32-4
poses, standard 141
pre–wedding meetings 16, 18-21, *18*, 26, 40
at the venue 22-3
first meeting 18-20
pre–wedding shoot 20, *20, 21*, 124
printing images 120-1
colour management 120-1
custom profiles 120
generic profiles 120
paper types 121
printing software 121, *121*
RIP (Raster Image Processor) 121
professional indemnity and public liability insurance 25
professionalism 69, 140, 141
professional photography tips 140-1

quirky shots *15*, 46, *47, 51, 55, 72, 73*

rapport 18, *18*, 19
reception 94-105
cake/cake cutting *012*, 102, *102*
dancing 102, 103, 105
detail shots 50-1, 95, 98
evening coverage 98
fireworks 104, *104*
interior shots 98-101
journey to 88-93
lighting 98, *98, 99*, 103
overview shots 50, 95, 96
reportage shots 94, 95, 96
speeches 98, *100*
venue manager, liaising with 27, 96
redeye 98
reflectors 24, 34, 35, 38, 40, 55
Rembrandt lighting *58*
reportage shots 12, 23
for the album 78-9
arrival at the wedding venue 66, 67
camera specifications 74
car 92
children 76-7
confetti ritual 90-1
en route to the wedding venue 64, 65
post–ceremony reportage 72-9
reception 94, 95, 96
ring cushions *44*
rings 48, *48, 49*, 62, 63, *63*
exchange of rings 69
romantic images *13*, 22, 23, *23*, 32-4, *32, 33, 34*, 102
rule of thirds 22

schedule of photographs 26-7, 141
bride's home 54-9

groom's home 60-3
group shots 80-7
journey to the wedding venue 64-7
post–ceremony reportage 72-9
reception 94-105
reception, journey to 88-93
wedding ceremony 68-71
'scrum' shots 41, *41*
seating plan 50
sepia toning 118
shoes
bride's 44, *44, 45*, 48, *48*
bridesmaids' 50
signing the register 70-1
slow exposures 59, *98*
speeches 98, *100*
spontaneous shots 48-9
spot–colour 78, 90
street photography 34, *35*

table decorations 50
toning images 34, 50, *93*, 108, 118-19
blue toning *8, 13, 36*, 119
sepia toning 118
transport 34, *73, 78*, 88
horse–drawn carriages *67*
see also cars
tripods 24, 39
two–way radio communication 41

umbrellas *41, 64*

veil *11*, 36, *36, 45*, 55, *55*, 97
video light 24, 103, *105*
vignettes *13, 19*, 113

walking shots
bride and groom *30, 33, 78, 97*
groomsmen 65, *65, 85*
groups 41, *41*, 82, *83*
website design 138-9
wedding ceremony 68-71, *136*
arrival at the venue 66-7
procession down the aisle 67, *68*, 71
religious and cultural ground rules 69, 71
signing the register 70-1
wedding photographer's kit 24-5
back–up equipment 25
carrying 25
checklist 25
equipment insurance 25
wedding photography in the past 6
wedding photography styles
documentary style 12
group photography 12
intimate photography 12
reportage style 12
wet and dull weather 22, 141
photo opportunities 36, *41, 64*
windows and doorways as portrait frames *54*, 58

Acknowledgments

We would like thank many people who have helped us with this book.

Our sincere thanks go to all of the couples featured in this book whose weddings we have photographed, and whose special day we have shared. We thank them for allowing us to use the images that we have created for them.

Our parents, Betty, David, Harold and Vera.

Finally, our children; Dan, Sophie, Jayne, Joe and Clare for their support and encouragement.

We would like to acknowledge the following companies: Nikon UK, Epson Pro Portrait, Jorgensen Albums of Australia, Lastolite Ltd, Apple Macintosh, Adobe, Lexar Media, Ridata, Master Photographers Association, British Institute of Professional Photography, Queensbury Leather Ltd, New Zealand.

Contemporary Imaging Consultancy

Whether you are an aspiring photographer or an established working professional, Julie and Steve offer a range of training courses that are designed to provide you with the skills to drive your photography, creativity and your business forward. Their hands-on workshops, training courses, brand development and marketing consultations are designed to give you the confidence and technical knowledge you need to become a successful photographer.

Want to learn from an array of inspiring course leaders in a dynamic environment?

Please visit the photography training website for full details of courses:
www.contemporaryimagingconsultancy.com
or call: +44 (0) 845 370 7273

About the Authors

Julie Oswin AMPA

Julie Oswin and her partner Steve Walton are two of the most sought-after wedding photographers in the UK. Their creative, relaxed, innovative and editorial style of wedding photography is reflected in the many international and national awards they have achieved with their work.

Julie was honoured to become the UK Classical Wedding Phtotgrapher of the Year in 1999 and the UK Avant Garde Wedding Photographer of the Year in 2001. Julie was a finalist in the British Professional Photography Awards in 2003 and 2004.

As well as being an acclaimed wedding photographer, Julie has established an enviable reputation for her lifestyle portrait photography, winning numerous awards for her work. Julie's preference is for environmental portrait photography rather than the clinical, staged portraits of a studio.

Steve Walton FRSA, LMPA

In addition to being an acclaimed wedding photographer, Steve has established a reputation for his fine art, pictorial and landscape photography. As well as his qualifications with the MPA, Steve is a Fellow of the Royal Society of Arts. At the 2004 British Professional Photography Awards, Steve was honoured to become the UK Landscape and Travel Photographer of the Year.

Contact details
www.julieoswin.com
www.fineartimages.co.uk
www.fineartportraiture.co.uk
Tel: +44 (0) 845 370 7173